HOMESTYLE
KITCHEN

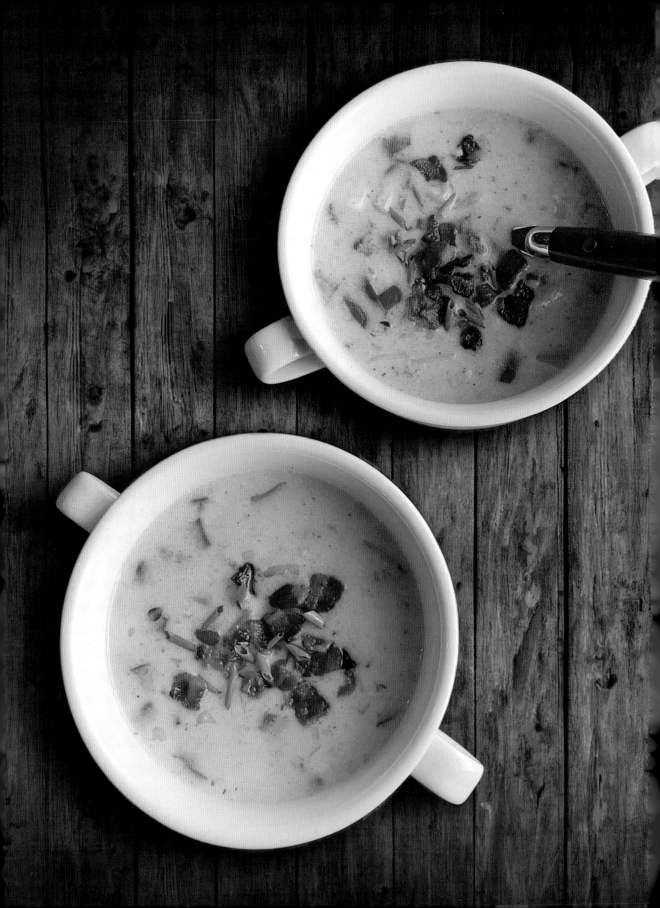

HOMESTYLE KITCHEN

FRESH & TIMELESS COMFORT FOOD *for* SHARING

➤ JULIA RUTLAND ◀

PUBLICATIONS
Adventure
an imprint of AdventureKEEN

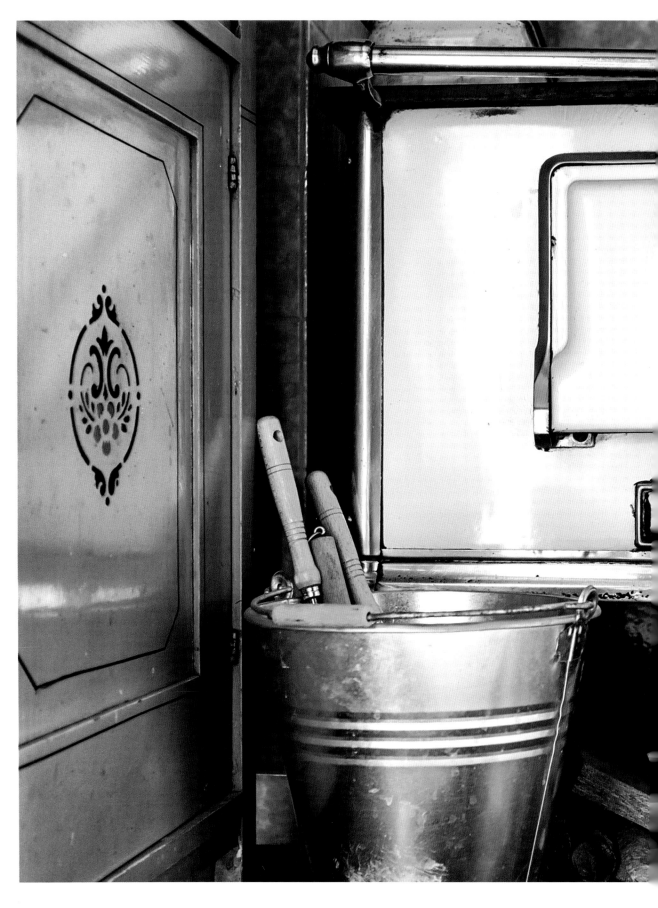

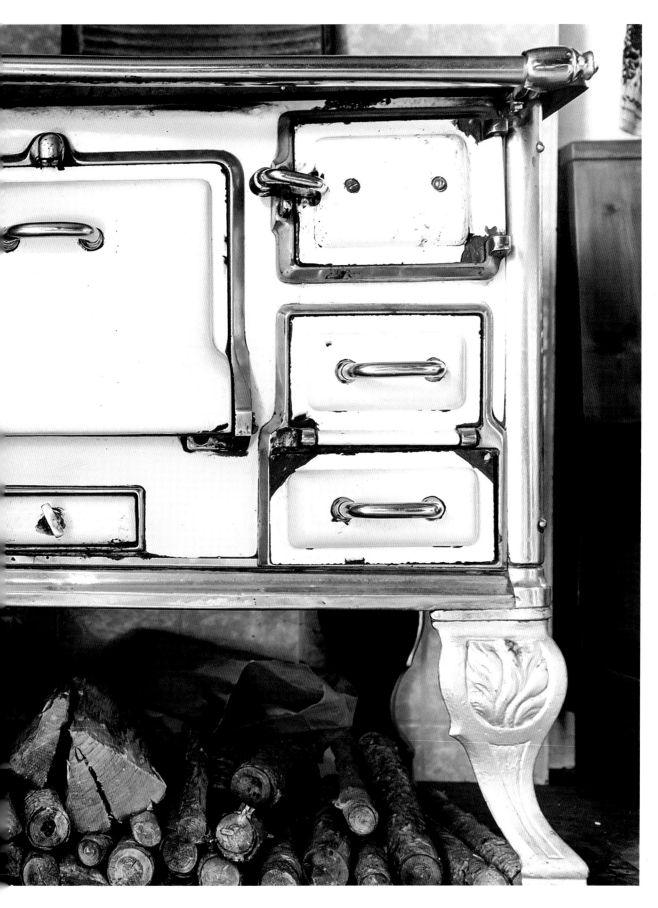

TABLE OF CONTENTS

ACKNOWLEDGMENTS

Much love and thanks to my dear family and friends who are always willing to go on the next culinary journey with me! Cooking for you all is my love language. To that end, I dedicate this book to everyone who enjoys preparing or eating a fresh, home-cooked meal. Special thanks to Molly, Brett, Emily, and the rest of the crew at AdventureKEEN for helping to shepherd this book from idea to the printed page.

INTRODUCTION

Homestyle cooking creates the type of food that embodies the warmth and familiarity of a loving home. While family and cultures differ, homestyle cooking relies on fresh ingredients, traditions, generational recipes, and comfort. Though some recipes can be considered quick and easy, that is not the primary reason for preparing them.

Whether it's a steaming bowl of chicken soup on a rainy day, a big side of creamy macaroni and cheese, or fresh-from-the-oven cookies—still soft and warm—comfort food soothes our senses and provides a much-needed respite from the challenges of life. It's not just about taste; it's about the emotional connection we have with these dishes.

At its core, homestyle cooking is about more than just nourishment; it's about the love and care that goes into each dish. What sets homestyle cooking apart is the personal touch.

It's the way a family recipe is passed down through generations, preserving not only the flavors but also the memories of shared meals around the table.

In a world of fast food and convenience, homestyle cooking reminds us of the joy of slow-cooked, thoughtfully prepared meals. It's a testament to the idea that dishes made with love and care can nourish our bodies as well as our souls, providing a sense of comfort and a connection to our roots. The recipes in *Homestyle Kitchen* are delicious reminders that home is truly where the heart—and the best food—is.

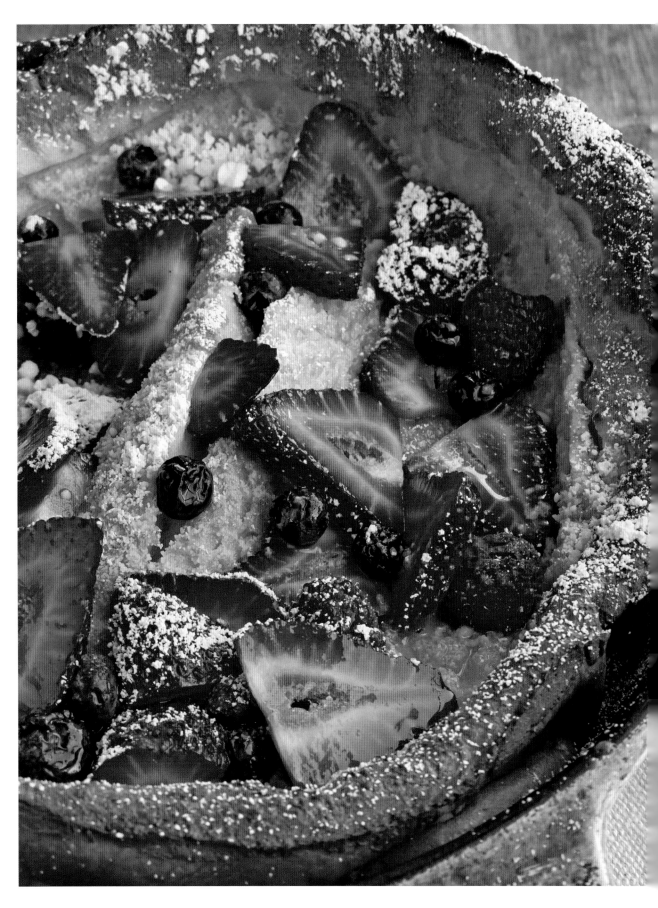

21

BREADS *and* BREAKFAST

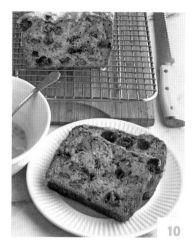

10

22

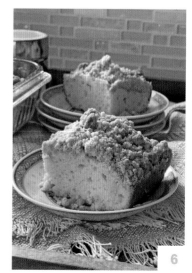

6

20

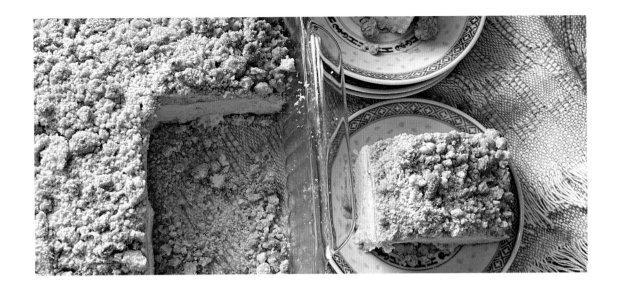

BUTTERMILK CRUMB CAKE

MAKES 1 (9-INCH) CAKE OR 9 SERVINGS

Double Crumb Topping
 (recipe at right)
1½ cups all-purpose flour
¼ teaspoon baking soda
½ teaspoon salt
½ cup unsalted butter, softened
½ cup granulated sugar
1 large egg
1 tablespoon vanilla extract
½ cup buttermilk
Powdered sugar (optional)

This simple coffee cake features a double crumb, arguably the best part of any cinnamon-flavored streusel topping! The tangy flavor of buttermilk offsets the sweetness and adds moisture to the cake. Unsalted butter has a delicate flavor but isn't necessary in this recipe. Substitute salted butter, if desired.

1 Preheat oven to 325°. Lightly grease (with butter) and flour a 9-inch baking pan or dish. Prepare Double Crumb Topping and set aside.

2 Combine flour, baking soda, and salt in a small bowl.

3 Beat ½ cup softened butter and ½ cup granulated sugar at medium speed with an electric mixer. Beat in egg and vanilla extract. Beat in flour mixture and buttermilk.

4 Spoon batter into prepared pan. Sprinkle evenly with reserved crumb topping.

5 Bake for 30 to 45 minutes or until a wooden pick inserted in center comes out clean. Cool to room temperature. Sprinkle with powdered sugar before serving, if desired.

Double Crumb Topping: Combine 1¾ cups all-purpose flour, ½ cup granulated sugar, ½ cup firmly packed light brown sugar, 1½ teaspoons ground cinnamon, and ½ cup melted unsalted butter in a bowl. Makes 2½ cups.

CARROT-WALNUT WHOLE WHEAT MUFFINS

MAKES 1½ DOZEN

1 cup all-purpose flour

¾ cup whole wheat flour

1½ teaspoons baking powder

½ teaspoon baking soda

½ teaspoon salt

2 teaspoons ground cinnamon

¼ teaspoon ground nutmeg

¼ teaspoon ground ginger

2 large eggs

¾ cup firmly packed light or
dark brown sugar

½ cup vegetable oil

1 cup buttermilk

2 teaspoons vanilla extract

2 cups finely grated carrots

½ cup coarsely chopped walnuts

½ cup golden raisins or
dried cranberries

¼ cup sunflower seeds

Take care not to overmix the muffin batter when stirring in the nuts and fruit, as the key to tender muffins is to stir just until dry ingredients are moistened. To avoid overcooked muffins, remove them from the pans immediately after baking and let them cool on wire racks.

1 Preheat oven to 375°. Line 18 muffin cups with paper liners.

2 Stir together all-purpose and whole wheat flours, baking powder, baking soda, salt, cinnamon, nutmeg, and ginger in a large bowl.

3 Beat eggs in a large bowl. Stir in brown sugar, oil, buttermilk, and vanilla extract. Stir in carrots.

4 Add egg mixture to flour mixture, stirring just until combined. Do not overmix. Fold in walnuts and raisins. Spoon batter into prepared muffin cups. Sprinkle evenly with sunflower seeds.

5 Bake for 20 minutes or until a wooden pick inserted in center comes out with moist crumbs clinging. Remove from pan and cool on a wire rack.

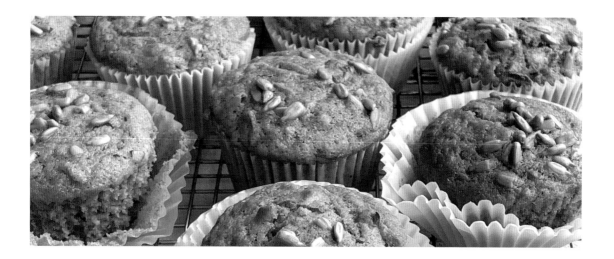

BANANA-OATMEAL MUFFINS

MAKES 1 DOZEN

Cinnamon-Oat Topping
(recipe at right)

1 cup old-fashioned or
quick oats

½ cup firmly packed light
brown sugar

1 cup all-purpose flour

2 teaspoons baking
powder

½ teaspoon baking soda

¼ teaspoon salt

1 teaspoon ground
cinnamon

Pinch of ground nutmeg

3 ripe bananas

⅓ cup milk or unsweet-
ened almond milk

1 large egg

½ cup melted butter or
vegetable oil

1 teaspoon vanilla extract

These make a great on-the-go breakfast or fiber-rich snack. You can also make these as mini-muffins—just bake for 10 minutes or until golden brown. Add choco-late mini-morsels for a sweeter snack.

1 Preheat oven to 375°. Line a muffin pan with 12 paper liners. Prepare Cinnamon-Oat Topping; set aside.

2 Combine 1 cup oats, ½ cup brown sugar, flour, baking powder, baking soda, salt, cinnamon, and nutmeg in a large bowl.

3 Mash bananas in another medium-size bowl until smooth. Stir in milk, egg, ½ cup melted butter, and vanilla. Stir banana mixture into oat mixture.

4 Spoon batter into prepared muffin cups. Sprinkle evenly with reserved Cinnamon-Oat Topping.

5 Bake for 18 minutes or until a wooden pick inserted in center comes out clean.

Cinnamon-Oat Topping: Combine ½ cup old-fashioned or quick oats, 2 tablespoons light brown sugar, and **2 tablespoons melted salted or unsalted butter** in a small bowl. Makes ½ cup.

TRIPLE-CHOCOLATE MOCHA MUFFINS

MAKES 1½ DOZEN

1¾ cups all-purpose flour

¼ cup cocoa powder

2 to 3 teaspoons espresso or instant coffee granules

1 teaspoon baking powder

½ teaspoon baking soda

½ teaspoon salt

1 cup whole milk

1 cup firmly packed light brown sugar

½ cup vegetable oil

4 ounces semisweet chocolate, melted

1½ teaspoons vanilla extract

2 large eggs

1 cup semisweet or dark chocolate chips

Garnish: powdered sugar

Is this dessert or breakfast? Maybe it's both! I serve these in the morning because the espresso contains caffeine. If you prefer, substitute a bit more flour in place of the espresso powder.

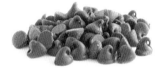

1 Preheat oven to 350°. Line muffin pans with 18 paper liners.

2 Whisk together flour, cocoa powder, espresso, baking powder, baking soda, and salt in a large bowl; set aside.

3 Combine milk, brown sugar, oil, chocolate, and vanilla in a large bowl, stirring until well blended. Beat in eggs.

4 Add flour mixture to milk mixture, stirring just until blended. Stir in chocolate chips. Spoon batter evenly into prepared muffin cups.

5 Bake for 15 minutes or until muffins spring back when touched lightly in center. Cool in pan for 3 minutes. Remove from pan and serve warm or at room temperature. Garnish, if desired.

CRANBERRY-ORANGE NUT BREAD

MAKES 1 LOAF

1½ cups all-purpose flour

1 tablespoon grated orange rind

1½ teaspoons baking powder

½ teaspoon baking soda

1 teaspoon salt

2 large eggs

1 cup granulated sugar

½ cup fresh orange juice

6 tablespoons salted or unsalted
butter, melted

1½ cups fresh (or frozen and thawed)
cranberries

¾ cup chopped walnuts

Orange Glaze (recipe at right)

One of my most-requested recipes is this delicious quick bread that I can serve for breakfast, an afternoon snack, or dessert. One difference between quick breads and risen breads (like French, sourdough, etc.) is the leavener. Quick breads utilize baking powder, baking soda, or a combination of both, while traditionally risen breads use yeast. Yeast is a single-cell organism (fungi) that eats sugar and starch and takes time to reproduce, hence the hours-long rising time. Baking powder and baking soda cause a chemical reaction that creates bubbles that lift the batter in minutes.

1 Preheat oven to 350°. Lightly grease (with butter) or line a 9x5-inch loaf pan with nonstick aluminum foil.

2 Combine flour, 1 tablespoon orange rind, baking powder, baking soda, and salt in a large bowl.

3 Whisk together eggs, granulated sugar, ½ cup orange juice, and butter in another bowl. Stir egg mixture into flour mixture just until combined (do not overmix). Stir in cranberries and walnuts.

4 Spoon batter into prepared pan. Bake for 50 to 60 minutes or until a wooden pick inserted in center comes out clean. Cover top with foil after 45 minutes, if necessary, to prevent overbrowning.

5 Cool on a wire rack for 10 minutes. Remove bread from pan and place on wire rack to cool. Drizzle with Orange Glaze.

Orange Glaze: Combine **⅔ cup powdered sugar, ½ tablespoon grated orange rind,** and **1 tablespoon fresh orange juice** in a small bowl. Makes ½ cup.

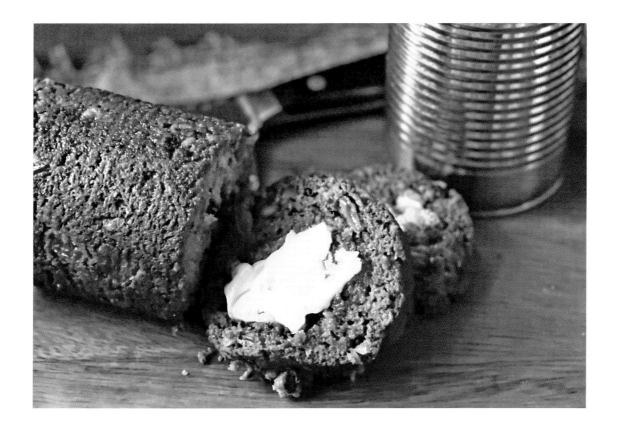

HOBO BREAD

MAKES 3 "LOAVES"

1 cup coffee or water

1 cup raisins

2 cups all-purpose flour

½ cup firmly packed light
 brown sugar

¼ cup granulated sugar

2 teaspoons baking soda

½ teaspoon salt

3 tablespoons melted butter or
 vegetable oil

½ teaspoon vanilla extract

¾ cup chopped walnuts

This quaint quick-bread recipe inspires images of vagabonds aboard rail cars, cooking with what was available. Around since the pioneer days, the bread's sweet-and-earthy flavor is timeless. It was originally baked in a coffee can; because today's coffee is often sold in bags or in plastic containers, you can substitute vegetable cans.

1 Bring coffee to a boil in a small saucepan. Stir in raisins. Remove from heat and let sit for 1 hour.

2 Preheat oven to 350°. Generously grease (with butter) and flour 3 (15-ounce) empty cans.

3 Combine flour, brown sugar, granulated sugar, baking soda, and salt in a bowl. Stir in soaked raisins and coffee, butter, and vanilla. Fold in walnuts.

4 Spoon batter into prepared cans. Bake for 40 to 45 minutes or until a wooden pick inserted in center comes out clean. Cool in cans for 10 minutes. Remove from cans and serve warm or at room temperature.

PARMESAN-ROSEMARY-PEPPER BREAD

MAKES 1 LOAF

1 (¼-ounce) package or 2¼ teaspoons active dry yeast

2 teaspoons granulated sugar

1¼ cups warm water (105° to 110°)

¼ cup extra-virgin olive oil

3¼ cups bread or all-purpose flour

1 tablespoon chopped fresh rosemary

1 tablespoon coarsely ground black pepper

1 teaspoon salt

1 cup (4 ounces) shredded Asiago or Parmesan cheese

Butter

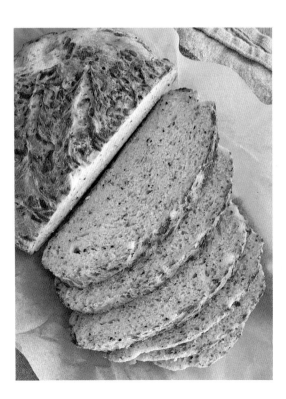

Baking round bread, or boules, in a Dutch oven creates tender, moist loaves with a delicious chewy, crispy crust. If you're baking bread on a heavy sheet pan instead, reduce baking time to about 20 to 25 minutes.

1. Dissolve yeast and sugar in 1¼ cups warm water in a large bowl; let stand for 5 minutes. Stir in olive oil. Stir in flour, rosemary, pepper, and salt; form a soft dough.

2. Turn dough out onto a lightly floured surface. Add cheese; knead 3 or 4 times. Shape dough into a ball, and place in a lightly greased (with butter) bowl, turning to grease top. Cover and let rise in a warm place (85°), free from drafts, 1½ hours or until doubled in size.

3. Preheat oven to 450°. Place a Dutch oven with lid in oven and heat for 15 to 20 minutes.

4. Turn dough out onto a floured surface and shape into a round loaf. Place on a large piece of parchment paper. Using a knife, cut 3 or 4 (¼-inch-thick) slashes in top of loaf. Using parchment as handles, carefully place into heated Dutch oven. Cover with lid. Bake for 25 minutes. Uncover and bake 15 more minutes.

5. Remove from pan and cool on a wire rack.

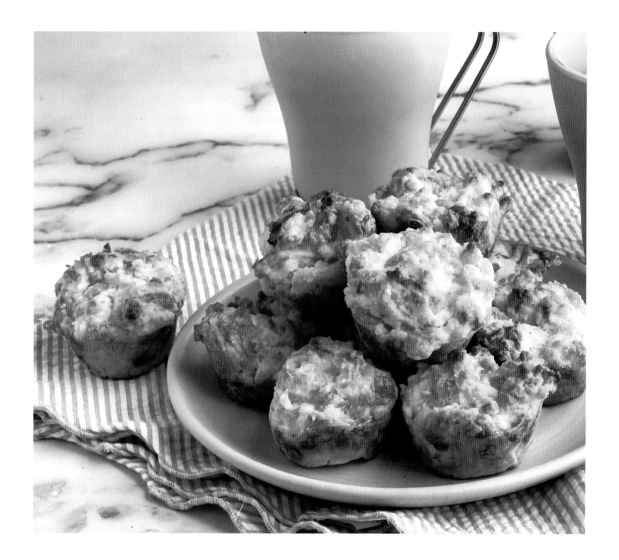

SOUR CREAM– CHEDDAR MINI-BISCUITS

MAKES 2 DOZEN

1 cup sour cream

1 cup (4 ounces) shredded cheddar cheese

½ cup salted butter, melted

1½ cups self-rising flour

So easy and addictive, these simple biscuits are crowd-pleasers. If you don't have a mini-muffin pan, just drop the dough onto a sheet pan that's been lightly greased (with cooking spray) or lined with parchment paper.

1 Preheat oven to 400°.

2 Combine sour cream, cheese, and butter in a large bowl. Add flour, stirring just until blended.

3 Drop batter by tablespoons into cups of a non-stick mini-muffin pan. Bake for 15 minutes or until golden brown.

PARKER HOUSE ROLLS

MAKES 16 ROLLS

1 cup whole milk

3 tablespoons granulated sugar

¾ cup unsalted or salted butter, cut into pieces and divided

½ cup warm water (105° to 110°)

1 (.25-ounce) package or 2½ teaspoons active dry yeast

1 large egg

3½ to 3¾ cups all-purpose flour, divided

1 teaspoon fine sea salt

Flaky sea salt (optional)

Whether you're serving your household on a weeknight or taking a dish to a gathering of friends, these rolls will delight everyone around the table.

These soft, fluffy, and buttery yeast rolls will disappear soon after they are pulled from the oven. Named for their creation in the 1870s at the Parker House hotel in Boston, these rolls differ from regular yeast rolls in that they are folded into layers, brushed with butter, and baked close together. The dough will be very soft—one reason these delicate rolls are so tender. Start with 3½ cups of flour; if the shaggy dough is still too sticky, add the remaining ¼ cup.

1 Place milk in a small saucepan over medium heat. Bring to a simmer. Remove from heat; stir in sugar and 8 tablespoons butter. Let stand until butter melts. Transfer to bowl of a stand-up mixer and let cool.

2 Combine warm water and yeast in a small cup and let stand for 5 minutes or until foamy. Stir yeast mixture into milk mixture.

3 Stir in egg, 1½ cups flour, and fine sea salt with the dough hook attachment or paddle, mixing until smooth. Add remaining 2 cups flour, ½ cup at a time, mixing until smooth (dough will be very soft). Knead for 3 minutes with dough hook or paddle, or transfer dough to a floured surface and knead lightly for 5 minutes. Place in a lightly greased (with butter) bowl, rotating dough to coat all sides. Cover loosely with plastic wrap and let rise in a warm place for 1 to 1½ hours or until doubled in bulk.

5 Melt remaining 4 tablespoons butter. Brush bottom and sides of a 9x13-inch (3-quart) baking pan lightly with some of the butter.

6 Roll or press half of dough out to a 12x8-inch rectangle on a floured surface. Brush with melted butter. Slice dough in half lengthwise, then fold each piece in half lengthwise. Cut each piece into 4 pieces, creating a total of 8 folded rolls. Arrange tightly in half of prepared pan. Repeat with remaining half of dough, creating 16 rolls total. Cover loosely with plastic wrap and let rise for 45 minutes or until puffy.

7 Preheat oven to 350°. Bake for 20 minutes or until golden brown. Brush with remaining butter and sprinkle with flaky sea salt, if desired.

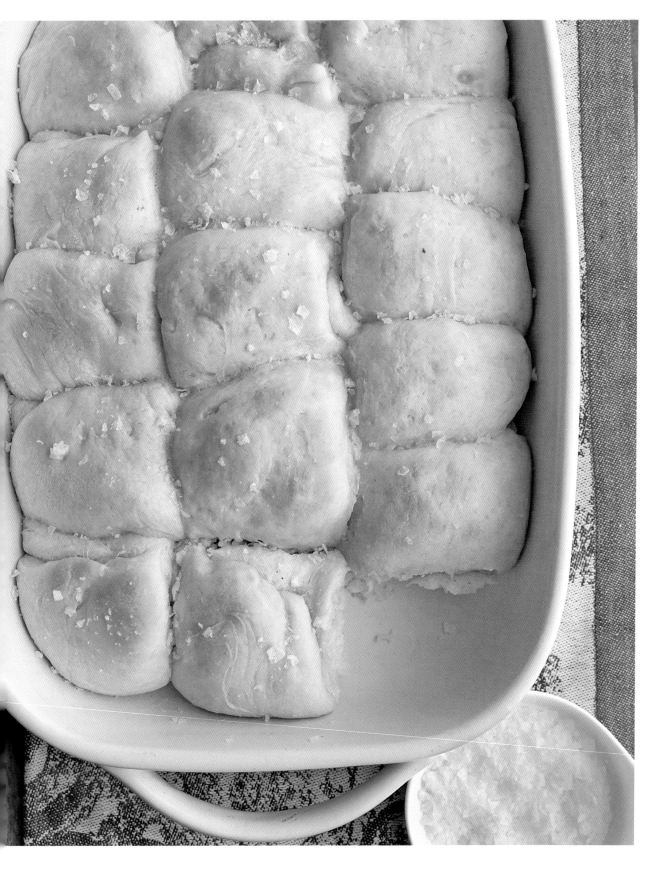

SWEET POTATO YEAST ROLLS

MAKES 2 DOZEN

¾ cup warm water (105° to 115°)

3 tablespoons light brown sugar

1 (¼-ounce) package active dry yeast

1 cup mashed sweet potatoes or yams (canned or boiled)

¼ cup salted or unsalted butter, melted

2 large eggs

2 teaspoons salt

3½ to 4 cups all-purpose flour

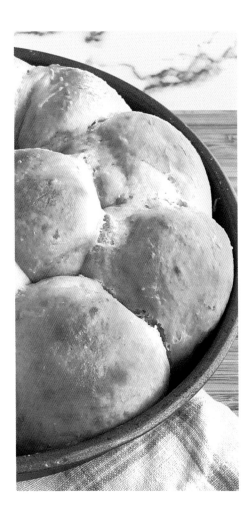

These lightly sweet rolls are a staple at Thanksgiving because they make amazing sandwiches with leftover turkey and cranberry sauce. The dough is slightly sticky; however, refrigerating it for several hours will not only make the dough easier to work with, but it will also allow the flavor to develop.

1 Stir together ¾ cup water and brown sugar in a small bowl. Add yeast. Let stand for 5 minutes.

2 Combine sweet potatoes, butter, eggs, and salt in a mixing bowl. Beat at medium speed with an electric mixer until smooth. Beat in yeast mixture.

3 Add 3½ cups flour, 1 cup at a time, and beat at slow speed until blended. Turn dough out onto a floured surface. Knead several times, adding flour if dough is extremely sticky. (Dough should be loose and somewhat sticky.)

4 Transfer dough to a lightly greased (with butter) bowl. Cover with plastic wrap. Cover and refrigerate for 4 to 8 hours or overnight.

5 Lightly grease (with butter) 2 (9-inch) round cake pans. Turn dough out onto a floured surface. Divide dough into 24 pieces and roll each into a ball. Place in prepared pans. Cover and let rise for 20 minutes.

6 Bake for 17 to 20 minutes or until rolls are golden brown.

BAKED CRISPY CHICKEN AND WAFFLES

MAKES 4 SERVINGS

5 cups crushed cornflakes

1 teaspoon garlic powder

1½ teaspoons salt

¾ teaspoon coarsely ground
 black pepper

⅛ teaspoon ground cayenne pepper

¼ cup (4 tablespoons) salted
 butter, melted

3 tablespoons honey

2 tablespoons water

1 egg

1½ to 2 pounds boneless, skinless
 chicken breasts, cut into (1-inch) strips

Vegetable cooking spray

Belgian Waffles (page 18)

Warm maple syrup

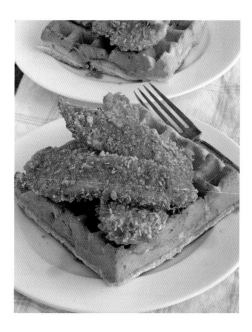

Serve this delicious mix of sweet, savory, and salty as a fancy breakfast or a comforting dinner. The chicken tenders have a subtle sweetness from being dipped in honey butter and coated in seasoned cornflakes. Kids love them, but skip the cayenne pepper and black pepper if they have tender palates. Lightly coating with cooking spray will help the "oven fried" chicken brown and crisp without getting too greasy. In this recipe, I like the additional flavor of olive oil cooking spray.

1 Preheat oven to 365°. Line a baking sheet with nonstick aluminum foil, parchment paper, or a silicone baking mat.

2 Combine cornflakes, garlic powder, salt, black pepper, and cayenne pepper in a food processor. Process until finely ground. Transfer to a shallow bowl.

3 Combine butter, honey, 2 tablespoons water, and egg in a bowl, whisking until well blended.

4 Dip chicken in butter mixture, allowing excess to drain off. Dredge in cornflake mixture and place on prepared baking sheets. Spray chicken lightly with cooking spray.

5 Bake for 15 to 20 minutes or until golden brown and cooked through, turning over halfway through cooking time. Divide chicken among waffles, and drizzle with warm syrup.

BELGIAN WAFFLES

MAKES 8 WAFFLES

These extra-deep waffles have generous pockets that hold plenty of melted butter and syrup. Adding beaten egg whites to the batter ensures they are fluffy on the inside. Freeze any extras and reheat in a toaster oven.

2 cups all-purpose flour

3 tablespoons firmly packed light brown sugar

2 teaspoons baking powder

¼ teaspoon salt

2 large eggs, separated

1¾ cups milk

⅓ cup vegetable oil

1 Preheat oven to 200°. Place a wire rack in a large baking sheet. Preheat a nonstick Belgian waffle iron.

2 Combine flour, brown sugar, baking powder, and salt in a large bowl. Whisk together egg yolks, milk, and oil in another bowl.

3 Beat egg whites with an electric mixer until stiff peaks form.

4 Pour milk mixture into flour mixture, stirring just until moistened. Fold egg whites gently into batter with a spatula. Do not overmix; it's okay if batter is slightly lumpy.

5 Fill waffle iron with ½ to ¾ cup batter, according to manufacturer's directions. Cook for 5 minutes or until golden brown and crisp. Place cooked waffles in oven to keep warm; repeat with remaining batter.

PRALINE FRENCH TOAST CASSEROLE

MAKES 8 SERVINGS

Butter

1 (16-ounce) loaf stale French or
sourdough bread, cubed

8 large eggs

3½ cups half-and-half

¼ cup firmly packed light brown sugar

¾ teaspoon ground cinnamon

¼ teaspoon fine sea salt

2 teaspoons vanilla extract

Pecan Topping (recipe at right)

Toppings: maple syrup, fresh fruit

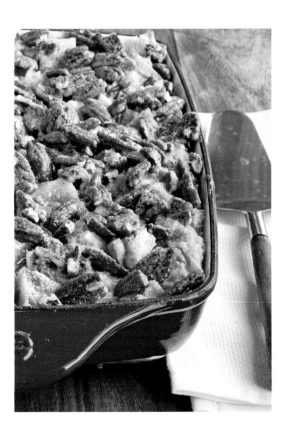

This breakfast casserole is similar to bread pudding, except it is "eggier" and, therefore, more suitable for breakfast, making it a sweet delight on lazy weekend mornings. The egg custard mixture soaks into stale bread more efficiently than fresh loaves, but you don't have to wait. Cube the bread and allow to dry on a sheet pan or toast in a 350° oven for 10 minutes. Don't fret—fresh bread can get a little smashed when cubed but will still work in this recipe.

1 Butter bottom and sides of a 9x13-inch (3-quart) baking dish. Place stale bread cubes in prepared baking dish.

2 Whisk together eggs, half-and-half, ¼ cup brown sugar, cinnamon, salt, and vanilla in a large bowl. Pour egg mixture over bread and press gently so bread absorbs liquid. Cover and refrigerate overnight.

3 Preheat oven to 350°. Uncover and sprinkle Pecan Topping evenly over bread. Bake, uncovered, for 45 to 55 minutes or until golden brown and bubbly. Serve warm with desired toppings.

Pecan Topping: Combine ¾ cup firmly packed light brown sugar, ½ cup softened unsalted or salted butter, 2 tablespoons light corn syrup, and 1½ cups pecan halves or pecan pieces. Makes about 2¼ cups.

DUTCH BABY

MAKES 6 SERVINGS

4 large eggs

1 cup whole milk

¼ cup salted or unsalted butter, melted and divided

1 cup all-purpose flour

¼ cup granulated sugar

½ teaspoon salt

2 teaspoons vanilla extract

1 cup sliced strawberries, raspberries, blueberries, or a mix of fresh fruit

Powdered sugar

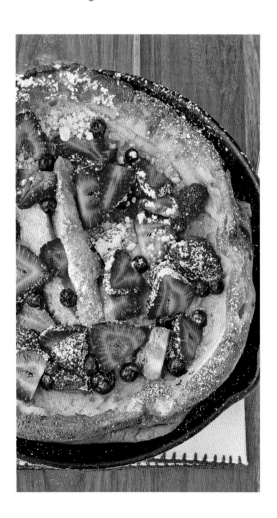

Sometimes called a German Pancake, Dutch babies are puffy, soufflé-like pancakes that are cooked in a cast-iron skillet, then finished in the oven. Legend has it that the dish became popular at a Seattle restaurant in the early 1900s. The recipe is related to a German dish, but the owner's daughter couldn't pronounce "Deutsch," so the dish's name morphed into "Dutch." Originally served with butter, lemon juice, and powdered sugar, Dutch baby pancakes are now frequently served with sliced fresh fruit.

1 Combine eggs, milk, 2 tablespoons melted butter, flour, sugar, salt, and vanilla in a large bowl. Whisk briskly until mixture is smooth. (You may also use a blender or food processor.) Let batter rest for 20 to 30 minutes.

2 Preheat oven to 425°. Place a 10- to 12-inch cast-iron or heavy oven-safe skillet in oven to preheat.

3 Carefully remove hot skillet and add remaining 2 tablespoons butter. Tilt and swirl pan until butter melts and coats bottom and sides of skillet. Pour batter over butter.

4 Bake for 20 minutes or until puffed and golden brown.

5 Remove from oven. (Dutch Baby will collapse when it starts to cool.) Top with sliced fresh fruit, and sprinkle with powdered sugar.

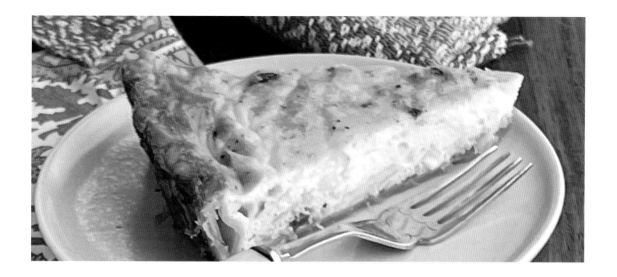

QUICHE LORRAINE

MAKES 6 SERVINGS

1 refrigerated piecrust dough or Pastry Dough (recipe on page 150)

4 slices bacon, cooked and crumbled

3 shallots, sliced, or ½ onion, halved and thinly sliced

1 cup (4 ounces) shredded Gruyère or Swiss cheese

4 large eggs

1¾ cups half-and-half

¼ teaspoon ground nutmeg

Pinch ground cayenne pepper

¾ teaspoon salt

¼ teaspoon coarsely ground black pepper

This egg dish is a classic for good reason. The combination of smoky bacon, lightly caramelized shallots or onion, and rich Gruyère cheese is immensely satisfying. Tart pans with removable bottoms make it easy to serve, but you can use ceramic tart dishes (though baking time may increase). Substitute a regular pie plate if you wish.

1 Preheat oven to 400°. Line a 10-inch tart pan or 9-inch pie plate with piecrust dough. Place a piece of parchment paper over pastry and add enough pie weights or dried beans to cover the bottom. Bake for 10 minutes. Remove parchment and weights, and set piecrust aside. Decrease oven temperature to 375°.

2 Cook bacon in a skillet until crispy. Transfer bacon to paper towels, reserving 1 tablespoon drippings in pan. Add shallots and cook over medium heat for 3 minutes or until light golden brown and tender.

3 Crumble bacon and place in prebaked crust. Add shallots and cheese.

4 Whisk together eggs, half-and-half, nutmeg, cayenne pepper, salt, and black pepper in a bowl. Pour egg mixture over bacon-and-cheese mixture. (Egg mixture will reach the top of the crust; take care when placing in the oven.)

5 Bake for 30 to 35 minutes or until golden brown and set in the center.

THREE-CHEESE GRITS SOUFFLÉ

MAKES 6 SERVINGS

2 cups vegetable or chicken broth

1 cup half-and-half or whole milk

1 cup grits

1 teaspoon salt

1 cup (4 ounces) shredded smoked Gruyère or cheddar cheese

4 ounces cream cheese, softened

1 tablespoon salted or unsalted butter

½ teaspoon coarsely ground black pepper

2 to 3 tablespoons freshly grated Parmesan cheese

5 large eggs, separated

Take your breakfast side dish from simple to special by creating a soufflé—it's delicious with a ham for a spectacular brunch or holiday meal. Remember to add cooked grits to the egg yolks in small amounts so the yolks don't cook; do the same with the egg white mixture. Substitute your favorite cheese for the Gruyère or cheddar—even a soft one like goat cheese.

1 Bring broth and milk to a boil in a large saucepan. Stir in grits and salt. Reduce heat and simmer for 12 to 15 minutes or until grits are tender. (If using quick grits, simmer for less time according to package directions, using amount of liquid indicated on package.)

2 Remove from heat. Stir in Gruyère, cream cheese, butter, and pepper.

3 Preheat oven to 375°. Butter an 8x8- or 9x9-inch baking dish. Sprinkle bottom and sides with Parmesan cheese.

4 Beat egg yolks in a small bowl. Stir in ½ cup grits mixture to heat yolks. Stir egg yolk mixture into remaining grits. (This tempering method keeps the egg yolks from cooking into clumps when added to hot grits).

5 Beat egg whites until stiff peaks form. Stir in ½ cup grits mixture. Fold egg white mixture gently into remaining grits mixture. Spoon into prepared dish.

6 Bake for 35 minutes or until puffed and golden brown. Serve immediately.

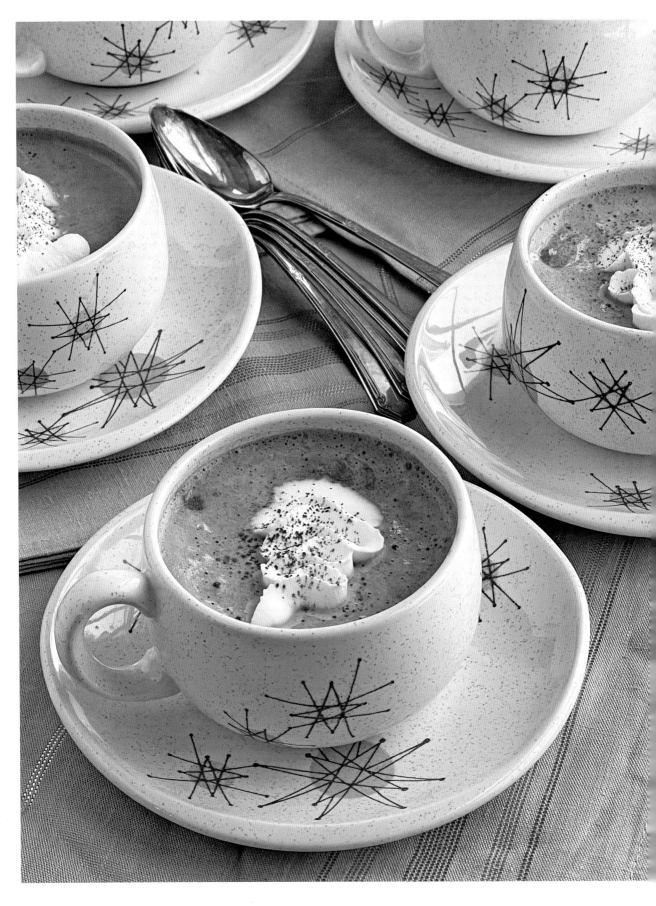

APPETIZERS *and* BEVERAGES

30

39

26

38

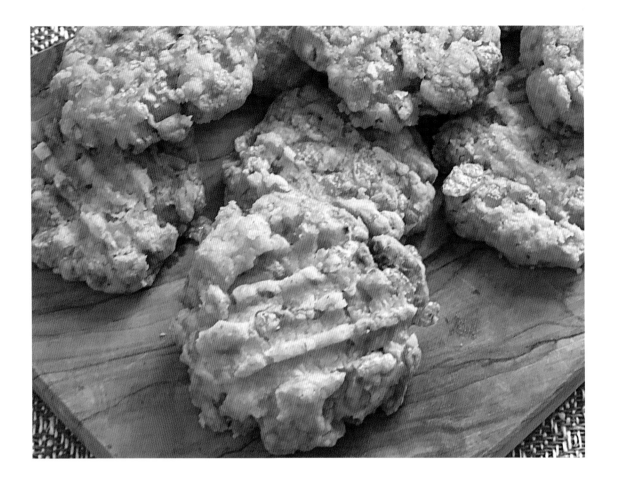

CRISPY CHEESE WAFERS

MAKES 4½ DOZEN

2 cups all-purpose flour

½ teaspoon ground cayenne pepper

½ teaspoon salt

1 cup salted or unsalted butter, cut into small pieces

2 teaspoons Worcestershire sauce

1 (8-ounce) package sharp cheddar cheese, shredded

2 cups crisp rice cereal

These addictive wafers are cousins to other bite-size snacks like cheese straws and cheese biscuits. Crisp rice cereal adds a lovely crunch, while the cayenne pepper and Worcestershire sauce provide more flavor.

1 Preheat oven to 350°.

2 Combine flour, cayenne pepper, and salt in a large bowl. Cut butter into flour mixture with a pastry blender or fork until mixture resembles coarse meal. Stir in Worcestershire sauce. Stir in cheese and cereal.

3 Shape mixture into 1-inch balls. Place about 1 inch apart on ungreased baking sheets; press with a fork in a crisscross pattern.

4 Bake for 15 minutes.

SWEET-AND-SPICY BARBECUE PECANS

MAKES 6 CUPS

3 tablespoons salted or unsalted
 butter, melted

¼ cup prepared barbecue sauce

¼ cup firmly packed
 light brown sugar

1 tablespoon chili powder

1 tablespoon kosher salt

1 tablespoon paprika

1½ teaspoons garlic powder

½ teaspoon coarsely ground
 black pepper

¼ to ½ teaspoon cayenne pepper

6 cups pecan halves or
 mixed nuts

Pecans just happen to be my favorite nut, but you
can use any that you like or mix them up!

1 Preheat oven to 300°. Line a rimmed baking sheet
 with nonstick aluminum foil, lightly greased (with
 butter) aluminum foil, or parchment paper.

2 Combine butter and barbecue sauce in a large
 bowl. Stir in brown sugar, chili powder, salt, paprika,
 garlic powder, black pepper, and cayenne pepper.

3 Add nuts, stirring to coat. Spread nuts in a single
 layer on prepared baking sheet. Bake for 30 min-
 utes, stirring every 5 to 10 minutes. Let dry on the
 pan, then store in an airtight container.

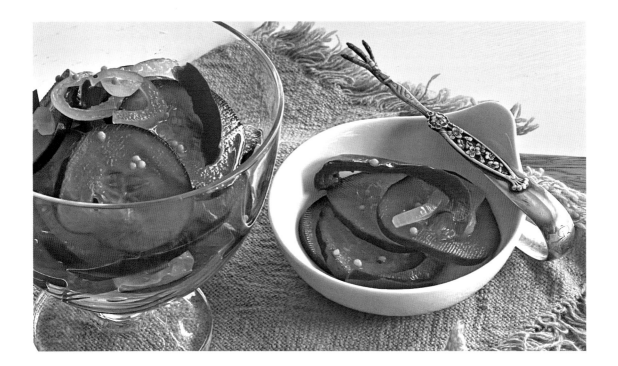

SWEET FREEZER PICKLES

MAKES 6 CUPS

6 cups sliced cucumbers

1 small onion, halved and thinly sliced

1 small red bell pepper or 2 banana peppers, thinly sliced (optional)

⅓ cup kosher salt

1 cup apple cider vinegar

1½ cups granulated sugar

1 teaspoon celery seed

1 teaspoon mustard seed

My dear friend Jackie Mills gave me this easy-and-delicious pickle recipe that requires no canning equipment. Generally, cucumbers become mushy and unsavory if frozen because they are made up of mostly water. In this recipe, however, the salt brine extracts a good bit of the water that is then replaced with a sweet-and-sour syrup. Store these for up to 6 months in the freezer. Once thawed, store in the refrigerator and eat within 2 weeks.

1 Place cucumbers, onion, and, if desired, bell pepper in a large bowl. Add salt and toss to coat; add enough cold water to cover vegetables. Cover and refrigerate overnight.

2 Combine vinegar, sugar, celery seed, and mustard seed in a medium-size saucepan and bring to a boil, stirring until sugar dissolves. Let stand to cool.

3 Drain cucumber mixture and discard liquid. If salt is a concern, rinse with cold water. Pour cooled vinegar mixture over cucumber slices, tossing to coat. Cover and refrigerate for 24 hours.

4 Place pickled cucumbers and syrup in freezer containers. Place a layer of plastic wrap over cucumber slices, pressing so cucumbers are under syrup. Freeze. Thaw in refrigerator a day before serving.

RADISH BUTTER

MAKES 1½ CUPS

Radishes are one of the earliest maturing vegetables that don't mind a bit of chill, so I always plant radishes early each year. I usually get more than I can eat raw on salads or roasted with other root veggies, so a batch of radish butter helps utilize a bounty. The peppery-salty butter makes a nice snack when spread on crostini or sandwiches. Also try a dollop over grilled steak or fish—or even cooked veggies.

12 radishes (about 10 to 12 ounces)
½ to 1 teaspoon salt, plus more to taste
8 tablespoons salted or unsalted butter, softened
Garnishes: radish slices, coarsely ground
 black pepper

1 Trim ends of radishes and cut into quarters. Place in a food processor, and add salt. Pulse until very finely chopped.

2 Transfer radishes to a colander or plate lined with paper towels. Let stand for 15 to 30 minutes. Blot with additional paper towels until no liquid is visible.

3 Combine chopped radishes and butter, stirring until well blended. Taste, and add salt, if needed; garnish, if desired. Serve with carrot sticks, celery sticks, and pita chips.

CHOWCHOW

MAKES 7 (1-PINT) JARS

Chowchow is a pickled relish made from a variety of vegetables, its ingredients based on seasons and availability. Different vegetables are often substituted, so chowchow can be a delicious way to use up leftover raw ones and get creative. (Don't have green peppers? Just use all red.) Serve it Southern style with cornbread and fried catfish or with sausages, hotdogs, and sandwiches instead of sauerkraut.

3 pounds green tomatoes (about 6 large), seeded and chopped

3 yellow or white onions, chopped

2 green bell peppers, chopped

2 red bell peppers, chopped

½ head cabbage, chopped (about 6 cups)

¼ cup kosher salt

4 cups white vinegar

2 cups granulated sugar

1 tablespoon whole black peppercorns

1 tablespoon whole cloves

1 tablespoon mustard seed

1 teaspoon celery seed

1 teaspoon ground turmeric

¼ to ½ teaspoon red pepper flakes

1. Combine tomatoes, onions, bell peppers, and cabbage in a large nonreactive (nonaluminum) bowl. Sprinkle salt over mixture, tossing to coat. Cover and refrigerate for 6 hours or overnight.

2. Sterilize 7 (1-pint) canning jars, lids, and rings for 10 minutes in boiling water. Drain and set aside.

3. Drain vegetables in a colander, but do not rinse. Set aside.

4. Combine vinegar and sugar in a large nonreactive (nonaluminum) soup pot. Wrap peppercorns and cloves in cheesecloth to make a small bundle; tie to secure. (Note: You don't have to make a bundle, and it's okay if some of the spices escape. The peppercorns will be spicy but edible; however, the cloves will be too tough to chew. Just pick those out before serving.) Add spice bundle, mustard seed, celery seed, turmeric, and red pepper flakes. Cook over medium heat, stirring occasionally, for 5 minutes or until sugar dissolves.

5. Add chopped vegetables to vinegar mixture, stirring until well blended. Bring mixture to a boil, reduce heat, and simmer over medium-low heat, stirring occasionally, for 20 minutes. Remove from heat.

6. Ladle relish into canning jars, leaving ½ of headspace at top of each jar. (If you don't have enough to fill the seventh jar, set that portion aside and store in an airtight container in the refrigerator for up to 1 month.) Remove air bubbles and wipe jar rims. Top with lids and bands and adjust to fingertip tight. Place in a boiling water canner.

7. Process jars for 15 minutes, adjusting for altitude if necessary. Turn off heat, and let jars stand for 5 minutes. Remove jars from canner and cool for 12 to 24 hours. Check lids for seal (they should not flex when center is pressed). If not completely sealed, store in the refrigerator up to 3 months.

PHOTO ON PAGE 25

CRANBERRY COCKTAIL MEATBALLS

MAKES 5 DOZEN

1½ pounds lean ground beef

⅓ cup seasoned breadcrumbs

2 teaspoons dried Italian seasoning

½ teaspoon garlic powder

½ teaspoon salt

1 large egg

4 green onions, finely chopped and divided

1 (8-ounce) can jellied cranberry sauce

½ cup orange marmalade

½ cup chili sauce

2 tablespoons soy sauce

1½ tablespoons balsamic vinegar

¼ teaspoon crushed red pepper flakes

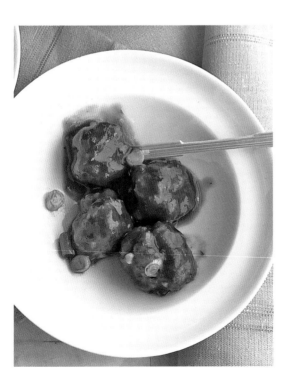

Family and guests will nosh all night on these sweet-and-spicy bite-size meatballs. If you don't have a chafing dish, combine the sauce ingredients in a slow cooker, add meatballs, and cook on low for 2 to 3 hours or until cooked through. Keep the cooker on warm to serve, stirring occasionally.

1 Preheat oven to 350°. Line 2 baking sheets with nonstick aluminum foil, lightly greased aluminum foil, or parchment paper.

2 Combine ground beef, breadcrumbs, Italian seasoning, garlic powder, salt, egg, and half of green onions in a large bowl. Blend mixture with hands, if necessary.

3 Shape into 1-inch balls and arrange on prepared baking sheets. Bake for 8 to 10 minutes or until browned and cooked through.

4 Meanwhile, combine cranberry sauce, marmalade, chili sauce, remaining half of green onions, soy sauce, vinegar, and red pepper flakes in a large Dutch oven. Cook over low heat for 2 or 3 minutes, stirring occasionally, until ingredients are smooth and well blended.

5 Add meatballs to sauce, stirring to coat. Transfer to a chafing dish or slow cooker for extended service.

STUFFED EGGS WITH BACON-ONION JAM

MAKES 2 DOZEN

Bacon and eggs make a great combo! In this delicious snack, a dollop of bacon jam adds just the right amount of smoky sweetness. You can substitute crumbled bacon for a similar flavor.

12 hard-cooked eggs
½ cup mayonnaise
1 teaspoon lemon juice
1 teaspoon prepared Dijon mustard
¼ teaspoon coarsely ground black pepper
Dash of hot sauce
¼ cup Bacon-Onion Jam (page 33)

1 Cut eggs in half. Remove yolks and transfer to a bowl. Mash yolks and stir in mayonnaise, lemon juice, mustard, pepper, and hot sauce.

2 Stir yolk mixture until very smooth. Spoon or pipe yolk mixture into center of egg whites. Dollop about ½ teaspoon bacon jam onto each stuffed egg.

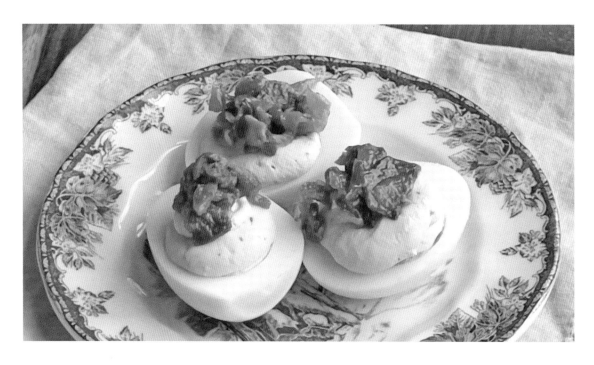

BACON-ONION JAM

MAKES 2 CUPS

¾ pound bacon, chopped

1 tablespoon butter

3 large or 4 medium-size yellow or sweet onions, chopped

¼ cup firmly packed dark brown sugar

¼ cup balsamic vinegar

½ teaspoon salt

¼ teaspoon coarsely ground black pepper

2 tablespoons water

I spread this delicious sweet-and-salty condiment on so many foods—deviled eggs, turkey-and-cheese sandwiches, hamburgers, melted Brie cheese, and much more. It's a time-consuming recipe—but worth it! Make sure you cook the mixture until the onions are a rich golden brown. You won't need to stir often in the beginning, but you'll stir more frequently toward the end of the cook time to keep the jam from sticking to the bottom of the pot.

1 Cook bacon in a Dutch oven or large pot over medium heat, stirring occasionally, for 10 to 12 minutes or until crisp. Drain, reserving 1 tablespoon of drippings in pot. Add butter, allowing it to melt. Stir in onions, brown sugar, vinegar, salt, pepper, and 2 tablespoons water.

2 Cook over medium-low heat, partially covered with lid, for 55 to 65 minutes or until onions are a rich dark brown and mixture has a thick consistency. Season with additional salt and pepper, if desired.

3 Spoon into small jars or bowls. Cover and store in the refrigerator up to 1 week.

SAUSAGE BALLS

MAKES 6 DOZEN

Vegetable cooking spray

3 cups prepared biscuit and pancake mix

1 pound bulk ground sausage, any flavor

4 cups (16 ounces) freshly shredded cheddar cheese

½ cup milk

Every year after Thanksgiving, my mother would make these sausage balls along with her giant batches of Christmas cookies and freeze them to enjoy as snacks throughout the season. While people have been making sausage snacks for centuries, this retro version hit the mainstream when the recipe used Bisquick, a convenience product originally introduced to American home cooks in the 1930s. There are numerous variations, and it seems everyone wants to add an ingredient or two to make it theirs or appeal to modern tastes. I like wrapping the dough around olives—the result is salty but delicious!

1. Preheat oven to 350°. Line 2 baking sheets with nonstick aluminum foil, lightly greased (with cooking spray) aluminum foil, or parchment paper.

2. Combine biscuit mix, sausage, cheese, and milk in a large bowl, mixing with hands, if necessary.

3. Shape mixture into 1- to 1½-inch balls and place on prepared baking sheets.

4. Bake for 18 to 20 minutes or until golden brown and cooked through.

PORK RILLETTES

MAKES ABOUT 6 CUPS

1 cup duck fat or pork fat

2 onions, chopped

2 celery stalks, cut into large pieces

1 (4-pound) boneless pork shoulder, cut into pieces

4 cloves garlic, chopped

2 large sprigs fresh thyme

2 bay leaves

1 teaspoon red pepper flakes

2 teaspoons kosher salt

1 teaspoon coarsely ground black pepper

4 cups chicken stock or broth

1 cup white wine

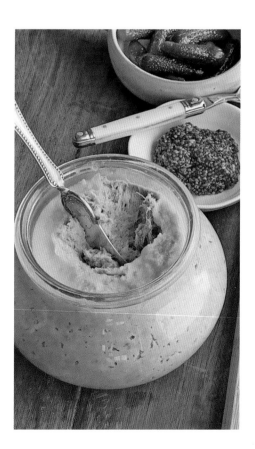

Rillettes are potted shredded meats, usually pork, that are slow cooked and then placed in a container and covered with fat, a centuries-old method for long-term preservation. Duck fat adds amazingly rich flavor, but you can use lard (not the hydrogenated kind) or low-sodium bacon fat. It takes a while to cook, but the tenderness and flavor of the spread is beyond delicious! Serve on toasted artisan bread with whole-grain mustard and bread-and-butter pickles.

1 Melt duck fat in a large soup pot over medium heat. Add onions and celery. Cook, stirring occasionally, for 10 minutes.

2 Cut large pieces of fat and silverskin from pork and discard. Add pork, garlic, thyme, bay leaves, red pepper flakes, salt, pepper, chicken stock, and wine.

3 Bring mixture to a boil. Reduce heat to low, and simmer, covered, for 3 hours. Cool slightly.

4 Remove pork from liquid with a slotted spoon and transfer to a mixing bowl. Discard celery, thyme stems, bay leaves, and any fatty pieces from pork. Reserve liquid in pot.

5 Stir pork on low speed with an electric mixer until meat is shredded and somewhat blended together. You can also stir by hand with a heavy spoon. Taste pork, and season with additional salt and pepper, if desired.

6 Spoon pork mixture evenly into small canning jars or ramekins, pushing out any air bubbles. Spoon fat that rises to surface of liquid evenly over pork. Cover and refrigerate for 2 hours or until firm. Let stand at room temperature for 30 minutes before serving. Store in the refrigerator up to 1 week or freeze up to 3 months. Serve on toasted artisan bread with whole-grain mustard and mini-gherkins.

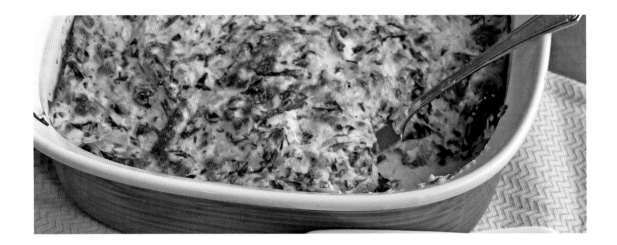

BAKED SPINACH-AND-ARTICHOKE DIP

MAKES 10 TO 12 SERVINGS

Butter

1 cup (4 ounces) shredded mozzarella or white cheddar cheese

¾ cup (6 ounces) shredded Parmesan cheese

1 (8-ounce) package cream cheese, softened

1 cup sour cream

⅓ cup mayonnaise

1 (10-ounce) package frozen and thawed chopped spinach, drained well

2 (14-ounce) cans quartered artichoke hearts, coarsely chopped

2 teaspoons hot sauce, plus more to taste

1 teaspoon garlic powder

½ teaspoon salt

½ teaspoon coarsely ground black pepper

Pita chips, bagel chips, or crostini

This creamy, hot dip is loaded with extra artichokes. It's not only yummy on chips, but you can also toss leftover dip on some hot cooked pasta for a quick lunch.

1. Preheat oven to 400°. Lightly grease (with butter) an 8x8-inch (2-quart) baking dish.

2. Combine mozzarella and Parmesan in a small bowl.

3. Combine cream cheese, sour cream, and mayonnaise in a large bowl, stirring until smooth and well blended. Add spinach, artichoke hearts, half of cheese mixture, hot sauce, garlic powder, salt, and pepper. Spoon into prepared baking dish. Top with remaining half of cheese mixture.

4. Bake for 30 minutes or until hot and bubbly. If desired, broil for 2 or 3 minutes or until golden brown. Serve with pita chips.

SMOKED SALMON DIP

MAKES 2 CUPS

1 (8-ounce) package cream
cheese, softened

1 (8-ounce) container
sour cream

1 tablespoon lemon juice

4 ounces thinly sliced smoked
salmon, coarsely chopped

2 tablespoons chopped fresh dill

2 tablespoons capers

2 tablespoons finely chopped
red onion

Garnishes: sliced red onion,
capers

Flatbread crackers or bagel
chips

This is one of my go-to appetizers and a hit at parties—it's so easy and flavorful. I'll also make some for overnight guests and offer it at breakfast with a selection of toasted bagels. I prefer cold smoked sockeye salmon, but I've also tried it with firmer-textured hot smoked salmon.

Combine cream cheese, sour cream, and lemon juice in a food processor. Pulse until well blended. Add salmon and dill. Pulse until evenly chopped. Add capers and onion; pulse only until blended. Garnish, if desired, and serve with flatbread crackers.

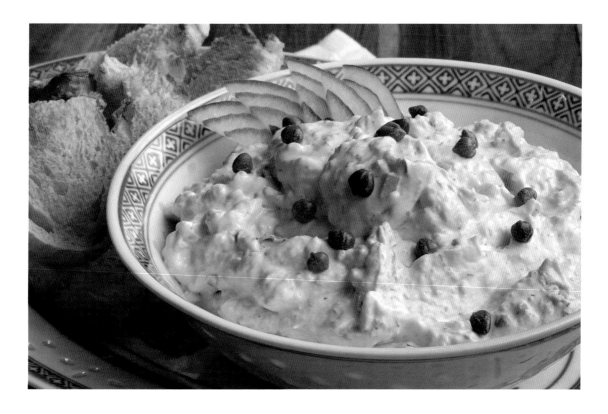

HOT CRAB DIP

MAKES 10 TO 12 APPETIZER SERVINGS

Butter

2 (8-ounce) packages cream cheese, softened

2 tablespoons milk

1 tablespoon dry sherry

1 teaspoon seafood seasoning

½ teaspoon lemon pepper seasoning

½ teaspoon hot sauce

½ cup freshly grated Parmesan cheese

1 pound fresh or 2 (7-ounce) cans crab meat, drained and flaked

Garnishes: chopped toasted walnuts, chopped green onions

Toasted baguette slices

This recipe is adapted from one given to me by a former coworker, Ardith Bradshaw, who often brought this delicious appetizer, by request, to many of our work functions. Her version used white wine Worcestershire sauce, which has been discontinued, so I have replaced it with dry sherry. You can use fresh-picked crab, but there's no need to go for jumbo lump. It's the most expensive and best saved for crab cakes or other luxury dishes. Lump is my favorite in this recipe, but you can use backfin or even stronger-flavored claw meat. Use canned or refrigerated pasteurized crab for an economical version.

1 Preheat oven to 350°. Lightly grease (with butter) a (9-inch) pie plate or shallow baking dish.

2 Combine cream cheese, milk, sherry, seafood and lemon pepper seasonings, and hot sauce. Fold in Parmesan cheese. Fold in crab gently, taking care not to break up any large pieces.

3 Spoon into prepared dish. Bake for 20 to 25 minutes or until hot and bubbly. Garnish, if desired. Serve with toasted baguette slices.

BLACKBERRY LIMEADE

MAKES 8 SERVINGS

For parties, I make the syrup ahead and keep it in the freezer until I need it. Because it's a syrup you mix with still or sparkling water, it lasts longer; you can even substitute a bit of gin or vodka for a refreshing adult beverage. Substitute raspberries for a fine variation.

1 (16-ounce) package frozen blackberries, thawed
1 cup granulated sugar
1·cup fresh lime juice
Still or sparkling water
Garnishes: blackberries, lime slices, fresh mint sprigs

1 Combine berries and any juices, sugar, and lime juice in a blender. Process until no lumps remain. Let stand 30 minutes for sugar to dissolve.

2 Pour mixture through a fine wire-mesh strainer set over a bowl, pressing mixture down with a spatula. Discard seeds. Pour mixture into a decanter. Cover and chill until ready to serve.

3 To serve, pour equal parts blackberry-lime syrup and still or sparkling water into ice-filled glasses. Garnish, if desired.

MOCHA PUNCH

MAKES 10 CUPS

1 cup granulated sugar

⅓ to ½ cup instant
 coffee granules

3 tablespoons cocoa powder

1 cup boiling water

1 tablespoon vanilla extract

1 (1½- or 2-quart) container
 chocolate ice cream

5 cups milk

Homemade Whipped Cream (recipe at
 right) or purchased whipped cream

Cocoa powder (optional)

This delicious beverage is a hit anytime but especially on hot summer days. I will often serve it for dessert alongside a simple shortbread cookie. Using instant coffee rather than brewed coffee is important because the concentrated flavor is necessary. I give a range for the instant granules—I drink black coffee, so the higher range is perfect for me. If you use a lot of cream and sugar in your morning beverage, start with less coffee. Be aware that this punch contains caffeine; if serving in the evening, consider decaf. Ice-cream cartons seem to get smaller. I like a natural brand that comes in 1½-quart containers, but use a half gallon (2 quarts) if you prefer.

1 Combine sugar, coffee, and cocoa in a bowl. Add 1 cup boiling water, stirring until sugar and coffee dissolve. Stir in vanilla. Cover and refrigerate until chilled.

2 Spoon ice cream into a punch or other large bowl. Add chilled coffee mixture and milk, whisking until somewhat smooth. Ladle into cups, and top with whipped cream and a small dusting of cocoa powder, if desired.

Homemade Whipped Cream: Beat **1 cup chilled heavy whipping cream, 3 tablespoons powdered sugar,** and **1 teaspoon vanilla extract (optional)** in a large bowl until soft peaks form. Makes about 2 cups.

PEACH SANGRIA

MAKES 4 TO 6 SERVINGS

This refreshing adult beverage tastes like summer in a glass. I use nectarines because they have similar flavor and don't require peeling. If drinking off-season or when you don't want it diluted, buy frozen peaches and use them to help chill the beverage. Peach vodka tends to taste less sweet than peach schnapps, but you can use either.

1 (750-ml) bottle white wine (sauvignon blanc or pinot grigio), chilled

1 cup peach-flavored vodka, chilled

½ cup frozen lemonade concentrate

2 cups sliced nectarines

Garnishes: orange slices, fresh mint sprigs

Combine wine, vodka, and lemonade in a pitcher. Stir in nectarines. Chill until ready to serve. Serve over ice and garnish, if desired.

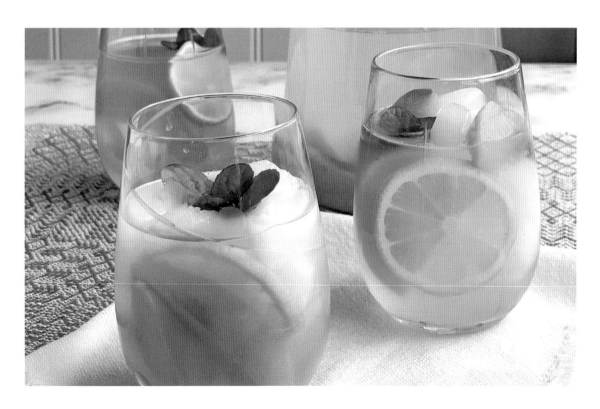

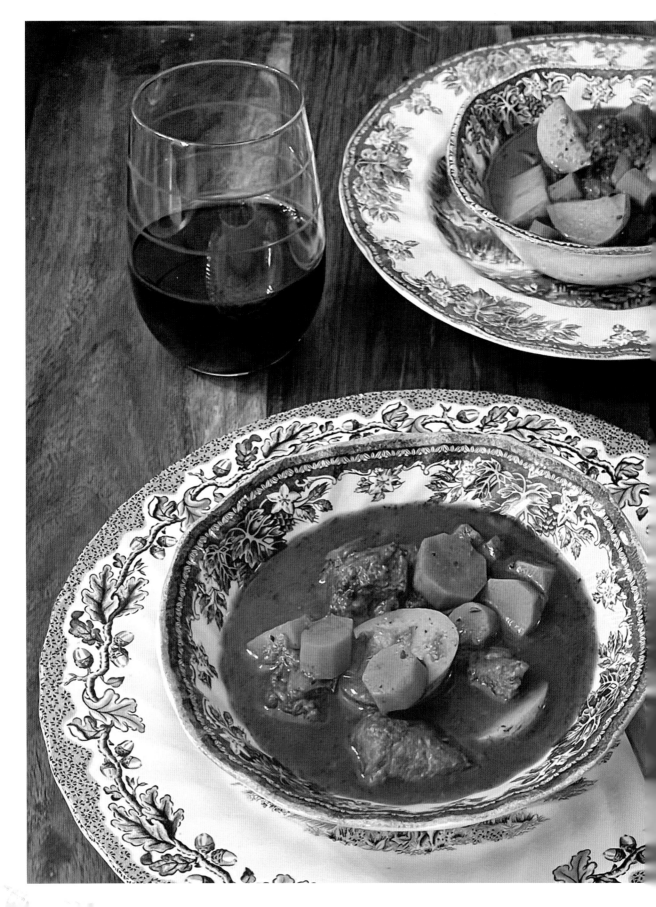

SOUPS *and* STEWS

47

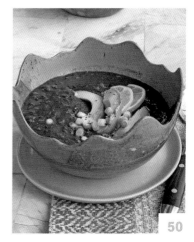
50

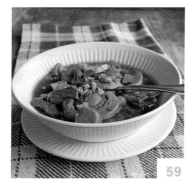
59

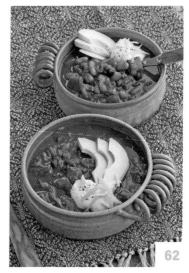
62

60

QUICK CHICKEN BROTH

**MAKES 8 CUPS BROTH AND
1½ CUPS SHREDDED CHICKEN**

2 pounds bone-in chicken thighs

1 teaspoon salt-free seasoning blend

1 tablespoon extra-virgin olive oil

2 onions, quartered

2 carrots, cut into pieces

2 celery stalks, cut into pieces

2 bay leaves

2 quarter-size slices fresh ginger

1 tablespoon kosher salt

1 teaspoon whole peppercorns

¼ teaspoon ground turmeric

8 cups water

The word "quick" is used here in comparison to traditional homemade methods. Ever since I figured out how easy it is to make delicious, fresh chicken broth with a multi-cooker using the pressure cooker function, making broth has become its primary purpose. I use this recipe when I need both broth and cooked chicken to make a dish. You can skip the sauté step, but you'll need to cut the chicken into pieces that will easily fit in the pot. Proceed the same way.

1 Sprinkle chicken with seasoning blend.

2 Heat oil in a multicooker using the sauté function. Add chicken, skin side down, and sauté for 3 to 4 minutes or until golden brown. Turn chicken over and sauté 2 to 3 minutes.

3 Place onion, carrots, celery, bay leaves, ginger, kosher salt, peppercorns, and turmeric on top of chicken. Pour in 8 cups water.

4 Place lid on cooker and set vent to its sealing position. Cook on high pressure for 40 minutes. Let pressure release naturally for 30 minutes, then release fully and remove top. Set chicken aside until cool enough to handle. Strain and discard vegetables and bay leaves. Remove chicken meat, discarding skin and bones.

HOMEMADE BEEF STOCK

MAKES 16 CUPS

6 pounds beef bones

1 pound beef stew meat, cut into pieces

2 large onions, quartered

4 large carrots, cut into pieces

4 celery stalks, cut into pieces

2 tablespoons extra-virgin olive oil

1 (6-ounce) can tomato paste

7 quarts water, divided

4 garlic cloves, crushed

6 fresh parsley sprigs

2 fresh thyme sprigs

2 bay leaves

2 teaspoons black peppercorns

Although often used interchangeably, beef stock differs from beef broth in that it is made with roasted bones, rather than simmered meat pieces. The bones add a lot of richness, and the resulting liquid is generally thicker than broth. Use this as a base for Classic French Onion Soup (page 58), Old-fashioned Beef-and-Barley Soup (page 59), or any of your favorite recipes requiring beef stock or broth.

This is a great time to use the green tops of leeks that are usually too tough to eat on their own. Just add them with the vegetables, replacing some of the onion. I cut them into 1-inch pieces and save them in the freezer until ready to use (letting them thaw while I roast the bones).

1 Preheat oven to 425°.

2 Arrange bones in a single layer in a large roasting pan. Roast bones, turning occasionally, for 45 minutes or until dark brown.

3 Add stew meat, onions, carrots, celery, and olive oil to pan, tossing until meat, vegetables, and bones are coated in oil. Roast for 30 to 35 minutes or until vegetables are dark brown.

4 Transfer bones and vegetables to a large stockpot. Pour off excess grease from roasting pan. Place on cooktop over medium heat. Stir in tomato paste. Cook, stirring constantly, for 2 minutes. Add 4 cups water. Cook, stirring constantly and scraping bits from bottom of pan, for 5 minutes. Transfer tomato paste mixture to stock pot. Add remaining 6 quarts water. Stir in garlic, parsley, thyme, bay leaves, and peppercorns. Add additional water if bones and vegetables are not covered.

5 Bring mixture to a gentle simmer. Periodically skim top of mixture with a ladle and discard fat and impurities. Rinse ladle each time. Partially cover pot, and simmer over low heat for 4 to 6 hours or until stock reduces by one-half to two-thirds.

6 Pour stock through a cheesecloth-lined strainer into a large bowl. Let stand for 30 minutes, then chill in the refrigerator until fat solidifies on top. Remove fat. Pour stock into freezer-safe containers, leaving about 1 inch of headspace. Use within 5 days and/or freeze up to 3 months.

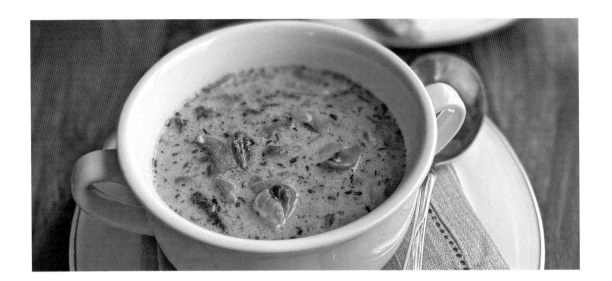

CREAM OF MUSHROOM SOUP

MAKES 6 CUPS

¼ cup salted butter

1 large onion, chopped

1½ pounds baby bella, cremini, or
 button mushrooms

1 tablespoon fresh or 1 teaspoon
 dried thyme

1½ teaspoons salt

½ teaspoon coarsely ground
 black pepper

2 garlic cloves, minced

¼ cup all-purpose flour

¼ cup dry sherry

3 cups vegetable or chicken broth or
 Quick Chicken Broth (page 44)

1 cup heavy whipping cream or
 half-and-half

¼ teaspoon ground nutmeg

Before Campbell's began selling cans of condensed cream of mushroom soup in 1934, cooks had to prepare the thickened soup from scratch. While you can't beat canned for convenience, I find a home-made cream soup delicious and comforting. It's especially tasty when the mushrooms are allowed to caramelize and a dash of sherry is added. The fresh thyme and pinch of nutmeg are my modern additions, and they really blend well with the earthy mushroom-and-onion flavors.

1 Melt butter in a soup pot or Dutch oven over medium heat. Add onion, mushrooms, thyme, salt, and pepper. Cook, stirring frequently, for 10 minutes or until mushrooms are tender and liquid has mostly evaporated. Add garlic; cook for 1 minute.

2 Add flour and cook for 2 minutes, stirring constantly. Whisk in sherry; cook about 1 minute.

3 Whisk in broth and cream. Cook, stirring frequently, for 5 minutes or until thickened. Stir in nutmeg. If desired, pour half of the soup in a blender and blend until smooth. Repeat with remaining soup for a silky-smooth texture.

ROASTED TOMATO-GARLIC SOUP

MAKES 7 CUPS

4 to 4½ pounds mixed tomatoes, halved or quartered

¼ cup extra-virgin olive oil

1 teaspoon salt

½ teaspoon coarsely ground black pepper

⅛ to ¼ teaspoon crushed red pepper flakes

1 head garlic

2 cups vegetable broth

1 tablespoon chopped fresh basil

½ cup heavy whipping cream

Garnish: fresh basil

This is my easy go-to soup at the end of the season when there are a ton of tomatoes on the vine but not enough of any one variety—use a mixture of halved cherry tomatoes and quartered larger ones. Not removing the skin and seeds is a shortcut that yields a soup with a bit more texture than a smooth bisque that's been pressed through a fine wire-mesh strainer. Immersion blenders are amazing—ours gets used several times a week to make sauces, soups, and protein smoothies. If you don't have one, use a regular blender, but blend before simmering the soup—or remove the small center cap on the lid and cover with a kitchen towel because blending hot liquids may cause the lid to pop off.

1 Preheat oven to 450°.

2 Combine tomatoes, olive oil, salt, pepper, and red pepper flakes in a large bowl, tossing to coat. Place tomatoes on 1 or 2 rimmed baking sheets. (I use a 12x17-inch commercial sheet pan with 1-inch sides. Depending on the types of tomatoes, there may be a lot of liquid.) Remove papery exterior of garlic and slice in half crosswise. Rub cut ends of garlic in olive oil on baking sheet, then place, cut sides down, in center of tomato mixture.

3 Bake for 30 minutes or until tomatoes are tender and edges begin to char. Set tomatoes aside until cool enough to handle.

4 Remove garlic from pan and set aside. Transfer tomato mixture, along with juices, to a soup pot. Stir in broth. Squeeze garlic pulp into soup, discarding garlic skin. Stir in 1 tablespoon chopped basil.

5 Blend soup with an immersion blender or in a blender until smooth. Cook over medium-low heat until hot but not boiling. Stir in cream. Garnish, if desired.

PARSNIP SOUP

MAKES 6 CUPS

1 tablespoon extra-virgin olive oil

1 large onion

⅛ teaspoon crushed red pepper flakes

1¼ pounds parsnips (about 4 large)

4 cups vegetable or chicken broth or Quick Chicken Broth (page 44)

1 teaspoon salt

½ cup heavy whipping cream

Garnish: chopped fresh chives

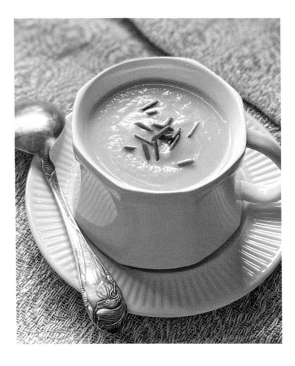

Parsnips are an underappreciated root vegetable. If you aren't familiar, they resemble blond carrots with the starchiness of a potato and the slightly bitter flavor of a turnip, occasionally exhibiting a hint of licorice. My first encounter with parsnips as the basis for soup happened at the museum cafe after a tour of Fallingwater, a historic home designed by renowned architect Frank Lloyd Wright in Mill Run, Pennsylvania. The rich-and-earthy dish was ideal on that crisp fall day, and it became the inspiration for one of my favorite soups. I created this vegetarian version to suit many family members and friends, but, I admit, the bacon variation is my favorite.

1 Heat olive oil in a large soup pot over medium heat. Add onion and red pepper flakes. Cook, stirring frequently, for 5 minutes or until onion is tender. Add parsnips. Cook, stirring occasionally, for 2 minutes.

2 Stir in vegetable broth and salt; bring mixture to a boil. Reduce heat to a simmer and cook, covered, for 30 minutes or until parsnips are tender.

3 Puree soup with an immersion blender until smooth. Stir in cream. Garnish, if desired.

Variation: Omit olive oil. Cook **4 coarsely chopped slices of thick-cut bacon** in a soup pot until crispy. Remove to paper towels, reserving drippings in pot. Cook parsnips, onion, and red pepper flakes in drippings for 5 minutes or until onion is tender. Proceed with recipe. Sprinkle servings evenly with cooked bacon.

QUICK BROCCOLI-CHEDDAR SOUP

MAKES 6 CUPS

1 (12-ounce) package frozen and thawed broc-
 coli florets (about 5½ cups)

2 tablespoons salted butter

½ small yellow or white onion, chopped

2 tablespoons all-purpose flour

2 cups vegetable or chicken broth or
 Quick Chicken Broth (page 44)

1½ cups half-and-half or whole milk

¼ teaspoon salt

⅛ teaspoon coarsely ground black pepper

¼ teaspoon dry mustard

⅛ teaspoon ground cayenne pepper

6 ounces (¾ cup) freshly shredded sharp
 cheddar cheese

Garnishes: broccoli florets, shredded
 cheddar cheese

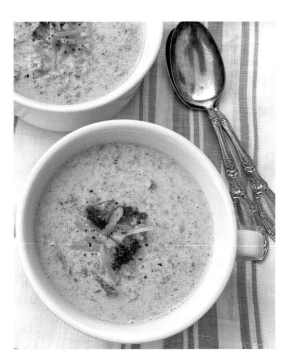

Keep this recipe around for busy weeknights when you want to make dinner with items you probably already have in your pantry or refrigerator. Serve a bowl alongside grilled chicken or burgers, or double up the amount in large bowls for main-dish servings. For the creamiest soup, shred the cheese from a block, rather than buying it pre-shredded. The packaged type is tossed in a light starch that keeps the shreds from sticking together and can sometimes hinder its ability to melt smoothly.

1 Cut broccoli into very small florets, slicing any stems about ⅛-inch thick.

2 Melt butter in a large pot over medium heat. Add onion. Cook, stirring frequently, for 5 to 8 minutes or until onion is tender. Sprinkle with flour. Cook, stirring constantly, for 2 to 3 minutes or until flour is cooked and very light golden.

3 Stir in broth, half-and-half, salt, black pepper, mustard, and cayenne pepper. Stir in broccoli. Simmer gently over medium heat for 20 minutes (do not boil) or until broccoli is tender.

4 Remove from heat. Add cheese, stirring until smooth and well blended. Garnish, if desired.

SLOW COOKER BLACK BEAN SOUP

MAKES 8 CUPS

1 pound dried black beans, rinsed

1 large onion, chopped

1 green bell pepper, chopped

4 garlic cloves, minced

4 cups vegetable broth

1 tablespoon ground cumin

1 teaspoon salt

1 to 2 tablespoons chopped chipotle chiles in adobo sauce

¼ cup chopped fresh cilantro

3 tablespoons fresh lime juice

Garnishes: avocado slices, lime slices, chopped green onions, fresh cilantro sprigs

This soup is fun to serve at a football-watching party. It has a long prep time, but most of the work is hands-off. And, of course, it's worth it— especially on a cold night!

Nutritious black beans are the star of this cozy slow-cooked main-dish soup. Dried beans are economical but require soaking before cooking on top of the stove to decrease lectins that can cause gassiness and other digestive issues. Chipotle adds smoky heat, so start with half the amount for sensitive palates. Taste a few spoonfuls, then add a bit more chipotle if it's not too spicy.

1 Place dried black beans in a large bowl or stock pot, adding water to cover by 3 inches. Soak for 12 hours; drain and discard water.

2 Combine beans, onion, bell pepper, and garlic in a 4-quart slow cooker. Stir in broth, cumin, and salt. Cover and cook on low for 10 hours or until beans are tender. Stir in chipotle, cilantro, and lime juice.

3 For a smooth, thick texture, blend mixture in the slow cooker with an immersion blender for 30 seconds or until desired consistency. Or transfer, in batches, to a blender. Remove stopper in lid and cover with a kitchen towel (hot steam will cause the lid to pop off if not vented); blend until desired texture is achieved.

4 Taste soup and add additional chipotle or salt, if desired. Garnish, if desired.

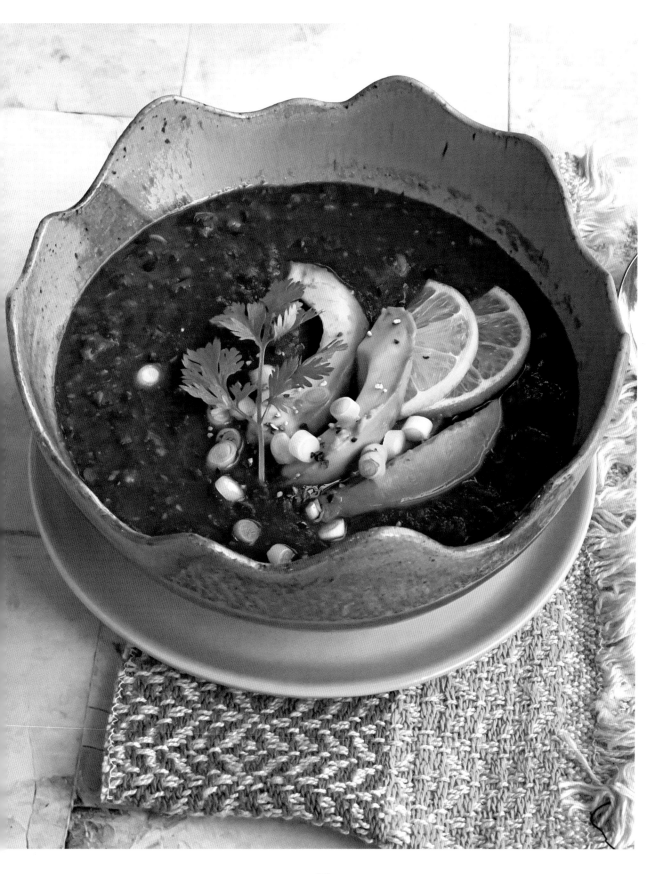

CORN CHOWDER

MAKES 8 SERVINGS

4 slices bacon, chopped

¼ cup salted or unsalted butter

1 red bell pepper, chopped

1 small onion, chopped

2 celery stalks, chopped

⅛ teaspoon crushed
 red pepper flakes

¼ cup all-purpose flour

4 cups vegetable or chicken broth or
 Quick Chicken Broth (page 44)

1 cup half-and-half

1 teaspoon salt

1 pound baby yellow or red potatoes,
 peeled, if desired, and diced

3 cups fresh corn or 1 (16-ounce)
 package frozen corn

2 teaspoons chopped fresh thyme

1 tablespoon chopped fresh chives

This jewel-toned soup includes potatoes for heartiness. If you're using fresh corn, scrape the cobs a few times to get as much flavor as possible. For more smoky bacon flavor, you can substitute the drippings for some of the butter. Waxy potatoes are thin skinned, usually gold or red, and hold their shape better than russet potatoes. Since they are diced, use any size. Keeping the peel on adds nutrition and texture.

This one-pot wonder makes enough to serve a small crowd without creating a large mess in the kitchen. If you have fewer people to feed, you'll have leftovers for later in the week.

1 Cook bacon in a Dutch oven or large saucepan over medium heat until crispy. Remove and drain on paper towels.

2 Melt butter in the same Dutch oven over medium heat. Add bell pepper, onion, celery, and red pepper flakes. Cook for 5 to 7 minutes or until tender. Add flour; cook, stirring constantly, for 1 minute.

3 Stir in broth, half-and-half, and salt. Bring to a simmer and stir in potatoes, corn, and thyme. Simmer for 20 minutes or until potatoes are tender. Top each serving with crumbled bacon and chives.

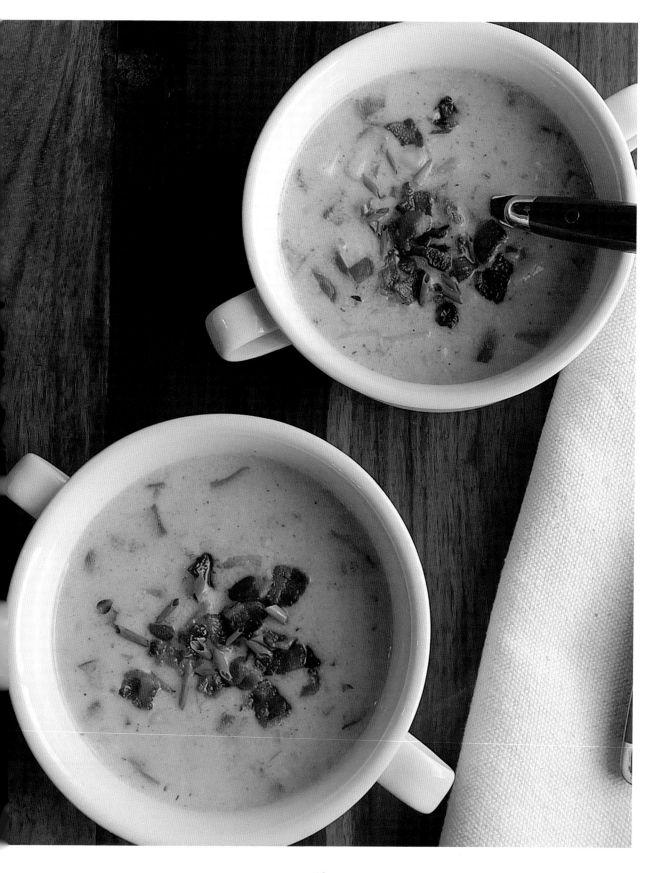

CHICKEN NOODLE SOUP FROM SCRATCH

MAKES 4 TO 6 SERVINGS

1 tablespoon extra-virgin olive oil

2 to 2½ pounds bone-in chicken thighs or breasts

½ teaspoon salt

½ teaspoon coarsely ground black pepper

8 cups chicken broth or Quick Chicken Broth (page 44)

2 carrots, diced

2 celery stalks, diced

½ yellow onion, finely chopped

½ teaspoon dried thyme

½ teaspoon celery seed

⅛ teaspoon crushed red pepper flakes

1 bay leaf

8 ounces broken spaghetti or wide egg noodles

2 tablespoons fresh parsley or chopped green onions

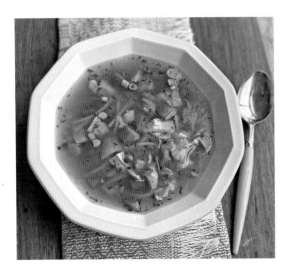

Chicken soups are the go-to meal for cozy winter nights and for anyone needing a healthy boost of protein and vegetables. Cooking the bone-in pieces in broth adds much more flavor than just stirring in chopped cooked chicken, but it's okay to use leftover turkey or rotisserie chicken as a shortcut. Be aware that the pasta will plump up even more the next day (if you have leftovers!), so it'll be less brothy (but even tastier).

1 Heat oil in a Dutch oven or soup pot over medium-high heat. Sprinkle chicken evenly with salt and pepper. Cook chicken, in batches, turning occasionally, for 8 minutes or until golden brown on all sides.

2 Return all chicken to pot. Add broth, carrots, celery, onion, thyme, celery seed, red pepper flakes, and bay leaf to pot. Bring mixture to a boil, reduce heat to low, and simmer, covered, for 20 minutes or until chicken is cooked through and vegetables are tender.

3 Remove chicken from pot and let stand until cool enough to handle. Remove and discard bay leaf. Shred or chop chicken, discarding bones and skin. Set chicken aside.

4 Bring soup to a gentle boil. Add pasta and cook for 10 minutes or until tender. Stir in chicken and parsley. Taste and add more salt and pepper, if desired.

WHITE BEAN– CHICKEN CHILI

MAKES 8 SERVINGS

1 tablespoon extra-virgin olive oil

1 large onion, chopped

1 red bell pepper, chopped

3 garlic cloves, minced

2 teaspoons ground cumin

1 teaspoon dried oregano

1 teaspoon salt

¼ teaspoon ground cayenne pepper

4 cups chicken broth or Quick Chicken Broth (page 44)

3 (15-ounce) cans Great Northern or cannellini beans, rinsed and drained

1 (4-ounce) can chopped green chilies, undrained

3 cups shredded cooked rotisserie or chopped grilled chicken

1 cup sour cream

Garnish: shredded cheddar cheese

If you like a spicy chili, increase the cayenne pepper to ½ teaspoon (or more, if you dare!) and use pepper-Jack cheese on the top. Rotisserie chicken makes a great shortcut, while grilled chicken adds a delicious smoked flavor. Use vegetarian meat crumbles for a meatless option.

1 Heat oil in a large Dutch oven or soup pot over medium-high heat. Add onion and cook for 3 minutes, stirring frequently. Add bell pepper and garlic. Cook, stirring frequently, for 3 to 5 minutes or until tender.

2 Stir in cumin, oregano, salt, and cayenne pepper. Add broth, stirring until blended. Bring mixture to a boil, reduce heat, and simmer over medium-low heat.

3 Mash 1 can of beans until smooth (it's okay if some lumps remain). Stir in mashed beans, remaining 2 cans beans, and green chilies. Stir in chicken. Cook, stirring occasionally, for 10 to 15 minutes or until thoroughly heated.

4 Remove from heat, and stir in sour cream. Garnish, if desired.

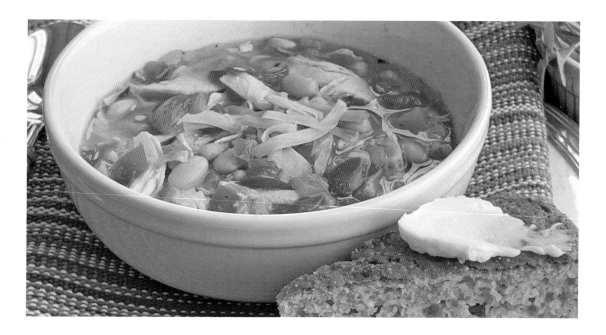

CHICKEN-AND-SAUSAGE GUMBO

MAKES 12 CUPS

2 teaspoons smoked paprika
 or paprika

2 teaspoons salt

1 teaspoon garlic powder

½ teaspoon coarsely ground
 black pepper

½ teaspoon dried thyme

½ teaspoon dried oregano

¼ to ½ teaspoon cayenne pepper

1½ to 2 pounds boneless, skinless
 chicken thighs

¾ cup plus 1 tablespoon vegetable oil

12 to 16 ounces andouille sausage,
 sliced

1 cup all-purpose flour

1 large onion, finely chopped

3 celery stalks, finely chopped

1 green bell pepper, finely chopped

4 garlic cloves, minced

6 cups seafood or chicken broth or
 Quick Chicken Broth (page 44)

1 tablespoon Worcestershire sauce

2 bay leaves

4 green onions, sliced

Hot cooked rice

Garnishes: fresh thyme sprigs, sliced
 green onions

This variation on the Louisiana specialty features chicken thighs and spicy andouille sausage. Thighs have more flavor due to their fat content, and they remain tender even with lengthy cooking times. A dark roux—the oil-and-flour combo—adds a rich smoky flavor, but take care not to scorch it because it might take a while to reach a dark mahogany color.

1 Combine paprika, salt, garlic powder, black pepper, thyme, oregano, and cayenne pepper in a small bowl. Sprinkle chicken with 1½ teaspoons seasoning mixture. Set remaining seasoning mixture aside.

2 Heat 1 tablespoon oil in a large soup pot over medium-high heat. Add chicken and cook, stirring occasionally, for 3 to 4 minutes on each side or until golden brown. Transfer to a plate. Cut into pieces and set aside.

3 Add sausage to pot. Cook over medium-high heat for 4 to 5 minutes or until browned on both sides. Transfer to a plate; set aside.

4 Heat remaining ¾ cup oil in pot over medium heat (no need to wipe clean). Whisk in flour. Cook, whisking frequently and then constantly the last 10 minutes, for 30 minutes or until flour mixture is dark brown.

5 Stir in onion, celery, and bell pepper. Cook, stirring frequently, for 10 minutes or until vegetables are tender. Add garlic and reserved seasoning mixture; cook for 2 minutes, stirring constantly. Gradually stir in broth and Worcestershire sauce. Stir in bay leaves, green onions, and reserved chicken and sausage. Bring to a boil, reduce heat to medium-low, and simmer for 45 minutes.

6 Skim away any excess oil that appears on top. Remove and discard bay leaves. Serve with rice; garnish, if desired.

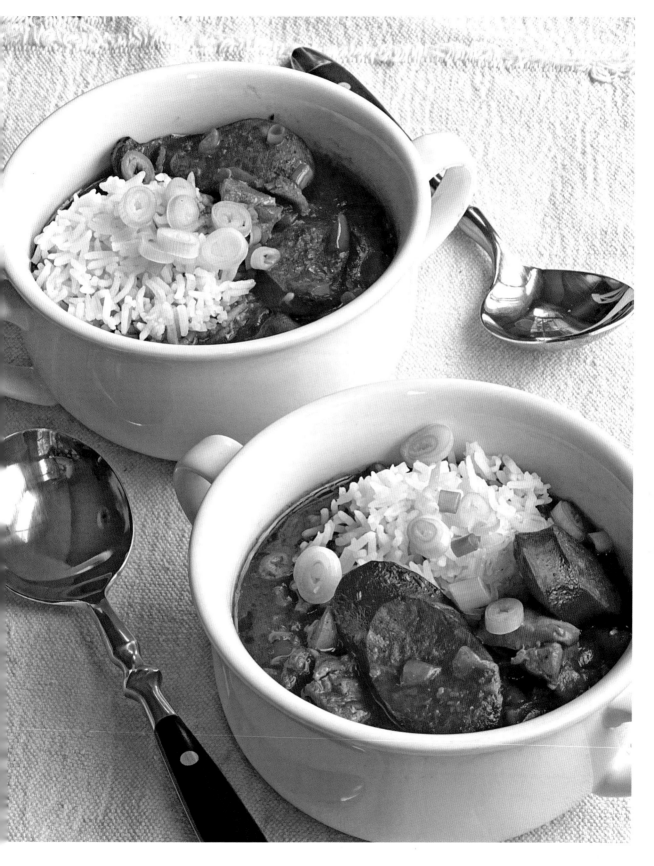

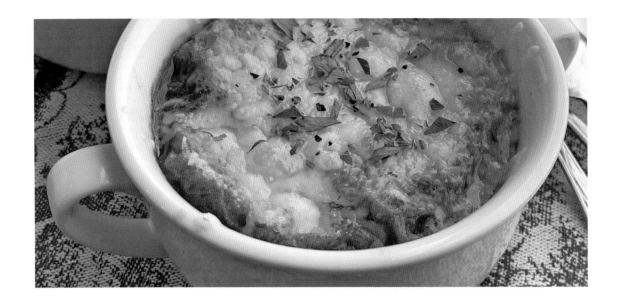

CLASSIC FRENCH ONION SOUP

MAKES 6 TO 8 SERVINGS

3 tablespoons salted or unsalted butter

1 tablespoon extra-virgin olive oil

8 cups halved and sliced yellow onions
(about 4 large)

½ teaspoon salt

½ teaspoon granulated sugar

4 tablespoons all-purpose flour

½ teaspoon coarsely ground
black pepper

¼ cup Cognac or sherry

1 cup dry white wine

6 cups beef broth or Homemade
Beef Stock (page 45)

6 to 8 (½-inch) slices French bread

1½ cups (6 ounces) grated Gruyère or
Swiss cheese

Garnish: chopped fresh parsley

Caramelized onions and beef stock are the
building blocks of a delicious onion soup.
Be patient and allow the onions to fully car-
amelize. Slice them about ¼-inch thick, not
too thin or they'll fall apart while cooking.
Gruyère is the traditional cheese choice,
but Swiss cheese may be substituted.

1 Melt butter with oil in a Dutch oven or large
 soup pot over medium heat. Add onions,
 salt, and sugar, stirring until well blended.
 Cover and cook for 10 minutes. Uncover
 and cook, stirring occasionally, for 45 to 60
 minutes or until onions are dark brown.

2 Stir in flour and black pepper; cook for
 1 to 2 minutes, stirring constantly. Stir in
 Cognac and wine. Cook, stirring frequently,
 for 1 to 2 minutes. Slowly stir in broth.

3 Cook soup, stirring occasionally, for 20 min-
 utes. Season to taste with additional salt
 and pepper, if necessary.

4 Preheat broiler. Place 6 to 8 ovenproof
 soup bowls on a sheet pan. Ladle soup
 into bowls and top each with 1 bread slice.
 Sprinkle evenly with cheese. Broil for 1 to 2
 minutes or until cheese is melted and light
 brown. Garnish, if desired.

OLD-FASHIONED BEEF-AND-BARLEY SOUP

MAKES 6 SERVINGS

1½ pounds boneless beef chuck roast or sirloin steaks, cut into ½-inch pieces

½ teaspoon salt, plus more to taste

½ teaspoon coarsely ground black pepper, plus more to taste

4 teaspoons extra-virgin olive or vegetable oil

2 tablespoons salted or unsalted butter or extra-virgin olive oil

2 (8-ounce) packages mushrooms, sliced

1 onion, chopped

4 garlic cloves, minced

2 tablespoons all-purpose flour

½ cup red wine

6 cups beef broth or Homemade Beef Stock (page 45)

¾ cup pearl barley

3 celery stalks, sliced

2 large carrots, sliced

2 bay leaves

2 sprigs fresh thyme or ½ teaspoon dried thyme

¼ cup chopped fresh parsley

Garnish: chopped fresh parsley

Pearl barley has been processed to remove the outer hull, and it cooks more quickly than whole-grain barley. Quick barley has been pre-steamed and takes much less time to cook until tender. If using quick barley, add it to the soup for the last 10 minutes of cooking. The flavor of the soup is richer with well-marbled meat, but you should remove thick layers of fat and any silverskin.

1 Sprinkle beef evenly with salt and pepper. Heat 2 teaspoons oil in a Dutch oven or soup pot over medium-high heat. Add half of meat and cook, stirring frequently, for 3 minutes or until browned on all sides. Transfer to a plate. Repeat with remaining 2 teaspoons oil and remaining beef. Transfer beef to plate.

2 Melt butter in Dutch oven (no need to wipe clean) over medium heat. Add mushrooms and onion. Cook, stirring frequently, for 7 to 10 minutes or until vegetables are tender. Stir in garlic; cook, stirring frequently, for 1 minute.

3 Add flour and cook, stirring constantly, for 1 minute. Whisk in wine; cook for about 1 minute or until almost evaporated.

4 Stir in broth; add reserved beef and any accumulated liquid. Bring to a boil, reduce heat, and simmer, covered, for 20 minutes.

5 Add barley, celery, carrots, bay leaves, and thyme. Bring to a boil, reduce heat, and simmer, covered, for 35 minutes or until vegetables and barley are tender. Remove and discard bay leaves and thyme stems. Stir in parsley. Taste, and then add more salt and pepper, if needed. Garnish, if desired.

PHOTO ON PAGE 43

HOMESTYLE BEEF STEW

MAKES 6 SERVINGS

1½ pounds beef stew meat

¼ cup all-purpose flour

½ teaspoon coarsely ground black pepper, plus more to taste

1 to 2 tablespoons vegetable oil

1 cup red wine

2 tablespoons tomato paste

4 cups beef broth or Homemade Beef Stock (page 45)

1 tablespoon Worcestershire sauce

1 teaspoon dried thyme

2 bay leaves

4 medium-size carrots, thickly sliced

1 pound baby red, yellow, or Yukon Gold potatoes, cut into bite-size chunks

1 large onion, chopped

2 teaspoons salt

This richly flavored meal-in-a-bowl is so comforting, especially on a chilly winter day. I dust the beef in a bit of flour because I like the way it browns and adds just the slightest bit of thickness—but not too much because I prefer a thinner stew that allows the flavor of the rich broth to really stand out. A lengthy cooking time tenderizes affordable cuts of beef like chuck roast. Ask your butcher for a recommendation at the market.

1 Cut beef into 1-inch cubes or pieces, removing any silverskin or particularly dense pieces of fat (well marbleized pieces are ideal). Place in a bowl and sprinkle with flour and pepper, tossing to coat.

2 Heat 1 tablespoon oil in a soup pot over medium-high heat. Add half of beef and cook, turning occasionally, for 5 minutes or until browned on all sides. Repeat with remaining beef, adding more oil, if necessary. Transfer beef to a plate.

3 Add wine to pot. Cook over medium-high heat, scraping browned bits from bottom of pot with a wooden spoon. Stir in tomato paste. Stir in broth, Worcestershire, thyme, and bay leaves. Return beef to pot. Bring to a boil, reduce heat to low, and simmer, partially covered, for 1½ hours.

4 Add carrots, potatoes, and onion. Cover and simmer for 45 minutes or until vegetables are tender. Remove and discard bay leaves. Stir in salt and additional pepper, if desired.

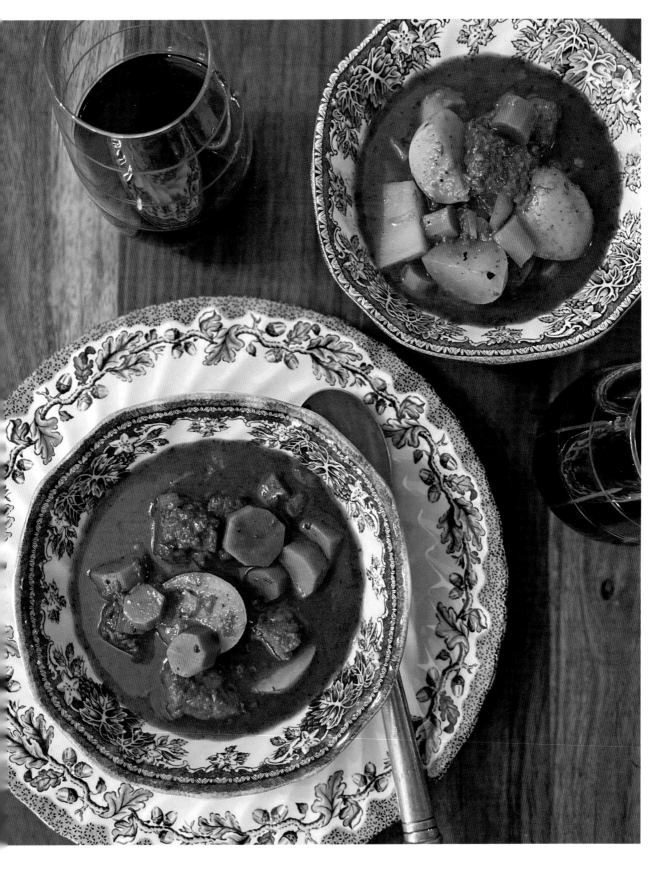

SKIRT STEAK CHILI

MAKES 10 CUPS

2 tablespoons extra-virgin olive oil

1 pound skirt steak, cubed

1 teaspoon salt, divided

½ teaspoon coarsely ground black pepper, divided

1 onion, chopped

1 red bell pepper, chopped

2 poblano or Anaheim peppers, chopped

3 garlic cloves

1 tablespoon chili powder

1 tablespoon paprika

2 teaspoons ground cumin

½ teaspoon dried oregano

2 cups beef broth or Homemade Beef Stock (page 45)

1 (28-ounce) can fire-roasted diced tomatoes, undrained

2 tablespoons tomato paste

1 (15.5-ounce) can black beans, rinsed and drained

1 (15.5-ounce) can pinto beans, rinsed and drained

2 teaspoons chipotle peppers in adobo sauce (optional)

1 teaspoon cocoa powder

Toppings: sour cream, shredded cheddar cheese, sliced avocado

A little bit of cocoa powder enhances the rich, smoky flavor of this hearty chili. You can use any cut of beef you prefer.

1 Heat oil in a soup pot over medium-high heat. Sprinkle steak with half of salt and pepper. Add steak to pot and cook, stirring occasionally, for 3 to 4 minutes or until browned on all sides. Transfer to a plate and set aside.

2 Add onion to pot; cook over medium-high heat, stirring frequently, for 2 to 3 minutes or until softened. Add bell pepper, poblano pepper, garlic, chili powder, paprika, cumin, oregano, remaining salt, and remaining pepper. Cook, stirring frequently, for 3 to 5 minutes or until vegetables are tender.

3 Return steak to pot. Stir in broth, diced tomatoes, and tomato paste. Bring to a boil, reduce heat, and simmer over medium-low heat, partially covered, for 20 minutes or until meat is very tender.

4 Stir in black beans; pinto beans; chipotle peppers, if desired; and cocoa powder. Cook for 10 minutes or until thoroughly heated.

5 Ladle chili into bowls, and serve with desired toppings.

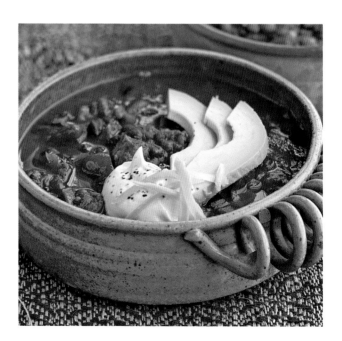

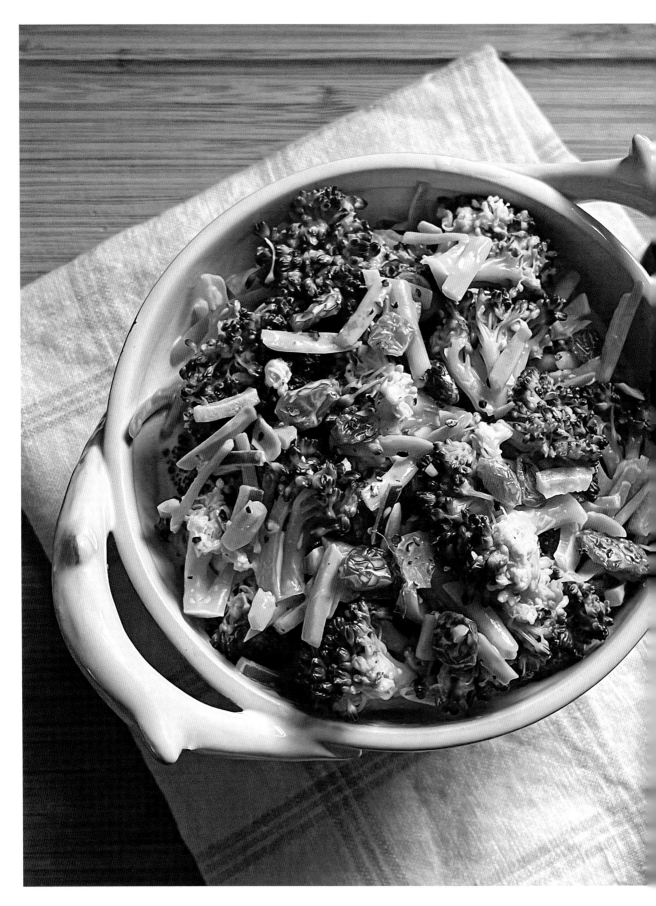

SALADS

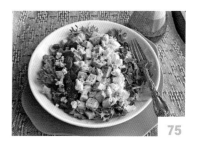

75

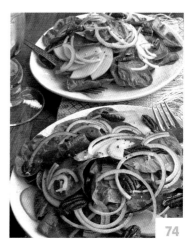

74

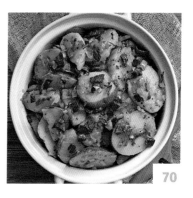

70

66

68

TRICOLOR SLAW

MAKES 8 SERVINGS

½ cup mayonnaise

¼ cup sour cream

3 tablespoons granulated sugar

3 tablespoons apple cider or white wine vinegar

2 teaspoons celery salt

2 teaspoons grated sweet onion (optional)

½ head green cabbage, cored and thinly sliced (about 8 cups)

½ head small purple cabbage, cored and thinly sliced (about 5 cups)

1 large carrot, shredded or julienned

This festive side dish is perfect with barbecue, burgers, fried chicken, or pork tenderloin. To get the finest, most even shreds, use a mandolin slicer. If slicing with a knife, the cabbage may be thicker and require about an hour or so in the refrigerator for the flavors to marry. Ideally, the slaw is eaten a few hours after mixing. Any longer and the purple cabbage will color the other ingredients—but it'll still be delicious!

1 Combine mayonnaise, sour cream, sugar, vinegar, celery salt, and, if desired, onion in a very large bowl.

2 Add cabbage and carrot. Toss until well blended.

3 Cover and refrigerate until ready to serve. Toss well before serving.

CUCUMBER SALAD

MAKES 4 CUPS

3 garden cucumbers, peeled and very thinly sliced

1½ tablespoons kosher salt, divided

1 tablespoon granulated sugar

½ teaspoon dry mustard

3 tablespoons apple cider vinegar

1 cup sour cream

1 tablespoon fresh or 1 teaspoon dried dill

Common garden cucumbers contain thick seeds that can sometimes be difficult to digest, and the peel can be quite bitter. Long, thin English cucumbers have been bred to have none or few seeds and a thin peel that does not need to be removed. They are sold in markets (wrapped in plastic to preserve moisture) as seedless, burpless, or hothouse cucumbers. If desired, substitute two English cucumbers.

1 Place sliced cucumbers in a large bowl, sprinkling 1 tablespoon salt evenly between layers. Add water to cover by 1 inch. Set aside for 1 hour. Drain well and blot with paper towels until cucumbers are dry.

2 Combine remaining 1½ teaspoons salt, sugar, dry mustard, vinegar, sour cream, and dill in a bowl. Combine cucumbers and vinegar mixture, tossing to coat. Chill until ready to serve.

BROCCOLI SALAD

MAKES 4 SERVINGS

1 head broccoli (12 to 16 ounces), cut into small florets (about 4 to 4½ cups)

2 tablespoons golden or dark raisins

2 tablespoons sliced or minced red onion, chopped

¼ cup shredded cheddar cheese

¼ cup sour cream

3 tablespoons mayonnaise

2 tablespoons granulated sugar

1 tablespoon white or cider vinegar

½ small garlic clove, minced

½ teaspoon salt, plus more to taste

¼ teaspoon coarsely ground black pepper

2 tablespoons sunflower seeds (optional)

This retro side dish makes a great alternative to coleslaw at summer picnics. While this recipe is designed for a single head of broccoli, you can double, triple, or quadruple the recipe for crowds. Blanching the broccoli in boiling water for a minute gives it a vibrant green color without overcooking and creating a mushy texture. You can add a few slices of chopped cooked bacon for more flavor.

1 If desired, blanch broccoli florets in boiling water for 1 minute. Plunge into ice water to stop the cooking process; drain well.

2 Combine broccoli, raisins, onion, and cheese in a large bowl.

3 In a small bowl, stir together sour cream, mayonnaise, sugar, vinegar, garlic, salt, and pepper. Add sour cream mixture to broccoli mixture, stirring to coat. Cover and refrigerate for at least 2 hours or until well chilled. Sprinkle with sunflower seeds, if desired.

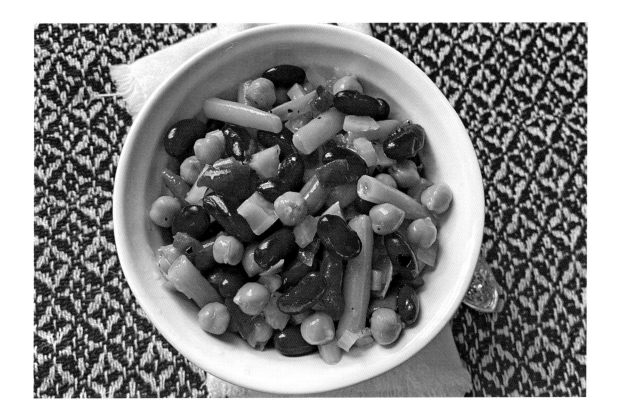

CLASSIC BEAN SALAD

MAKES 8 CUPS

1 cup chopped celery

½ cup chopped red onion

1 green bell pepper, chopped

1 (14.5-ounce) can wax beans, drained

1 (15.5-ounce) can kidney beans, drained

1 (14.5-ounce) can green beans, drained

1 (15.5-ounce) can garbanzo beans, drained

1 (4-ounce) jar diced pimientos, drained

Sweet Dressing (recipe at right)

Easy and flavorful, this veggie salad tastes best when made the day before and will stay fresh up to a week in the refrigerator. Many older versions use baby peas instead of garbanzos. This dish is economical, making it great for large picnics and gatherings. Prepare it ahead for extra flavor. The side dish will keep, covered, in the refrigerator for 3 to 5 days.

Combine celery, onion, bell pepper, beans, and pimientos in a large bowl. Pour dressing over vegetables, stirring well. Cover and refrigerate for 2 to 3 hours or until chilled, stirring occasionally.

Sweet Dressing: Combine **¾ cup granulated sugar, 1 cup white wine vinegar, ½ cup extra-virgin olive or vegetable oil, 1 teaspoon salt,** and **½ teaspoon coarsely ground black pepper** in a small saucepan over medium heat. Cook, stirring occasionally, until sugar dissolves. Makes 1½ cups.

GERMAN POTATO SALAD

MAKES 8 SERVINGS

3 pounds unpeeled red potatoes

1 tablespoon kosher salt

5 thick-cut bacon slices, chopped

1 onion, chopped

1 tablespoon all-purpose flour

½ cup beef broth

¼ cup white wine or apple cider vinegar

2 tablespoons granulated sugar

1 tablespoon whole-grain mustard

½ teaspoon celery seeds

½ teaspoon coarsely ground
 black pepper

2 tablespoons chopped fresh parsley

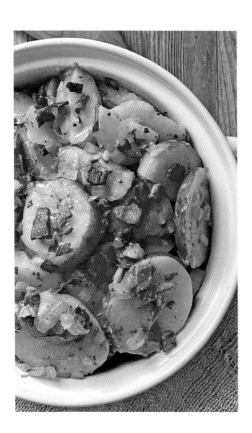

This version of potato salad, served warm, is heavy on the bacon, making it a hearty option for potluck dinners. You can use red or yellow potatoes, but try to keep the size about the same (smaller potatoes may become mushy in the boiling water before larger ones are ready).

1 Place potatoes in a Dutch oven or large pot. Add water to cover by 2 inches. Stir in salt. Bring to a boil over high heat. Reduce heat to medium and simmer for 15 minutes or until tender when pierced with a fork. Drain water, leaving potatoes in pot. Set aside until cool enough to handle.

2 Meanwhile, cook bacon in a large skillet over medium heat until halfway cooked. Add onion and cook for 10 minutes, stirring occasionally, until bacon is crisp and onion is tender. Remove bacon and onion with a slotted spoon, setting aside and reserving 3 tablespoons bacon drippings in skillet. (If less than 3 tablespoons, add olive oil.)

3 Heat reserved bacon drippings in skillet over medium heat. Add flour and cook for 1 minute. Stir in broth, vinegar, sugar, mustard, celery seeds, and pepper. Cook, stirring constantly, until smooth. Remove from heat.

4 Peel potatoes, if desired, and cut into ¼-inch-thick slices. Transfer to a large bowl. Add broth mixture, bacon and onion, and parsley, tossing to coat. Serve warm or at room temperature.

HONEY-POPPY SEED DRESSING

MAKES ¾ CUP

Serve this versatile dressing over any salad. It's particularly nice with spinach and arugula, along with fresh berries and toasted nuts.

¼ cup apple cider vinegar

¼ cup canola, light olive, or vegetable oil

¼ cup mild flavored honey

1 tablespoon poppy seeds

1 teaspoon grated white onion

½ teaspoon dry mustard

½ teaspoon salt

⅛ teaspoon coarsely ground black pepper

Combine vinegar, oil, honey, poppy seeds, onion, dry mustard, salt, and pepper in a jar. Cover and shake vigorously. Shake again before serving.

CHUNKY BLUE CHEESE DRESSING

MAKES 2¼ CUPS

I love the fresh flavor of homemade blue cheese dressing and usually only make this full recipe when hosting a party and serving a lot of grilled, smoked, or oven-fried buffalo chicken wings. For family use, divide the recipe in half and store in the refrigerator for a week. Drizzle over wedge salads, pasta, and even grilled steak. Blue cheese comes mild to funky, so go with a big-name, inexpensive crumbled blue cheese to please most people.

1 cup sour cream

⅔ cup mayonnaise

½ cup buttermilk

1 teaspoon Worcestershire sauce

½ teaspoon granulated sugar

¼ teaspoon garlic powder

¾ teaspoon salt

¼ teaspoon coarsely ground black pepper

4 ounces blue cheese, crumbled

Combine sour cream, mayonnaise, buttermilk, Worcestershire, sugar, garlic powder, salt, and pepper in a large bowl, stirring until well blended. Fold in blue cheese.

CHOPPED SALAD WITH AVOCADO-BUTTERMILK DRESSING

MAKES 6 SERVINGS

This salad features the delicious elements of a favorite summer sandwich—but in a more elegant serving. Make it for lunch with a friend, or serve it for dinner on a weeknight when you're craving a lighter meal with big flavor.

My favorite sandwich is a crisp BLT with avocado slices. While this salad is missing the bread, it has all those amazing flavors served with a large helping of healthy greens. To keep the dressing bright green for a few days in the fridge, press plastic wrap on the surface to prevent air contact.

3 heads Romaine lettuce, sliced

2 large tomatoes, cut into wedges

½ seedless cucumber, sliced

6 slices cooked bacon, chopped

8 tablespoons Avocado-Buttermilk Dressing (recipe below)

Combine lettuce, tomatoes, and cucumber in a large bowl or portion onto salad plates. Sprinkle with bacon. Serve with dressing.

Avocado-Buttermilk Dressing: Combine 2 avocadoes, chopped; 1 small garlic clove, minced; ¼ cup mayonnaise; ¼ cup sour cream; ¼ cup buttermilk; 1 tablespoon cider vinegar; ¼ cup chopped fresh herbs such as basil, parsley, and chives; ½ teaspoon salt; and ¼ teaspoon coarsely ground black pepper in a blender or food processor. Process until smooth. Cover surface with plastic wrap and chill until ready to serve. Makes 2 cups.

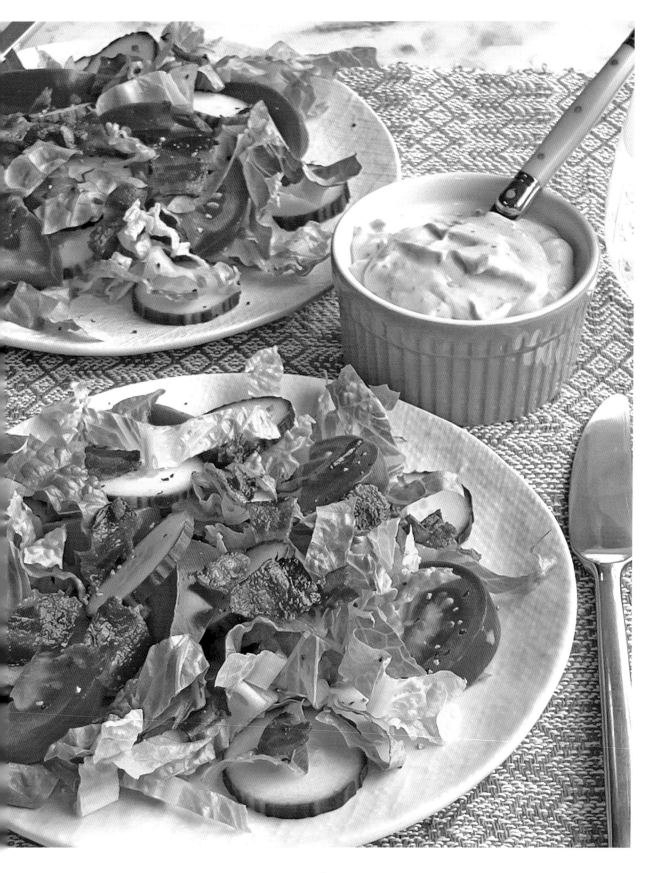

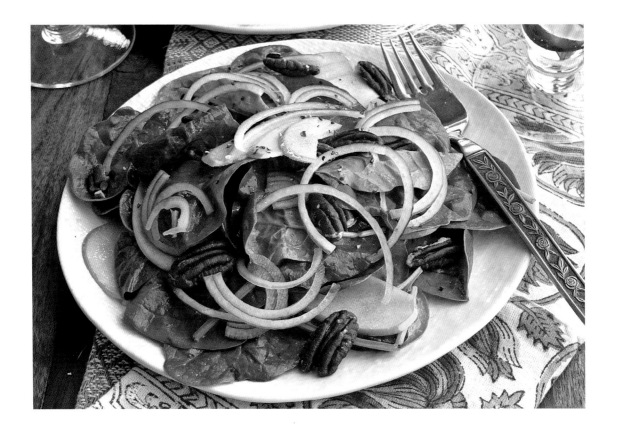

MAPLE-APPLE-SPINACH SALAD

MAKES 4 SERVINGS

½ cup pecan halves

½ cup apple cider vinegar

¼ cup maple syrup

⅓ cup extra-virgin olive oil

½ teaspoon salt

¼ teaspoon dry mustard

¼ teaspoon coarsely ground
 black pepper

1 (10-ounce) container fresh spinach

2 apples, cored and chopped or sliced

½ red onion, thinly sliced

4 slices chopped cooked bacon
 (optional)

Here's one of my favorite fall salad recipes. Sliced apples tend to brown when exposed to air, but they stay crisp and bright when drizzled in the vinaigrette.

1 Preheat oven to 350°. Spread pecans in a single layer on a baking sheet. Bake for 4 to 5 minutes or until toasted and fragrant. Let cool.

2 Meanwhile, whisk together vinegar, maple syrup, olive oil, salt, dry mustard, and pepper in a bowl. Add spinach, apples, and onion, tossing to coat. Divide among serving plates. Sprinkle with pecans and, if desired, bacon.

COBB SALAD

MAKES 4 SERVINGS

1 small head Romaine lettuce, chopped

½ head iceberg lettuce, chopped

1 small bunch curly endive, chopped

½ bunch watercress

2 tablespoons minced fresh chives

2 tomatoes, peeled and diced

2 cups diced cooked chicken breasts

6 bacon strips, cooked and chopped

3 hard-cooked eggs, diced

1 ripe avocado, diced

½ cup crumbled Roquefort or
 blue cheese

French Vinaigrette Dressing
 (recipe at right)

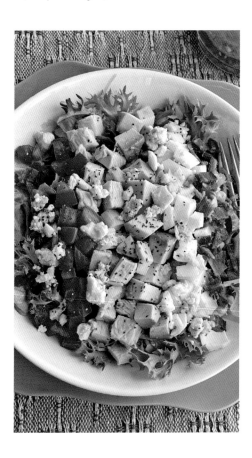

Originally made famous at Hollywood's Brown Derby Restaurant, this salad has changed little over the years. In 1937, owner Bob Cobb explored the kitchen one night in search of a snack. He pulled out various ingredients from the refrigerator and created a hearty salad that he shared with his friend Sid Grauman of Grauman's Chinese Theatre. Grauman returned the next day and asked for a "Cobb salad." The Cobb salad is a favorite on menus today. Off season, endive and watercress might be tricky to find in markets. Substitute easily found spring salad mix instead.

Combine Romaine, iceberg, endive, watercress, and chives in a large salad bowl, mixing well. Place on a serving platter or on individual salad plates. Arrange tomatoes, chicken, bacon, eggs, and avocado in strips across salad greens. Sprinkle with cheese. Drizzle with French Vinaigrette Dressing.

French Vinaigrette Dressing: Combine **¼ cup water, ¾ teaspoon dry mustard, 1 teaspoon salt, ½ teaspoon coarsely ground black pepper, ¼ teaspoon granulated sugar, ¼ cup red wine vinegar, 1½ teaspoons lemon juice, ½ teaspoon Worcestershire sauce,** and **1 minced garlic clove** in a bowl. Whisk in **¾ cup vegetable oil** and **¼ cup extra-virgin olive oil.** Blend well just before serving. Store in refrigerator up to 2 weeks. Makes 1½ cups.

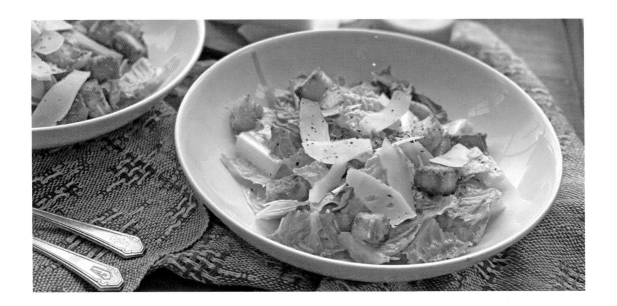

CAESAR SALAD

MAKES 4 SERVINGS

⅓ cup mayonnaise

1½ teaspoons lemon zest

3 tablespoons fresh lemon juice

1 teaspoon Worcestershire sauce

1 teaspoon Dijon mustard

½ to 1 teaspoon anchovy paste (optional)

1 garlic clove, minced

½ teaspoon salt

½ teaspoon coarsely ground black pepper

½ cup extra-virgin olive oil

3 tablespoons shredded Parmesan cheese

3 heads Romaine lettuce, torn or chopped

Toasted Croutons (recipe at right or store-bought)

Shaved Parmesan cheese

Traditional Caesar dressing uses raw egg yolks to emulsify the ingredients, but you can use a bit of mayonnaise instead. Anchovy paste is a strong-flavored condiment that gives the dressing an authentic flavor but can be easily omitted, if desired. Make this an entrée by topping each serving with grilled salmon or a grilled-and-sliced chicken breast.

1 Combine mayonnaise, zest, juice, Worcestershire, Dijon, anchovy paste, garlic, salt, and pepper in a blender or food processor. While blades are running, drizzle in olive oil. Add Parmesan, pulsing until well blended.

2 Just before serving, place lettuce and croutons in a large bowl. Add mayonnaise mixture, tossing to coat. Divide among serving bowls and sprinkle with shaved Parmesan, croutons, and additional black pepper, if desired.

Toasted Croutons: Combine **2 tablespoons extra-virgin olive oil, 1 grated or finely minced garlic clove, ¼ teaspoon salt,** and **⅛ teaspoon coarsely ground black pepper** in a bowl. Add **2 cups cubed rustic bread,** tossing to coat. Spread in a single layer on a baking sheet, and bake at 375° for 8 to 10 minutes or until golden brown. Makes 2 cups.

PIMIENTO CHEESE

MAKES 3½ CUPS

2 (8-ounce) packages sharp cheddar cheese

4 ounces cream cheese or Neufchatel, softened

⅔ cup mayonnaise

½ teaspoon grated onion (optional)

2 teaspoons Worcestershire sauce

½ teaspoon hot sauce

¼ teaspoon coarsely ground black pepper

1 (4-ounce) jar chopped pimentos, drained

This zesty concoction has been adopted by the South as one of its iconic foods, but it actually has roots in (gasp) New York City. Around 1870, farmers began making soft, unripened cheese similar to the French Neufchatel and marketing it as "cream cheese." Soon after, imported Spanish peppers or pimientos hit the market, and the two ingredients were combined in recipes. Georgia provided an ideal climate to grow the peppers and, in the 1920s through 1940s, the state became home to one of the nation's largest packagers. By World War II, Southern cooks introduced hoop and then cheddar to the mix, and the tradition grew. Dozens of variations exist, and home cooks can alter many of the ingredients to suit their tastes. If you prefer a chunky texture, stir the shredded cheese gently. If you prefer something smoother, process in a food processor.

1 Shred cheddar cheese on a box grater or in a food processor. Set aside.

2 Combine cream cheese, mayonnaise, onion, Worcestershire, hot sauce, and black pepper in a food processor fitted with a blade or in a mixing bowl. Process or beat until smooth and well blended.

3 Add cheddar; process or beat until well blended. Stir in pimientos.

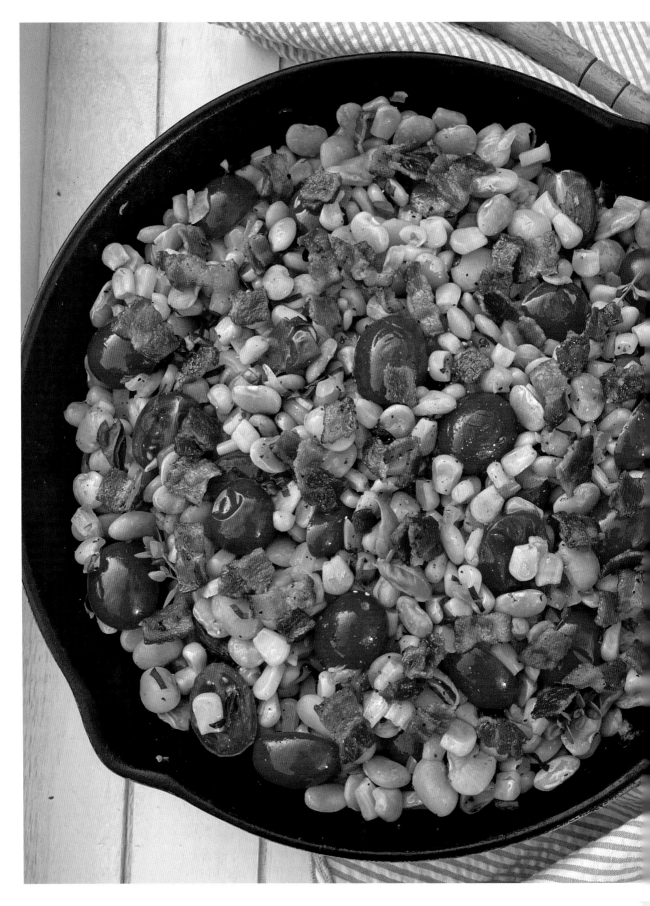

SIDES

82

94

86

88

85

GARLIC ROASTED ASPARAGUS

MAKES 4 TO 6 SERVINGS

3 tablespoons extra-virgin olive oil

6 garlic cloves, minced

¼ teaspoon salt

¼ teaspoon coarsely ground
 black pepper

1 pound fresh thin asparagus

¼ cup shredded Parmesan cheese

My family and I enjoy this asparagus recipe so much, I rarely make the green vegetable any other way. The only exception is in the summer, when I like to grill the asparagus, then drizzle it with the garlic-and-olive-oil mixture and sprinkle it with Parmesan after it's done.

1 Preheat oven to 375°.

2 Heat oil in a small pan over medium heat. Stir in garlic, salt, and pepper. Heat, stirring frequently, for 2 or 3 minutes or until garlic is light golden brown (do not let it over-darken). Let stand.

3 Meanwhile, rinse asparagus and slice off brittle, woody ends (or bend asparagus near the bottom to snap off woody ends). Place asparagus on a rimmed baking sheet.

4 Drizzle with reserved oil mixture, rolling asparagus around to coat. Roast for 10 minutes and sprinkle with Parmesan. Roast for 3 to 5 more minutes or until asparagus is tender and cheese melts (watch garlic so it doesn't burn).

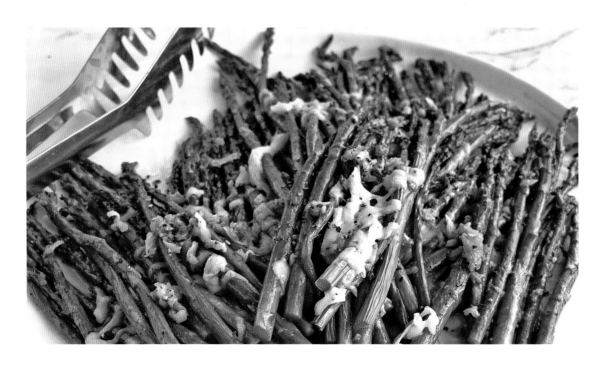

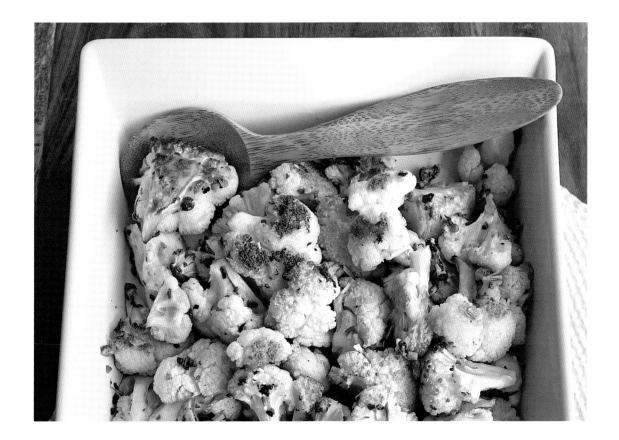

ROASTED GARLIC CAULIFLOWER

MAKES 4 SERVINGS

2 tablespoons extra-virgin olive oil

2 tablespoons salted or unsalted butter, melted

3 garlic cloves, minced

1 teaspoon chopped fresh rosemary

¾ teaspoon salt

¼ teaspoon crushed red pepper flakes

¼ teaspoon lemon zest

1 tablespoon fresh lemon juice

1 large head cauliflower, cut into florets

Garnish: chopped fresh parsley

This simple roasted side dish is as delicious as it is easy. It's a big hit with my family—my daughter Emily Bishop and her beau, Nick, skip everything else and just eat this one thing for dinner. You can omit the lemon zest and juice, but I enjoy the bright flavor with the olive oil and butter.

1 Preheat oven to 375°.

2 Combine oil, butter, garlic, rosemary, salt, red pepper flakes, zest, and juice in a large bowl. Add cauliflower, tossing to coat.

3 Spread cauliflower on a rimmed baking sheet in a single layer. Drizzle any remaining oil mixture over cauliflower.

4 Bake for 30 minutes. Stir gently and bake for 15 more minutes or until cauliflower is tender and browned on the edges. Garnish, if desired.

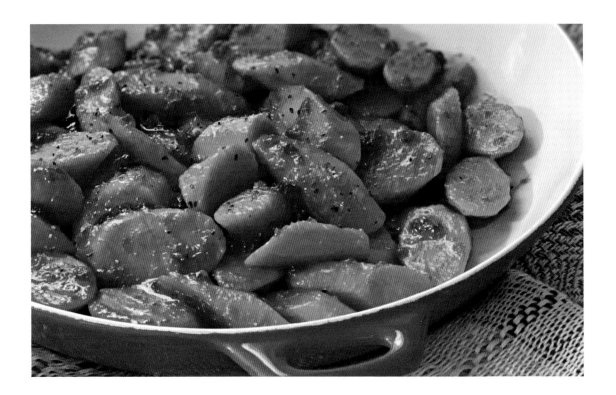

CRANBERRY CANDIED CARROTS

MAKES 4 SERVINGS

6 carrots

⅓ cup canned jellied cranberry sauce

3 tablespoons salted or unsalted butter

2 tablespoons firmly packed light brown sugar

¼ teaspoon salt

Carrots have been grown for food for a long time—there is evidence they were cultivated in the Iranian Plateau (Afghanistan, Iran, and Pakistan) and the Persian Empire, then domesticated in Central Asia. They were not originally orange but rather purple or yellow. You can find purple, white, yellow, and common orange carrots in specialty markets; these can be substituted along with packaged "baby" carrots. Unless small, slender carrots are sold in bunches with the green tops attached, what you see in markets as baby carrots are more likely pieces of long carrots that have been cut into 2-inch pieces and rounded at the edges.

1 Cut carrots diagonally into ½-inch-thick slices. Cook in boiling, salted water to cover for 6 minutes or until tender. Drain.

2 Combine cranberry sauce, butter, brown sugar, and salt in a skillet over medium-low heat. Cook, stirring occasionally, until cranberry sauce melts. Add carrots, and cook for 3 to 5 minutes, stirring occasionally, until carrots are heated through and glazed.

GREEN BEAN BUNDLES

MAKES 8 SERVINGS

8 slices lean bacon

1 pound haricots verts or thin
green beans

¼ cup unsalted or salted butter

¼ cup firmly packed light brown sugar

1 tablespoon soy sauce

1 teaspoon Worcestershire sauce

½ teaspoon coarsely ground
black pepper

A sweet-and-salty glaze coats these adorable veggie bundles. Haricots verts, French green beans, are thin and very tender. If you can't find them, you can use regular green beans, but they will need to be boiled or steamed a little longer to get tender. If you like very tender beans, cook until almost to your liking, but make sure they don't start falling apart. Remember that bacon will continue to crisp as it cools down, so make sure you don't overcook it—it needs to be pliable to wrap around the bean bundles.

1 Cook bacon in a skillet over medium heat until mostly cooked but still flexible. Drain and set aside.

2 Bring a pot of water to a boil. Trim ends of beans, if necessary, and boil 2 to 3 minutes or until crisp-tender. Drain and rinse in cold water.

3 Melt butter in a small saucepan over medium-low heat. Add brown sugar, soy sauce, Worcestershire sauce, and pepper. Cook for 1 to 2 minutes, stirring constantly, until sugar melts and mixture is smooth.

4 Preheat oven to 375°. Line a rimmed sheet pan with nonstick aluminum foil or parchment paper.

5 Divide beans into 8 bundles. Wrap each bundle with a piece of bacon, rotating so ends are on the bottom. Place on prepared sheet pan. (If bundles fall apart, secure with a wooden pick.)

6 Brush butter mixture on bean bundles and bake for 10 minutes or until bacon is cooked through and beans are thoroughly heated.

ROASTED BRUSSELS SPROUTS WITH GARLIC, PARMESAN, AND LEMON

MAKES 4 SERVINGS

¼ cup extra-virgin olive oil

6 garlic cloves, minced

1 tablespoon lemon juice

½ teaspoon salt

¼ teaspoon crushed red pepper flakes

¼ teaspoon coarsely ground black pepper

1½ pounds Brussels sprouts

¼ cup grated Parmesan cheese

This cruciferous vegetable grows as buds on a thick stalk, each one resembling a tiny cabbage. I grew up eating these boiled—not a favorite preparation for a child's palate—and had to drown them in lemon butter first. Try roasting Brussels sprouts instead—it caramelizes them and dissipates the natural sulfur-y flavor.

1 Combine olive oil, garlic, lemon juice, salt, red pepper flakes, and black pepper in a large bowl.

2 Trim ends and bruised leaves from Brussels sprouts. Cut in half and add to olive oil mixture. Let stand for 30 to 60 minutes.

3 Preheat oven to 375°. Spread sprouts on a baking sheet in an even layer. Bake for 30 to 40 minutes, turning once, or until browned and tender.

4 Sprinkle with cheese. For melted cheese that sticks to sprouts, place in warm oven for 3 to 5 minutes.

SUCCOTASH

MAKES 6 SERVINGS

2½ cups vegetable broth or
 water, divided

1 (12-ounce) package frozen baby
 lima beans

4 slices bacon, chopped

1 sweet onion, chopped

2 garlic cloves, chopped

4 cups fresh or 1 (19-ounce)
 package frozen corn kernels,
 thawed

1 teaspoon fine sea salt

¼ teaspoon coarsely ground
 black pepper

2 tablespoons salted or
 unsalted butter

1 cup halved grape tomatoes

2 tablespoons chopped
 fresh basil

1 tablespoon chopped
 fresh thyme

The term "succotash" is a variation of the Native American Narragansett tribe's word that means "broken corn kernels." I keep corn and lima beans in the freezer, so I can whip up this side dish or meal at the last minute. Frozen corn comes in a variety of package sizes, and there is flexibility in the recipe to use a range. I've made this recipe with 12 ounces and up to 19 ounces with equally delicious results. I'll skip the bacon for my vegetarian friends, sometimes roasting mushrooms as a substitute. I prefer tomatoes, but if you want to use red bell pepper instead, sauté it with the onion. Leftovers are delicious as is, but I'll heat them in a pile of oven-baked nachos or stir them into a cold salad.

1 Bring 2 cups broth to a boil in a small saucepan over medium-high heat. Add lima beans, reduce heat, and simmer for 5 to 8 minutes or until tender. Drain.

2 Cook bacon in a large cast-iron skillet until crispy. Remove and drain on paper towels, reserving 1 tablespoon drippings in skillet. Add onion and garlic, and cook over medium heat, stirring occasionally, for 5 minutes. Stir in lima beans, corn, salt, pepper, and remaining ½ cup broth. Cook for 5 to 8 minutes or until thoroughly heated. Stir in butter, tomatoes, basil, and thyme.

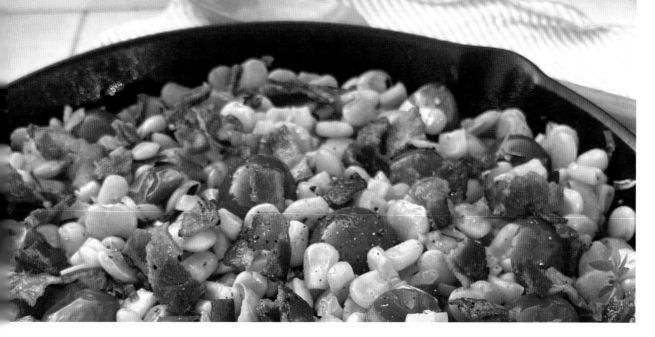

MARINATED GRILLED VEGETABLES

MAKES 6 SERVINGS

⅓ cup white balsamic vinegar

¼ cup extra-virgin olive oil

2 tablespoons molasses

2 garlic cloves, minced

1 tablespoon chopped fresh basil

2 teaspoons chopped fresh oregano

2 teaspoons chopped fresh thyme

½ teaspoon salt

½ teaspoon coarsely ground black pepper

2 zucchini, cut diagonally into ½-inch-thick slices

2 yellow squash, cut diagonally into ½-inch-thick slices

2 large carrots, halved

1 red bell pepper, cut into large pieces

1 orange or yellow bell pepper, cut into large pieces

1 large onion, quartered

½ pound asparagus (optional)

1 to 2 ounces soft goat cheese (optional)

Fire up the grill, and make these colorful, healthy bites for a summer-fresh side everyone will love.

This dish is far and away my favorite summer side. If there's a sale on asparagus, I'll toss that in the mix. Be careful with it—it can break when tossing in the marinade and cooks very quickly. Stay near the grill and remove veggies as they cook. Take them off the heat early (rather than waiting until they're fully cooked) because they'll continue to cook when piled in a serving dish. Grease your grill grates just before adding the vegetables—dip a wadded paper towel in a small amount of vegetable oil (too much will cause flare ups) and wipe over grates.

1 Combine vinegar, olive oil, molasses, garlic, basil, oregano, thyme, salt, and pepper in a very large bowl.

2 Add zucchini, squash, carrots, bell peppers, and onion, tossing to coat. Add asparagus carefully, if desired. Let marinate 15 to 30 minutes, stirring occasionally.

3 Preheat grill to medium-high (350° to 400°).

4 Remove vegetables with tongs or a slotted spoon; place on hot greased grill grates, reserving marinade. Grill vegetables 5 to 8 minutes, turning occasionally, until tender. Grill vegetables in batches, if necessary, and remove as soon as tender to avoid burning.

5 Return vegetables to marinade in bowl, tossing to coat. Transfer to a serving platter and sprinkle with goat cheese, if desired.

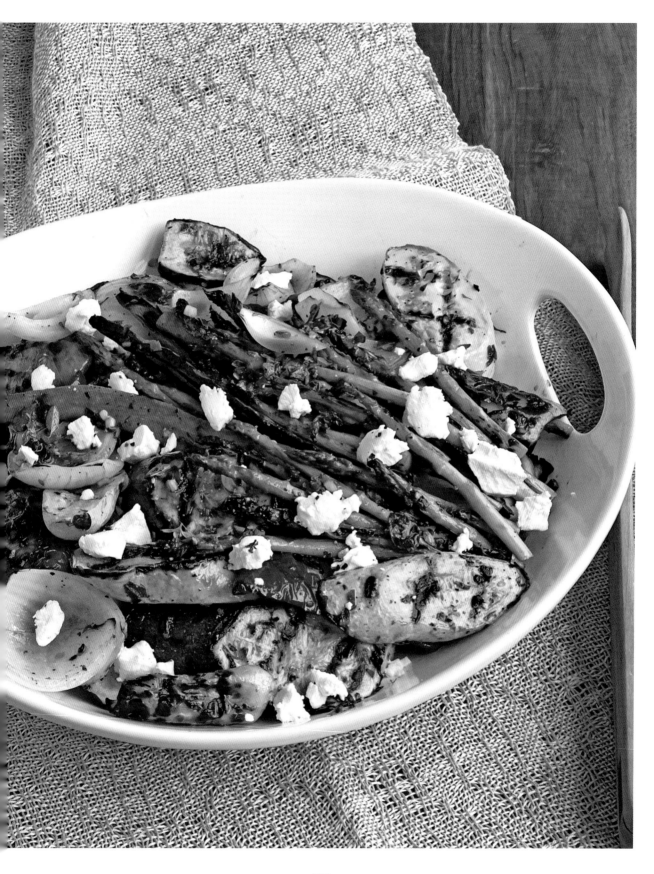

BAKED TOMATOES ROCKEFELLER

MAKES 8 SERVINGS

I found this one in a stash of old family recipes that spanned decades and was given to my mother, Helen, by her sister, Julia Ann Krallman Miller. It's a riff on the popular oysters Rockefeller appetizer named after the famously wealthy John D. Rockefeller. One of John's grandsons, Winthrop Rockefeller, became Governor of Arkansas in 1967. Since my mother's family was raised in Little Rock, I can imagine that they connected with the history of the name.

8 small ripe tomatoes (on the vine or Campari)

1 (9- to 10-ounce) package chopped frozen spinach, thawed

3 green onions, chopped

1 small garlic clove, minced

4 tablespoons salted or unsalted butter, melted

3 large eggs, slightly beaten

¼ teaspoon Worcestershire sauce

¼ teaspoon hot sauce

½ teaspoon salt

1 teaspoon fresh or ¼ teaspoon dried thyme

½ teaspoon coarsely ground black pepper

¾ cup seasoned dry breadcrumbs

½ cup grated Parmesan cheese

Butter

1 Slice tomatoes in half; remove seeds and liquid, and place on paper towels to drain.

2 Drain spinach well in a fine colander, pressing down to remove excess water. Transfer to a bowl, and stir in green onions, garlic, melted butter, eggs, Worcestershire, hot sauce, salt, thyme, black pepper, breadcrumbs, and cheese.

3 Preheat oven to 350°. Lightly grease (with butter) a 9x13-inch (3-quart) baking dish.

4 Arrange tomatoes in prepared dish. Spoon spinach mixture evenly on top of each tomato slice.

5 Bake for 20 to 25 minutes or until golden brown and heated through.

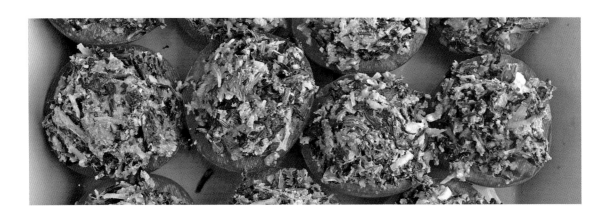

CREAMED SPINACH

MAKES 6 TO 8 SERVINGS

2 (12-ounce) packages frozen chopped spinach

¼ cup (4 tablespoons) salted or unsalted butter

2 tablespoons all-purpose flour

1 cup milk or half-and-half

1 (8-ounce) package cream cheese, cut into pieces

1 teaspoon salt

1 teaspoon hot sauce

½ cup grated Parmesan cheese, divided

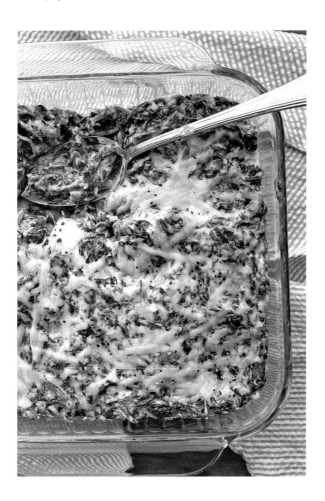

Serve this easy side dish with grilled steaks or barbecued chicken. The ingredients have a long life in the fridge and freezer, so you can keep them stocked for spontaneous cookouts. If you prefer, skip the flour or substitute a gluten-free version. The texture will be a little different, but the flavor will be just as rich and delicious.

1 Thaw chopped spinach and drain in a colander, pressing with a spoon and squeezing to remove excess liquid. Set aside.

2 Preheat oven to 350°. Lightly grease (with butter) an 8x8-inch (2-quart) baking dish.

3 Melt butter in a large skillet over medium-high heat. Add flour and cook for 1 minute, stirring constantly. Whisk in milk. Reduce heat to medium-low.

4 Add cream cheese, whisking until smooth. Stir in salt and hot sauce. Stir in spinach and half of cheese.

5 Spoon into prepared baking dish and sprinkle with remaining cheese. Bake for 30 minutes or until hot and bubbly.

BAKED PINEAPPLE

MAKES 6 SERVINGS

2 (20-ounce) cans pineapple chunks or tidbits, undrained

⅓ cup granulated sugar

½ all-purpose flour

1½ cups (6 ounces) shredded cheddar cheese

1 cup crushed round buttery crackers

¼ cup salted or unsalted butter, melted

From fruit imported from the Caribbean, the canned pineapple industry began in Baltimore in the 1860s. James Dole founded Dole's Hawaiian Pineapple Company in 1903; by 1930, Hawaii led the world market. Later, Del Monte, followed by Dole and other canneries, expanded its operations in the Philippines, Thailand, and eventually Central America. By 2007, all canneries in Hawaii had closed; however, fresh pineapples are still grown primarily for limited markets. This sweet-and-tangy side dish featuring canned pineapple tastes great with pork dishes like baked ham, pork chops, or pork tenderloin. It also pairs well with spicy grilled chicken breasts.

1. Preheat oven to 350°. Lightly grease (with butter) an 8x8-inch (2-quart) baking dish.

2. Drain pineapple, reserving ½ cup liquid. Combine reserved liquid, sugar, and flour in a large bowl. Stir in pineapple and cheese.

3. Combine crumbs and butter; sprinkle over pineapple mixture. Bake for 35 to 45 minutes or until golden brown and bubbly.

WILD RICE PILAF

MAKES 6 SERVINGS

3 tablespoons salted or unsalted butter, divided

¼ cup finely chopped shallot or yellow onion

4 cups vegetable or chicken broth

1 teaspoon salt

½ teaspoon coarsely ground black pepper

2 cups wild rice, rinsed

⅓ cup dried cranberries

½ cup chopped toasted pecans

4 green onions or chives, sliced

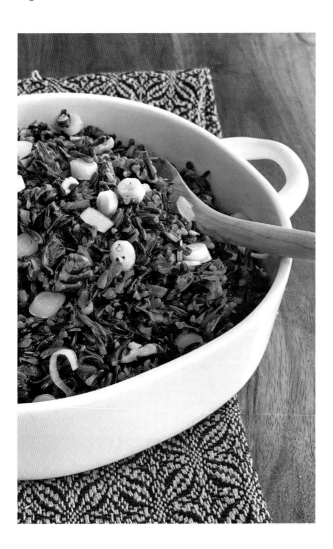

Wild rice isn't closely related to white rice. It's the seed of an aquatic grass that grows naturally in lakes in Minnesota, Wisconsin, and Canada, although much of the cultivated wild rice is grown in California. Wild rice has a chewy texture and, when fully cooked, has the appearance of being burst open. If it's difficult to find in your grocery store, order it online or substitute a blend of wild and other types of rice. Note that blends may take less time to cook.

1 Melt 2 tablespoons butter in a saucepan over medium heat. Add shallot and cook, stirring frequently, for 3 to 5 minutes or until tender. Stir in broth, salt, pepper, wild rice, and cranberries.

2 Bring to a boil. Reduce heat to low and simmer, covered, for 55 to 65 minutes or until rice is tender.

3 Remove from heat. Add remaining 1 tablespoon butter and stir until melted and well blended. Stir in pecans and green onions or chives.

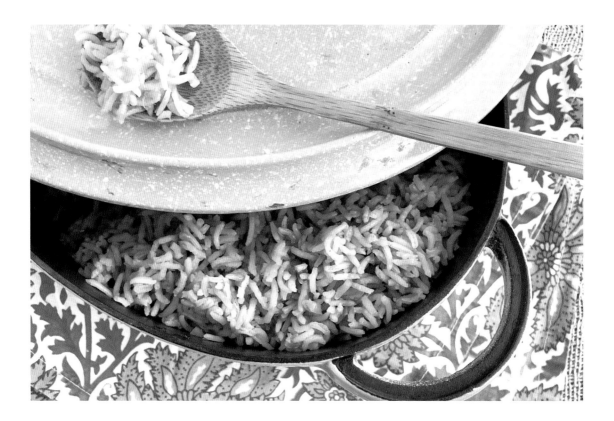

BAKED YELLOW RICE

MAKES 4 TO 6 SERVINGS

2 tablespoons salted or
 unsalted butter

½ sweet onion, minced

1 cup jasmine or basmati rice

2 garlic cloves, minced

1 teaspoon turmeric

½ teaspoon salt

2 cups chicken broth

I've always been a fan of hands-free rice cooking because I can walk away and not worry about scorching. Most of the time I use my beloved rice cooker; however, when adding sautéed vegetables and other flavors, I like to bake rice in the oven. Give this simple recipe a Moroccan twist by stirring in ½ teaspoon ground cumin and ¼ teaspoon ground cinnamon with the turmeric.

1 Preheat oven to 350°.

2 Melt butter in a Dutch oven, cassoulet pan, or ovenproof pot over medium-high heat. (You can also sauté ingredients in a skillet, then transfer to an 8x8-inch [2-quart] baking dish.)

3 Add onion and cook, stirring frequently, for 5 minutes or until tender. Add rice, garlic, turmeric, and salt. Cook, stirring constantly, for 3 minutes.

4 Stir in broth. Cover with lid and transfer to oven. Bake for 25 minutes. Let stand for 5 minutes. Uncover and fluff with a fork.

BEEFY BARBECUE BAKED BEANS

MAKES 12 SERVINGS

1 pound lean ground beef

6 slices thick-cut bacon, chopped

1 onion, chopped

¾ cup prepared barbecue sauce

2 tablespoons prepared Dijon mustard

2 tablespoons molasses

1 tablespoon chili powder

½ teaspoon salt

½ teaspoon coarsely ground
black pepper

1 (16-ounce) can red kidney beans, rinsed
and drained

1 (16-ounce) can black beans, rinsed
and drained

1 (16-ounce) can cannellini, butter,
Great Northern, or navy beans, rinsed
and drained

Garnish: chopped fresh parsley

This hearty, protein-packed side dish can be made into a sloppy joe-style sandwich if spooned between slices of a toasted burger bun.

1 Preheat oven to 350°.

2 Cook beef, bacon, and onion in a Dutch oven, cassoulet pan, or large ovenproof pot for 10 to 12 minutes or until beef is browned and bacon is cooked. Drain any excess drippings, if desired.

3 Stir in barbecue sauce, mustard, molasses, chili powder, salt, and pepper. Stir in beans.

4 Cover and bake for 45 minutes to 1 hour or until thoroughly heated. Garnish, if desired.

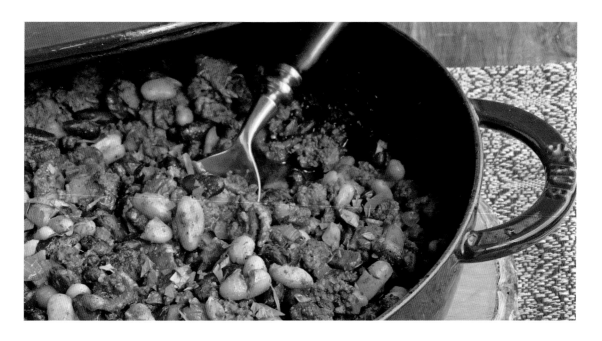

CRISPY SMASHED POTATOES

MAKES 4 SERVINGS

1 pound small yellow or baby
 red potatoes

3 tablespoons extra-virgin olive oil

1 teaspoon fine sea salt

½ teaspoons garlic powder

½ teaspoon coarsely ground
 black pepper

1 teaspoon chopped fresh rosemary

3 tablespoons shredded Parmesan
 cheese (optional)

The double cooking process—boiling, then finishing in a very hot oven—ensures this delicious side dish is super crispy on the outside while tender in the middle. The potatoes need to be about the same size for even cooking. If using regular-sized yellow or red potatoes, cut in half before cooking. Yukon Gold potatoes are a cross between yellow and white potatoes and all can be substituted, including red, in this recipe.

1 Preheat oven to 450°. Brush a large, rimmed baking sheet with olive oil or line with nonstick aluminum foil.

2 Cook potatoes in boiling water to cover for 15 to 17 minutes or until potatoes are tender when pierced with a knife (but not cooked so much they fall apart). Drain in a colander until surface is dry.

3 Combine oil, salt, garlic powder, pepper, and rosemary in a bowl. Add cooked potatoes, tossing to coat. Place potatoes, evenly spaced, on prepared baking sheet. Using a heavy mug or canning jar, press the potatoes firmly until evenly flat and about ¼-inch thick. Drizzle with any remaining oil mixture left in the bowl.

4 Bake for 20 minutes or until golden brown and crispy. For extra crispness, turn potatoes over halfway through cooking. Sprinkle with Parmesan cheese, if desired. Bake for 2 or 3 minutes or until cheese melts.

RUSTIC ROASTED GARLIC MASHED POTATOES

MAKES 8 SERVINGS

1 head garlic

2 teaspoons extra-virgin olive oil

2 pounds russet or white potatoes

2 pounds large red or yellow potatoes

8 tablespoons salted or unsalted butter, cut into pieces

1 cup heavy cream, at room temperature

2 teaspoons salt, plus more to taste

½ teaspoon coarsely ground black pepper, plus more to taste

1 tablespoon chopped fresh chives

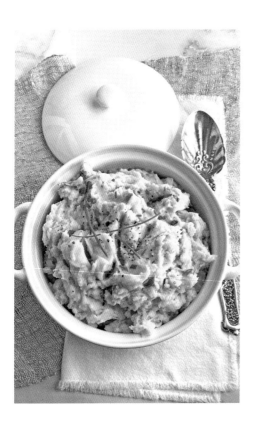

Earthy roasted garlic adds rich flavor to this chunky, homestyle mashed-potato side dish. Using a mix of starchy (russet or white) and waxy (red or yellow) potatoes creates a creamy-yet-light texture. If you want to use just one kind, all-purpose Yukon Golds are a cross between white/starchy and yellow/waxy. Many mashed-potato recipes call for boiling potatoes, but if the oven is on for the roasted garlic, I prefer to cook them all together. There's less cleanup too! You may need to remove smaller potatoes if larger ones are not cooked through and tender. A fully baked potato is about 210° in the center. (You can use that instant-read thermometer for more than just meat!)

1 Preheat oven to 400°.

2 Remove excess papery skin from outside of garlic head, but do not completely peel. Slice garlic in half and place in center of a medium-size square of heavy-duty aluminum foil or two sheets of regular foil. Drizzle oil over and around cut sides of garlic, and put cut halves back together.

3 Scrub potatoes and pat dry. Pierce several times with a fork. Place potatoes on oven rack alongside garlic. Bake for 40 minutes or until garlic is golden brown and center is very tender. Remove garlic from oven and set aside until cool enough to handle. Squeeze garlic cloves into a large bowl, discarding peel.

4 Continue to bake potatoes for 15 to 20 minutes or until center is very tender. Remove from oven. Carefully cut into large chunks and add to garlic, using tongs. Add butter to potato mixture.

5 Partially mash potatoes with a potato masher. Add cream and continue to mash until fluffy with an even texture. Stir in salt and pepper. Transfer to a serving bowl, and sprinkle with chives.

CHEESY SCALLOPED POTATOES

MAKES 8 SERVINGS

2 tablespoons butter

1 large shallot, minced

3 garlic cloves, minced

1 tablespoon chopped fresh rosemary, thyme, and/or sage

2 teaspoons sea salt

1 teaspoon cracked black pepper

2 pounds thinly sliced (⅛-inch-thick) russet or white potatoes

2 cups heavy cream

1 cup whole milk

1 cup (4 ounces) shredded Gruyère or other cheese

½ cup (2 ounces) grated Parmesan cheese

This dish has found a permanent spot on our holiday table when the main dish doesn't have gravy (because that's for mashed potatoes)! Starchy potatoes like russet or all-purpose ones like Yukon Gold or white are good choices in this recipe. The flavor is a bit more interesting with a mix of herbs. Just use whatever combination you like, as long as it all measures 1 tablespoon. You can also use dried herbs, but scale down to a total of 1 teaspoon. Dried herbes de Provence is a tasty choice.

1 Preheat oven to 400°. Lightly grease (with butter) a 2½- to 3-quart baking dish. Melt butter in a large skillet or saucepan over medium-high heat. Add shallot and garlic; sauté for 5 to 7 minutes or until tender. Stir in rosemary, salt, and pepper.

2 Add potatoes, cream, and milk to garlic mixture, stirring gently to combine. Bring mixture to a boil, reduce heat, and simmer, uncovered, for 10 to 15 minutes or until potatoes are barely tender. (Do not overcook. Potatoes will be pliable but not fully cooked.)

3 Spoon half of mixture into prepared baking dish. Sprinkle with half of cheeses. Top with remaining potatoes; sprinkle with remaining cheeses.

4 Bake for 20 minutes or until potatoes are tender and top is golden brown.

CORN CASSEROLE

MAKES 6 SERVINGS

1 (15.25-ounce) can corn, rinsed and drained

1 (14.75-ounce) can creamed corn, undrained

1 cup sour cream

½ cup salted or unsalted butter, melted

2 large eggs

1 (8.5-ounce) package corn muffin mix

Jiffy corn muffin mix was created in 1930, and its iconic corn casserole has graced family dinner tables for decades. While I generally prefer the flavor of freshly picked-and-shucked corn, this recipe transports me and anyone in my generation to backyard reunions and potluck get-togethers. The recipe also gets points for being a simple spur-of-the-moment side dish because the ingredients are shelf-stable or can stay in the refrigerator for weeks.

1 Preheat oven to 350°. Lightly grease (with butter) an 8x8-inch (2-quart) baking dish.

2 Combine corn, creamed corn, sour cream, butter, and eggs in a bowl. Stir in corn muffin mix.

3 Spoon into prepared baking dish. Bake for 45 to 50 minutes or until golden brown and cooked through.

Note: If you don't have packaged muffin mix or it's not available, you can make your own. Combine **⅔ cup all-purpose flour, ½ cup yellow cornmeal, ¼ cup granulated sugar, 1 tablespoon baking powder,** and **¼ teaspoon salt in a bowl. Stir in 2 tablespoons vegetable oil.** Makes about 1 cup.

SQUASH CASSEROLE

MAKES 8 SERVINGS

6 strips bacon, chopped

1 small onion, finely chopped

2 garlic cloves, minced

⅛ teaspoon crushed red pepper flakes

2 pounds yellow squash, sliced

2 large eggs

1 cup sour cream

½ teaspoon salt

½ teaspoon coarsely ground
 black pepper

1½ cups (12 ounces) shredded
 cheddar cheese

1 sleeve round buttery crackers, crushed

3 tablespoons butter, melted

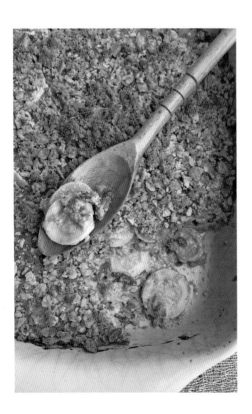

Anyone with a successful garden understands that when you grow squash, you end up growing a lot! This side dish is enough to feed company but will also keep well a few days in the fridge. Growing zucchini? No worries—just substitute that bountiful vegetable. Bacon adds a lot of flavor, but vegetarians can skip it. For that bit of smoky flavor, skip the meat and add about ¼ teaspoon smoked paprika with the pepper.

1 Preheat oven to 350°. Lightly grease (with butter) a 9x13-inch (3-quart) baking dish.

2 Cook bacon and onion in a skillet over medium heat until bacon starts to crisp and onion is tender. Add garlic and red pepper flakes; cook for 1 minute. Add squash; cover and cook for 10 minutes.

3 Whisk together eggs, sour cream, salt, and pepper in a large bowl. Fold in cheese. Stir squash mixture into cheese mixture. Pour into prepared baking dish.

4 Combine crumbs and butter in a small bowl; sprinkle evenly over casserole.

5 Bake for 30 minutes or until golden brown and bubbly.

SWEET POTATO CASSEROLE

MAKES 10 SERVINGS

3½ to 4 pounds sweet potatoes
(about 4 extra large)

4 large eggs, lightly beaten

1 cup whole milk

¼ cup unsalted or salted butter, melted

1 teaspoon salt

1 teaspoon vanilla extract

Pecan Topping (recipe at right)

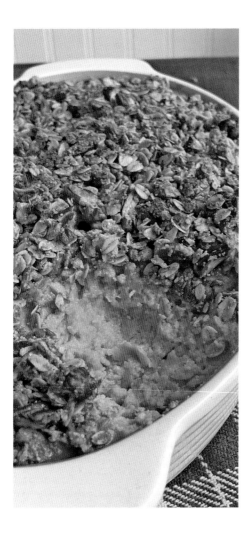

Some sweet potato dishes are so sweet, they are really a dessert. This recipe has a sweet topping but relies on the sweet potatoes' natural sugars rather than adding granulated or brown sugar (you can add some, if you wish!).

1 Peel sweet potatoes and cut into 1-inch cubes. Place in a large saucepan or soup pot, and add water to cover by at least 1 inch. Bring to a boil over medium-high heat. Reduce heat and simmer for 10 minutes or until tender.

2 Drain potatoes and return to pan. Add eggs, milk, butter, salt, and vanilla. Mash with a potato masher. Transfer to a lightly greased (with butter) 9x13-inch (3-quart) baking dish.

3 Sprinkle Pecan Topping evenly over top. Cover and refrigerate until ready to bake.

4 Preheat oven to 350°. Remove casserole from refrigerator and let stand while oven preheats.

5 Bake for 45 to 60 minutes or until thoroughly heated and center reaches 160° when measured with an instant-read thermometer. If topping begins to brown too much, cover lightly with aluminum foil.

Pecan Topping: Combine **1 cup chopped pecans, 1 cup old-fashioned oats, 2 tablespoons firmly packed light brown sugar, ⅓ cup all-purpose flour or almond flour, ¾ teaspoon ground cinnamon, ¼ teaspoon salt,** and **¼ cup melted salted or unsalted butter** in a small bowl. Makes 1½ cups.

BAKED FOUR-CHEESE MACARONI

MAKES 8 TO 10 SERVINGS

2 cups (8 ounces) shredded sharp cheddar cheese

1 cup (4 ounces) shredded Gouda, provolone, or Monterey Jack cheese

½ cup (2 ounces) shredded Parmesan cheese

½ cup salted butter

¼ cup all-purpose flour

½ teaspoon salt

½ teaspoon coarsely ground black pepper

½ teaspoon garlic powder

¼ teaspoon cayenne pepper

2 cups vegetable or chicken broth

2 cups milk or half-and-half

1 (8-ounce) package cream cheese, cut into pieces

1 (16-ounce) package macaroni, penne, or other short pasta

⅓ cup panko breadcrumbs

> If you want to please any crowd—vegetarians included—just serve this delicious macaroni and cheese! There are a number of ways to personalize it, using your favorite kinds of cheeses and crumb toppings.

This crispy-topped and creamy-centered macaroni and cheese features four cheeses that take the company-size side dish to the next level. Use a variety of your favorite cheeses—smoked Gouda is lovely! Grate from large pieces rather than buying packaged shredded cheese because those contain starches that keep them from clumping and melting well. It's okay to skip the topping and eat the dish before baking, but you'll miss the golden-brown crust. Instead of panko, feel free to try cheese crackers as a variation.

1 Preheat oven to 350°. Lightly grease (with butter) a 9x13-inch (3-quart) baking dish. Toss cheddar, Gouda, and Parmesan together in a small bowl. Reserve ½ cup shredded cheese mixture.

2 Melt butter in a large skillet or saucepan. Whisk in flour, salt, black pepper, garlic powder, and cayenne pepper. Cook, whisking constantly, for about 1 to 2 minutes. Whisk in broth and milk until smooth. Cook, whisking constantly, for 5 minutes or until thickened. Stir in cream cheese; cook until smooth. Stir in all but reserved ½ cup shredded cheese mixture; cook, stirring frequently, until smooth.

3 Cook pasta according to package directions; drain and transfer to prepared baking dish.

4 Pour sauce over pasta, stirring until well blended. Stir panko into reserved ½ cup cheese mixture; sprinkle over pasta mixture. Bake, uncovered, for 25 to 30 minutes or until golden brown.

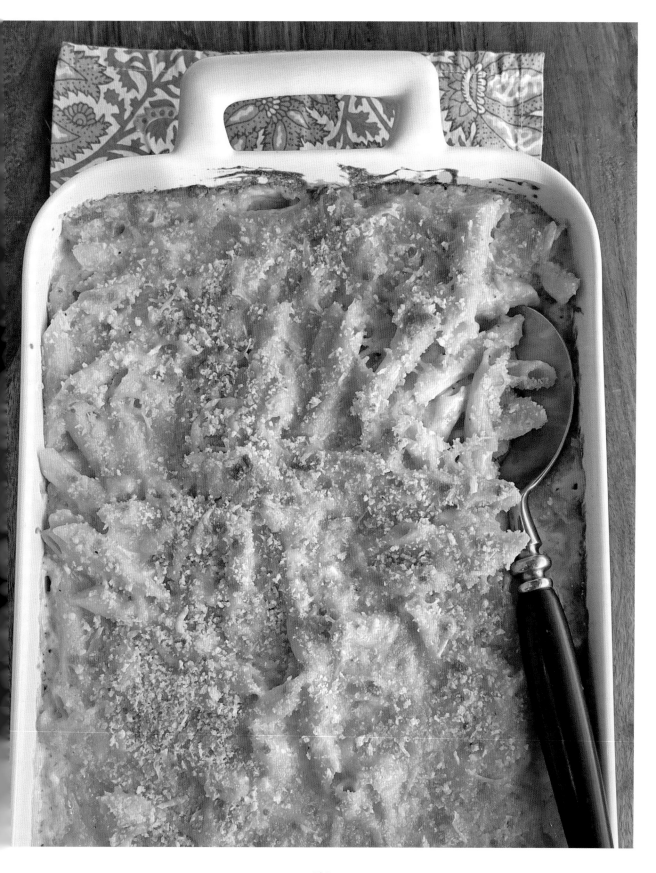

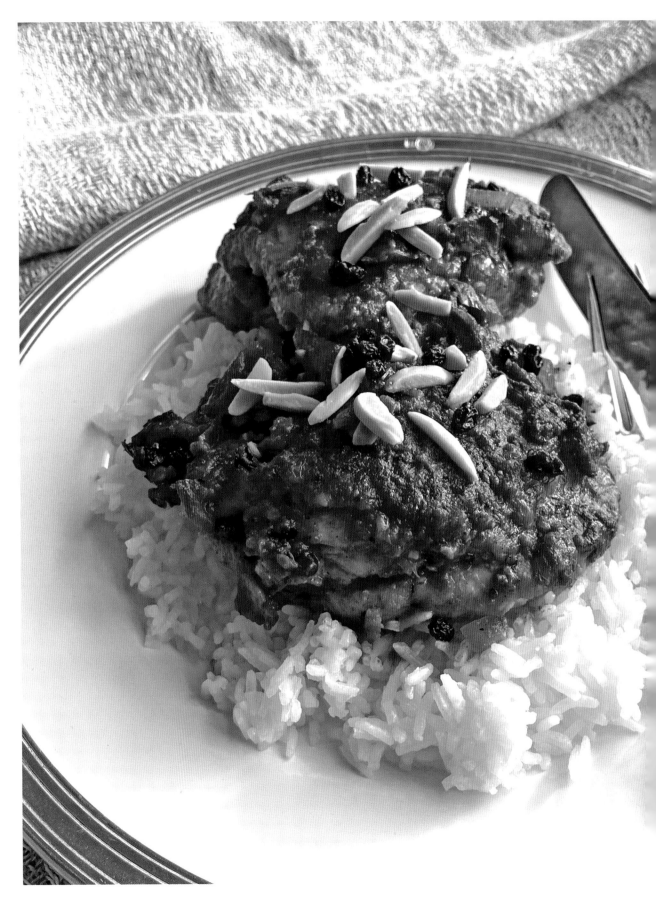

MAINS

125

128

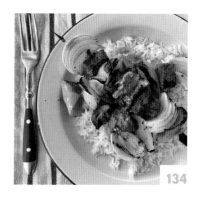

134

127

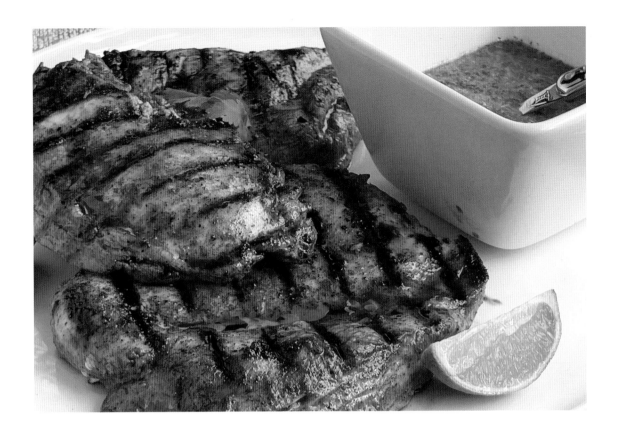

GRILLED CHILI-LIME CHICKEN

MAKES 4 SERVINGS

¼ cup extra-virgin olive oil

1 teaspoon chili powder

1 teaspoon ground cumin

1 teaspoon salt

1 teaspoon firmly packed
 brown sugar

½ teaspoon lime zest

2 to 3 teaspoons fresh lime juice

4 boneless, skinless chicken thighs
 or breasts

Chimichurri Sauce (optional; recipe on
 page 105)

Garnish: lime wedges, fresh
 cilantro sprigs

Slicing each chicken breast in half lengthwise creates two cutlets that will cook faster and more evenly than one large, thick-on-one-side breast.

1 Combine olive oil, chili powder, cumin, salt, brown sugar, lime zest, and juice in a zip-top plastic storage bag or baking dish.

2 Slice chicken breasts in half horizontally to create two flat cutlets each. Place in marinade, tossing to coat. Refrigerate for 30 minutes.

3 Preheat grill to medium heat. Remove chicken from marinade. Grill for 3 to 4 minutes on each side or until cooked through. Serve with Chimichurri Sauce, and garnish, if desired.

CHIMICHURRI SAUCE

MAKES ⅔ CUP

Chimichurri is a South American condiment that's delicious over grilled steak or rich, fatty fish like salmon (see page 123). It doesn't traditionally include cilantro, but I enjoy the addition. I'll also mix it up by adding fresh oregano, depending on what herbs are growing well in the garden. Use a food processor with a small bowl, if possible, because this is a small batch. If you prefer, you can finely chop all the ingredients.

¼ cup extra-virgin olive oil

3 tablespoons red wine vinegar

2 cups fresh cilantro and parsley (about half a bunch each)

1 garlic clove, coarsely chopped

½ teaspoon salt

⅛ crushed red pepper flakes

Combine oil, vinegar, cilantro, garlic, salt, and red pepper flakes in a small food processor. Process until finely chopped, scraping down sides of processor with a spatula, if necessary.

SMOKY BARBECUE SAUCE

MAKES 1¾ CUPS

1 cup tomato sauce

⅓ firmly packed light brown sugar

⅓ cup red wine vinegar

¼ cup molasses

2 tablespoons Worcestershire sauce

2 tablespoons yellow mustard

1 teaspoon liquid smoke

1 tablespoon chili powder

½ teaspoon smoked paprika

½ teaspoon garlic powder

½ teaspoon coarsely ground black pepper

1 teaspoon salt

A bit of liquid smoke is the secret to this yummy recipe's outdoorsy flavor. It's rich enough to make a delicious topping for beef or pork ribs and light enough to enhance (not overpower) grilled chicken. You can even spoon a bit into cooked ground beef for a zesty sloppy joe filling.

1 Combine tomato sauce, brown sugar, vinegar, molasses, Worcestershire, mustard, liquid smoke, chili powder, paprika, garlic powder, pepper, and salt in a saucepan over medium heat.

2 Bring to a boil, reduce heat, and simmer for 5 to 8 minutes or until mixture is reduced and slightly thickened (sauce should be thick enough to coat a spoon).

SPATCHCOCK CHICKEN

MAKES 4 TO 6 SERVINGS

1 (4½- to 5-pound) whole chicken

¼ cup unsalted or salted butter, softened

3 garlic cloves, minced

1½ teaspoons salt

1 teaspoon lemon zest

½ teaspoon coarsely ground black pepper

1 tablespoon chopped fresh herbs, such as rosemary and thyme

Once I tried roasting spatchcock chicken, I vowed I wouldn't cook a whole chicken any other way. Spatchcocking is a way of butterflying a whole, bone-in chicken. By removing the backbone, the chicken can be opened up and cooked relatively flat. This way, the chicken cooks more evenly and the breast meat doesn't overcook. I will occasionally take the chicken out of the oven, adjust the racks, and broil about 5 inches from heat for about 2 minutes to get the skin extra crispy and golden. This technique works for any size chicken, but adjust the timing and check with a meat thermometer if roasting a smaller or larger bird.

1 Remove neck and gizzards from inside of chicken. Place chicken, breast side down, on a cutting board. Using kitchen shears or a sharp knife, cut out backbone on both sides and discard. Turn chicken over, open back, and press down firmly in center to flatten chicken. Transfer to a shallow roasting pan or extra-large cast-iron skillet. Blot skin with paper towels to dry .

2 Combine butter, garlic, salt, zest, pepper, and herbs in a small bowl. Separate skin on breast and legs using fingers, and spread a little more than half of butter mixture under skin. Rub remaining butter mixture over entire top. Let stand until oven is preheated.

3 Preheat oven to 450°.

4 Roast chicken for 40 minutes or until cooked through and a meat thermometer reads 165° when inserted into thigh. Let chicken rest for 10 minutes before carving.

SPICY ORANGE–GLAZED CHICKEN

MAKES 6 SERVINGS

1 cup orange juice

1 tablespoon Mexican seasoning or ground cumin, divided

2 teaspoons minced chipotle peppers in adobo sauce, divided

1½ teaspoons salt, divided

6 boneless or bone-in chicken breasts

1 cup orange marmalade

3 tablespoons rice wine or balsamic vinegar

¼ teaspoon coarsely ground black pepper

Green onions or chopped chives

Chipotle peppers give the sweet sauce smoky heat; use less or more, depending on how spicy you like your food. This is also an amazing sauce for pork tenderloin. You can grill, use a grill pan, or simply bake the chicken or pork. The sauce goes well with side dishes like broccoli and rice.

1 Combine orange juice, 2 teaspoons seasoning blend, 1 teaspoon chipotle peppers, and 1 teaspoon salt in a large shallow bowl or large zip-top plastic storage bag. Add chicken, tossing to coat. Cover or seal; chill for at least 2 hours.

2 Preheat grill to medium-high heat (350° to 400°).

3 Combine marmalade, vinegar, remaining 1 teaspoon seasoning blend, remaining 1 teaspoon chipotle peppers, remaining ½ teaspoon salt, and black pepper in a saucepan over medium heat. Cook, stirring frequently, for 1 to 2 minutes or until well blended. Stir in onions.

4 Remove chicken from marinade, discarding marinade. Grill, with lid closed, for 5 to 8 minutes on each side or until chicken is done. Serve with sauce.

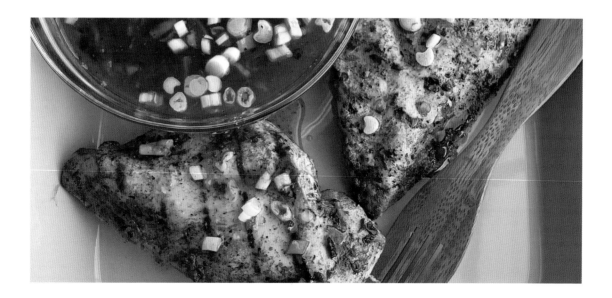

CHICKEN À LA FRANÇAISE

MAKES 3 TO 6 SERVINGS

½ cup all-purpose flour

1½ teaspoons salt

½ teaspoon coarsely ground black pepper

3 large eggs

3 tablespoons milk or water

3 large boneless, skinless chicken breasts (about 2 pounds)

3 tablespoons salted or unsalted butter, divided

1 lemon, sliced

¼ cup extra-virgin olive or avocado oil, divided

½ cup white wine

1 cup chicken broth or Quick Chicken Broth (page 44)

1 tablespoon fresh lemon juice

2 tablespoons chopped fresh parsley

This entrée, suitable for both an easy weeknight meal and an elegant dinner party, is simply chicken breasts breaded with flour and eggs, quickly sautéed, then finished with a lemon sauce. It is very similar to piccata, but the egg-and-flour coating is reversed and it is served without capers. It's okay to end up with several pieces of chicken, as they may come apart when you split them in half and remove any tendons or fat. The key is even thinness—the pieces, no matter how wide, should be about ¼-inch thick to cook quickly.

1. Place flour, salt, and pepper in a shallow bowl; set aside, reserving 1 tablespoon flour mixture. Beat eggs and milk in another shallow bowl until well blended. Set aside.

2. Slice each chicken breast in half lengthwise to create two thin pieces. Place chicken pieces on a cutting board and cover with plastic wrap. Pound with a meat mallet until ¼-inch thick.

3. Melt 1 tablespoon butter in a large skillet over medium heat. Add lemon slices, and cook for 1 to 2 minutes. Remove from pan and set aside (no need to wipe clean).

4. Heat 2 tablespoons oil in skillet over medium-high heat. Dredge half of chicken in flour mixture and then dip in egg mixture, allowing excess egg to drain off.

5. Add chicken to hot oil in a single layer. Cook for 1 to 2 minutes on each side or until golden brown and cooked through. Transfer to a platter; cover with aluminum foil to keep warm. Repeat with remaining 2 tablespoons oil, chicken, flour mixture, and egg mixture.

6. Add remaining 2 tablespoons butter to skillet and heat over medium-high heat until butter melts (no need to wipe clean). Add reserved 1 tablespoon flour mixture and cook, stirring constantly, for 1 minute. Add wine, scraping bottom of skillet to loosen any bits. Cook for about 1 minute or until wine is almost evaporated. Stir in broth and lemon juice. Cook, stirring occasionally, for 4 minutes or until sauce is slightly thickened.

7. Return chicken and lemon slices to skillet. Cover and cook over medium-low heat for 3 to 4 minutes or until chicken is hot and cooked through. Sprinkle with reserved lemon slices and parsley.

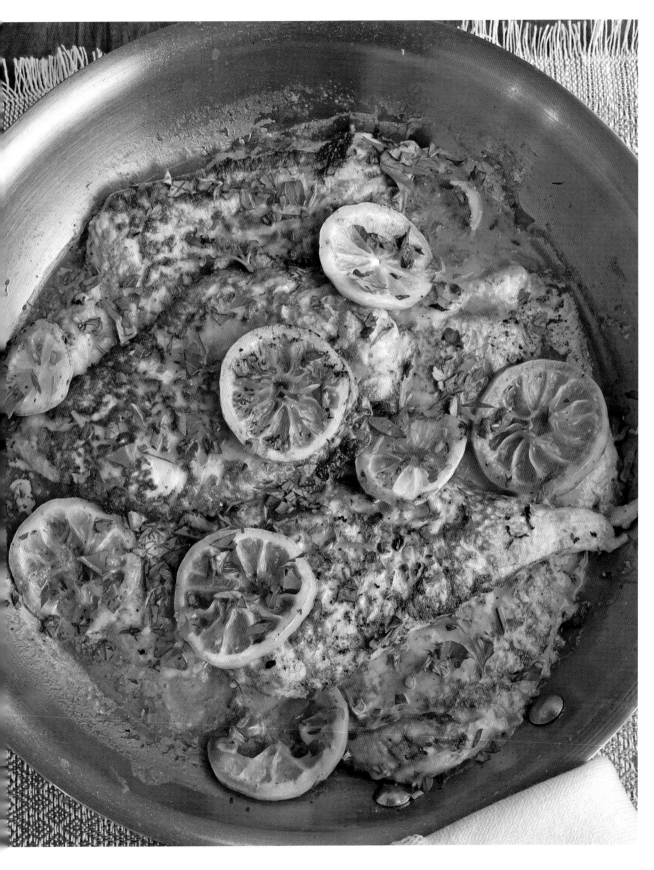

CREAMY TOMATO-AND-BASIL CHICKEN

MAKES 4 SERVINGS

1½ to 1¾ pounds boneless, skinless chicken breasts

1 teaspoon salt

¼ teaspoon coarsely ground black pepper

2 tablespoons olive oil, divided

2 large garlic cloves, minced

¼ teaspoon crushed red pepper flakes

⅓ cup white wine

¾ cup chicken broth or Quick Chicken Broth (page 44)

1 cup heavy whipping cream

½ cup sun-dried tomatoes

½ cup shredded Parmesan cheese

¼ cup slivered or chopped fresh basil

Hot cooked pasta

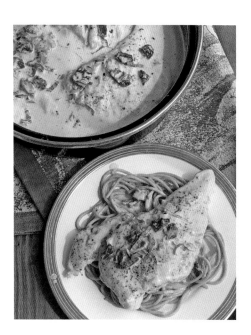

Sun-dried tomatoes have a deep earthy flavor and lovely chewy texture. You can find them packed in oil or dried in pouches. Either one works, but drain oil-packed tomatoes well. Try to select breasts that are not oversized. If you do get a package with chicken breasts thicker than 1 inch, butterfly cut the thick part or cut the entire breast in half lengthwise to create 2 thin breasts. Thinner chicken pieces will cook evenly and be more tender than very thick ones.

1 Pound chicken lightly with a meat mallet or rolling pin so each piece is an even thickness. Sprinkle evenly on both sides with salt and pepper.

2 Heat 1 tablespoon oil in a large skillet over medium-high heat. Add half of chicken and cook for 2 minutes on each side or until golden brown. Transfer to a plate and cover. Repeat with remaining 1 tablespoon oil and chicken. Remove chicken and set aside, reserving oil in skillet.

4 Add garlic and red pepper flakes to skillet. Cook over medium heat for 30 seconds to 1 minute, stirring constantly. Stir in wine and cook, stirring constantly, until evaporated. Stir in broth, cream, sun-dried tomatoes, and Parmesan cheese. Cook, stirring frequently, over medium heat for 2 minutes or until cheese melts and mixture is slightly thickened.

5 Add reserved chicken to sauce mixture. Cook chicken in sauce for 5 minutes or until heated through. Stir in half of basil. Serve with hot cooked pasta, and sprinkle with remaining basil.

BUTTERMILK FRIED CHICKEN

MAKES 6 SERVINGS

3 cups buttermilk

½ teaspoon ground cayenne pepper

2½ teaspoons salt, divided

1½ teaspoons coarsely ground black pepper, divided

4 pounds bone-in chicken pieces

2½ cups all-purpose flour

2 tablespoons paprika

2 teaspoons garlic powder

1 teaspoon onion powder

Vegetable oil

Garnishes: chopped fresh herbs, green onions, fried onions

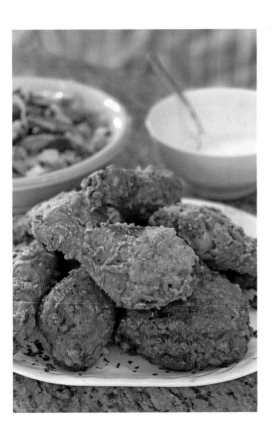

A spiced-up buttermilk marinade adds flavor and tenderness to bone-in chicken. After the chicken is done, I like to add thinly sliced onions to the leftover buttermilk, then flour and fry them while the oil is still hot. The fried onions are delicious on the side, or you can save some as a crispy topping for salads. The Hot Honey sauce on page 112 makes a nice accompaniment.

1 Pour buttermilk into a large, nonmetal bowl. Stir in cayenne pepper, ½ teaspoon salt, and ½ teaspoon black pepper. Add chicken, tossing to coat. Cover and chill for 8 hours or overnight, turning chicken pieces occasionally. Remove chicken from refrigerator, and let stand at room temperature for 30 minutes before dredging and frying.

2 Place a wire rack on a rimmed sheet pan; place in oven. Preheat oven to 200°.

3 Combine flour, paprika, garlic powder, onion powder, remaining 2 teaspoons salt, and remaining 1 teaspoon black pepper in a large bowl. Set aside.

4 Pour oil to a depth of 2 to 2½ inches in a large, deep cast-iron skillet or Dutch oven. Heat oil to 350° over medium-high heat.

5 Remove chicken from buttermilk mixture, draining excess. Dredge chicken in flour mixture, shaking off excess.

6 Place chicken in oil, skin side down, in batches. Reduce heat to medium and cover. Cook for 5 minutes. Remove lid and increase heat to medium-high. Turn chicken over and cook for 10 minutes or until golden and an instant-read thermometer inserted in thickest part of each piece registers 160°. Remove chicken with tongs, allowing oil to drain, and place on rack in oven to keep warm. Repeat with remaining chicken pieces. Garnish, if desired.

PANKO-PARMESAN CHICKEN WITH HOT HONEY

MAKES 4 SERVINGS

1½ pounds boneless, skinless chicken breasts

2 tablespoons water

1 large egg white

2 teaspoons Dijon mustard

⅓ cup all-purpose flour

½ teaspoon garlic powder

½ teaspoon salt

¼ teaspoon coarsely ground black pepper

⅛ teaspoon ground cayenne pepper

1 cup panko breadcrumbs

¼ cup grated Parmesan cheese

Vegetable oil

Chopped fresh herbs (optional)

Hot Honey (recipe at right)

Here's an elevated take on classic chicken fingers that will delight all ages, as long as they enjoy a little spice! For younger children, simply omit the cayenne pepper and serve with a side of Dijon mustard instead of Hot Honey.

Pan-frying gives this chicken dish the crispiest coating, but you can also make it in the oven. To do so, lightly grease an aluminum foil-lined baking sheet with vegetable cooking spray. Place the chicken on the pan, and lightly grease the top of the chicken with cooking spray. Bake at 375° for 15 minutes or until golden brown and cooked through.

1 Preheat oven to 200°. Place a baking sheet in the oven.

2 Slice chicken breasts in half lengthwise. Place on a cutting board and pound to ¼-inch thickness.

3 Whisk together 2 tablespoons water, egg white, and Dijon mustard in a shallow bowl.

4 Stir together flour, garlic powder, salt, black pepper, and cayenne pepper in a second shallow bowl.

5 Stir together panko and Parmesan in a third shallow bowl.

6 Dip chicken in egg mixture, allowing excess to drain off. Dredge in flour mixture, shaking off excess, and then dredge in panko mixture.

7 Heat a ¼-inch layer of vegetable oil in a large skillet. Add half of breaded chicken. Cook for 2 minutes on each side or until golden brown and cooked through. Place on baking sheet in oven to keep warm. Repeat with oil and remaining breaded chicken.

8 Sprinkle with herbs, if desired, and serve drizzled with Hot Honey.

Hot Honey: Combine **⅓ cup honey, 1 tablespoon apple cider vinegar, 1 teaspoon crushed red pepper flakes,** and **1 teaspoon hot sauce** in a small bowl. Makes ½ cup.

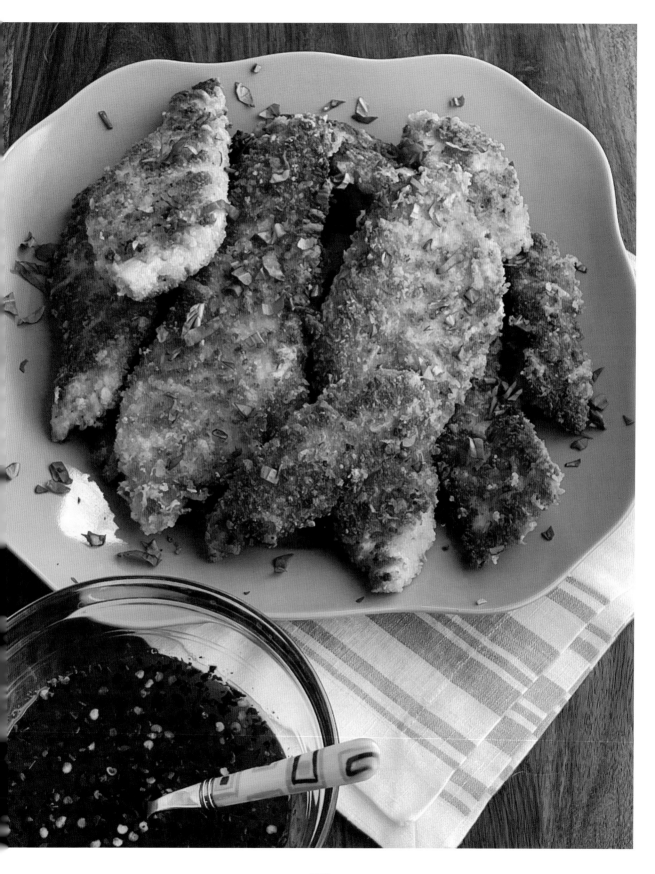

HOMEMADE CHICKEN-AND-HERB DUMPLINGS

MAKES 6 TO 8 SERVINGS

1 (7-pound) whole chicken or bone-in
 chicken pieces

3 carrots, sliced

3 celery stalks, sliced

1 small onion, chopped

2 bay leaves

2 teaspoons poultry seasoning

4 cups chicken broth or Quick Chicken Broth
 (page 44)

2 teaspoons salt, divided

1 teaspoon coarsely ground black pepper

2 tablespoons dry sherry or vermouth (optional)

1½ cups all-purpose flour

2 teaspoons baking powder

1 tablespoon fresh or 1 teaspoon
 dried thyme

3 tablespoons butter, cut into pieces

1 cup buttermilk or half-and-half

Garnish: fresh thyme sprigs

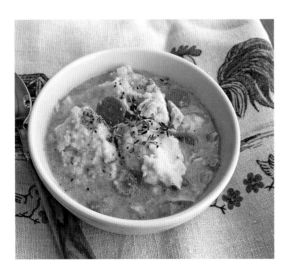

There was a time when buying a whole chicken and breaking it down was the most cost-effective way to get bone-on chicken pieces. That's not always the case now, and many markets only offer packages of breasts or thighs. No worries, though—use whatever bone-in chicken you prefer, aiming for the same amount of weight. Using only breasts will give you more meat, while using dark meat like thighs provides more flavor.

1 Cut chicken into 6 or 8 pieces with poultry scissors; remove and discard skin. Place chicken, carrots, celery, onion, bay leaves, poultry seasoning, broth, 1 teaspoon salt, and pepper in a large soup pot. Bring to a boil, reduce heat, and simmer, covered, for 30 to 40 minutes or until chicken is tender.

2 Remove from heat; remove chicken pieces from soup pot, reserving broth and vegetables. Let chicken stand until cool enough to handle. Remove chicken from bones, discarding bones, and cut meat into bite-size pieces. Stir boneless chicken and, if desired, sherry into broth mixture. Bring to a boil, reduce heat, and simmer.

3 Combine flour, baking powder, thyme, and remaining 1 teaspoon salt in a small bowl. Cut in butter with a pastry blender or fork until mixture resembles coarse meal. Add buttermilk, stirring just until mixture comes together.

4 Drop tablespoons of batter into hot broth. Cover and simmer for 15 minutes or until dumplings are cooked through. Remove and discard bay leaves. Garnish, if desired.

CHICKEN TETRAZZINI

MAKES 6 SERVINGS

According to legend, this dish was named for Luisa Tetrazzini, an Italian opera singer, sometime between 1908 and 1910 at the Palace Hotel in San Francisco. It's sometimes called "chicken spaghetti." While the original dish features chicken, it is an ideal use for leftover turkey. When dismantling the holiday bird, chop and freeze 3 cups and you'll have a great head start on dinner.

½ cup salted or unsalted butter, divided

2 (8-ounce) packages mushrooms, sliced

¾ teaspoon salt, divided

1 large onion, chopped

4 garlic cloves, minced

1 tablespoon chopped fresh or 1 teaspoon dried thyme

⅓ cup sherry or white wine

3 cups chopped or shredded cooked chicken or turkey

¾ cup frozen peas, thawed

⅓ cup all-purpose flour

3 cups half-and-half

2 cups chicken broth or Quick Chicken Broth (page 44)

½ teaspoon coarsely ground black pepper

⅛ teaspoon ground nutmeg

1 cup grated Parmesan or Romano cheese, divided

¼ cup chopped Italian parsley

1 (16-ounce) package spaghetti

½ Italian-seasoned breadcrumbs

1 Preheat oven to 400°. Lightly grease (with butter) a 9x13-inch (3-quart) casserole dish.

2 Melt 2 tablespoons butter in a Dutch oven or large, deep skillet over medium-high heat. Add mushrooms and ¼ teaspoon salt. Cook, stirring occasionally, for 7 to 10 minutes or until liquid is mostly evaporated. Reduce heat to medium. Add onion, garlic, and thyme; cook for 5 to 7 minutes or until onion is tender. Add sherry and cook for 2 minutes or until liquid is mostly evaporated. Transfer to a large bowl. Stir in chicken and peas; set aside.

3 Melt 3 tablespoons butter in the same pan (no need to wipe clean) over medium-high heat. Add flour and cook, stirring constantly, for 1 to 2 minutes (mixture will be lumpy). Wisk in half-and-half, broth, black pepper, nutmeg, and remaining ½ teaspoon salt. Bring to a boil, reduce heat to medium, and simmer for 5 minutes or until sauce thickens. Stir in ½ cup Parmesan cheese and parsley; cook for 1 to 2 minutes or until cheese melts. Stir sauce into chicken mixture.

4 Cook spaghetti in salted water according to package directions or until al dente or tender but still firm to the bite. Drain and stir into chicken-and-sauce mixture. Spoon into prepared casserole dish.

5 Combine remaining ½ cup Parmesan cheese and breadcrumbs in a small bowl; sprinkle evenly over casserole. Dot with small pieces of remaining 3 tablespoons butter.

6 Bake, uncovered, for 25 minutes or until golden brown and bubbly.

CHICKEN-AND-RICE CASSEROLE

MAKES 8 SERVINGS

3 tablespoons salted or unsalted butter

1 large onion, finely chopped

1 red, yellow, or orange bell pepper, chopped

2 garlic cloves

1½ teaspoons dried Italian seasoning

1½ teaspoons salt

½ teaspoon coarsely ground black pepper

1½ cups jasmine, basmati, or other long-grain white rice

1 cup sour cream

2 cups (8 ounces) shredded cheddar cheese

1½ to 1¾ pounds boneless, skinless chicken breasts, cut into pieces

3 cups chicken broth or Quick Chicken Broth (page 44)

This mildly flavored main dish is perfect for gatherings including kids and people with sensitive palates. I add bell pepper to keep the dish from looking too plain, but it's fine to skip for a more basic meal. There's a lot of liquid, so use a casserole with deep sides and take care when placing in the oven.

1 Preheat oven to 350°. Lightly grease (with butter) a 9x13-inch (2-inch-deep) casserole dish.

2 Melt butter in a large skillet over medium-high heat. Add onion, bell pepper, garlic, Italian seasoning, salt, and pepper. Cook, stirring occasionally, for 8 minutes or until vegetables are tender. Stir in rice, sour cream, cheese, and chicken.

3 Transfer mixture to prepared baking dish. Add broth, stirring until well blended. Cover with aluminum foil.

4 Bake for 50 minutes. Uncover and bake for 15 more minutes or until casserole is set and cooked through.

COUNTRY CAPTAIN CHICKEN

MAKES 4 TO 6 SERVINGS

½ cup all-purpose flour

1 tablespoon paprika

2 teaspoons kosher salt, divided

1½ teaspoons coarsely ground black pepper, divided

¼ teaspoon ground cayenne pepper

1 whole chicken, cut into 10 pieces (breasts cut in half) or 10 bone-in chicken thighs

¼ cup unsalted butter, divided

2 tablespoons vegetable oil, divided

1 large green bell pepper, chopped

1 large onion, chopped

⅓ cup chopped fresh parsley

3 garlic cloves, minced

1½ tablespoons curry powder

¼ teaspoon ground nutmeg

¼ cup currants or raisins, divided

1 (28-ounce) can chopped or diced tomatoes, undrained

¼ cup toasted blanched almonds

Hot cooked rice

This Lowcountry classic was featured in the Junior League of Charleston, South Carolina's cookbook, *Charleston Receipts*, in 1950. Earlier versions of the recipe appeared in the mid-1800s, and it is theorized that it was introduced to the port of Savannah, Georgia, by a captain running the spice route from India. Bone-in chicken pieces are fried, then smothered in a curry-spiced tomato gravy, with currents and almonds adding to the exotic and flavorful dish.

1 Combine flour, paprika, 1 teaspoon kosher salt, 1 teaspoon black pepper, and cayenne pepper in a shallow bowl. Trim excess fat from chicken. Dredge chicken in flour mixture, shaking off excess.

2 Melt 1 tablespoon butter with 1 tablespoon vegetable oil in a large skillet over medium heat. Add half of chicken and cook 8 minutes, turning occasionally, until golden brown on all sides. Transfer to a plate. Repeat with 1 tablespoon butter, 1 tablespoon vegetable oil, and chicken. Transfer remaining chicken to a plate. Drain excess fat from skillet. (If using in next step, drain all but 2 tablespoons.)

3 Melt remaining 2 tablespoons butter in skillet over medium heat. (You can use fat drippings from the step above, if desired.) Add bell pepper and onion. Cook, stirring occasionally, for 10 minutes. Stir in parsley, garlic, curry powder, nutmeg, remaining 1 teaspoon salt, remaining ½ teaspoon black pepper, and 2 tablespoons currants; cook, stirring occasionally, for 2 minutes. Stir in tomatoes and liquid. Cook sauce, stirring frequently, for 7 to 10 minutes.

4 Preheat oven to 325°. Spoon about 1 cup sauce into bottom of a 9x13-inch (3-quart) baking dish. Arrange chicken over sauce, then spoon remaining sauce over top. Place a piece of parchment paper over chicken, then cover with aluminum foil (so foil doesn't directly touch tomato).

5 Bake for 45 minutes. Remove parchment and foil. Bake for 15 more minutes or until chicken is cooked through and a meat thermometer inserted in thickest portion measures 165°. Remove from oven and top with remaining 2 tablespoons currants and almonds. Serve with hot cooked rice.

PHOTO ON PAGE 102

CHICKEN DIVAN CASSEROLE

MAKES 6 TO 8 SERVINGS

6 cups broccoli florets (about ¾ pound)

2 pounds boneless, skinless chicken breasts, cut into bite-size pieces

1 teaspoon fine sea salt, divided

¾ teaspoon coarsely ground black pepper

5 tablespoons salted or unsalted butter, divided

3 tablespoons all-purpose flour

2 cups chicken broth or Quick Chicken Broth (page 44)

1 cup half-and-half or whole milk

2 cups (8 ounces) shredded cheddar cheese

1 teaspoon Worcestershire sauce

⅛ teaspoon cayenne pepper

½ cup sour cream

Cheesy Topping (recipe at right)

Hot cooked pasta or rice (optional)

> **You can serve this comforting dish over white rice or with any pasta you prefer, from thin spaghetti to egg noodles. Or enjoy it on its own!**

This dish makes a comforting meal with or without a side of buttered noodles or hot cooked rice. Its origin is said to come from the Divan Parisien Restaurant at the Chatham Hotel in New York City sometime in the 1930s or 1940s, but it wasn't likely served in a casserole form. It became wildly popular in households in the 1950s; while many recipes use canned-soup shortcuts, this one is closer to the original with a homemade béchamel sauce.

1. Lightly grease (with butter) bottom and sides of a 9x13-inch (3-quart) baking dish.

2. Cook broccoli in boiling water to cover for 5 minutes or until crisp-tender. (You can also place broccoli in a microwave-safe bowl with ¼ cup water. Cover and microwave on high for 3½ minutes.) Drain and transfer to prepared baking dish.

3. Sprinkle chicken with ½ teaspoon salt and ¼ teaspoon black pepper. Melt 2 tablespoons butter in a skillet over medium-high heat. Add chicken in batches and cook, stirring occasionally, for 5 minutes or until browned on all sides. Transfer to baking dish.

4. Preheat oven to 375°.

5. Melt remaining 3 tablespoons butter in the same skillet (no need to wipe clean) over medium heat. Add flour and cook, stirring constantly, for 1 minute. Slowly whisk in broth and half-and-half. Cook, stirring frequently, for 2 minutes or until slightly thickened. Stir in cheese, Worcestershire, cayenne pepper, remaining ½ teaspoon salt, and remaining ½ teaspoon black pepper. Stir in sour cream. Pour sauce over chicken and broccoli.

6. Sprinkle Cheesy Topping evenly on top. Bake, uncovered, for 25 to 30 minutes or until golden brown and bubbly. Serve over hot cooked pasta or rice, if desired.

Cheesy Topping: Combine **½ cup shredded Parmesan or cheddar cheese, ½ cup panko or fine breadcrumbs,** and **2 tablespoons melted salted or unsalted butter** in a bowl. Makes ¾ cup.

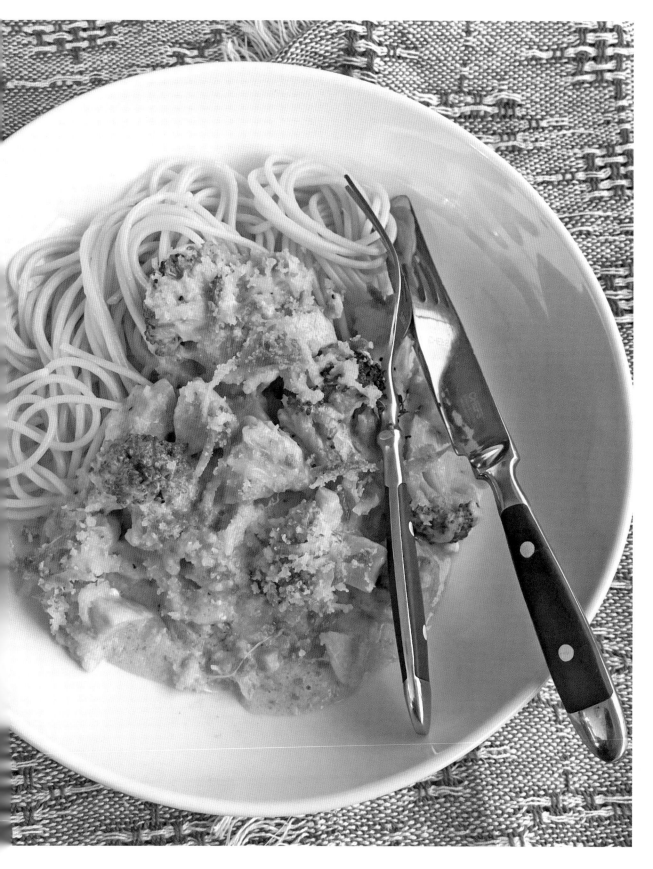

KING RANCH CHICKEN CASSEROLE

MAKES 8 TO 10 SERVINGS

¼ cup salted butter

2 tablespoons extra-virgin olive oil

2 yellow onions, chopped

1 large red bell pepper, chopped

2 poblano peppers, chopped

1 jalapeño pepper, minced

3 garlic cloves, minced

1 tablespoon chili powder

1 tablespoon ground cumin

1½ teaspoons salt

½ teaspoon coarsely ground
 black pepper

3 tablespoons all-purpose flour

2 cups chicken broth

1 (10-ounce) can diced tomatoes
 with green chilies, drained

1 cup sour cream

3 cups shredded cooked chicken

1 cup loosely packed fresh cilantro,
 chopped

12 (5½-inch) corn tortillas

2 cups (8 ounces) shredded
 cheddar cheese

2 cups (8 ounces) shredded
 Monterey Jack cheese

Anyone from the Southwest has probably had a few versions of this Tex-Mex-flavored casserole. Many cooks use canned soup as the base of the sauce, but a fresh-made base tastes amazing. There are, admittedly, a lot of ingredients and steps in this recipe, but the flavor is worth it. For a shortcut, I'll use chicken I've frozen from a previous meal or use rotisserie chicken.

1 Melt butter with olive oil in a large skillet over medium heat. Add onions, bell pepper, poblano peppers, and jalapeño pepper. Cook, stirring occasionally, for 10 to 12 minutes or until vegetables are tender. Stir in garlic, chili powder, cumin, salt, and black pepper. Cook, stirring occasionally, for 1 minute.

2 Increase heat to medium-high. Stir flour into vegetable mixture. Cook, stirring constantly, for 1 minute. Add broth; cook, stirring frequently, for 2 to 3 minutes or until mixture thickens. Remove from heat and stir in tomatoes and sour cream. Set sauce aside.

3 Combine chicken and cilantro in a medium-size bowl.

4 Preheat oven to 375°. Lightly grease (with butter) a 9x13-inch (3-quart) baking dish.

5 Heat a heavy skillet over medium-high heat. Brush tortillas on both sides with oil or spray evenly with cooking spray. Cook tortillas, in batches, for 30 seconds to 1 minute on each side.

6 Spread 1 cup reserved sauce in bottom of prepared baking dish. Spread 6 tortillas evenly over sauce. Top with half of chicken mixture, half of remaining sauce, 1 cup cheddar, and 1 cup Monterey Jack. Repeat with remaining 6 tortillas, half of chicken mixture, half of sauce, 1 cup cheddar, and 1 cup Monterey Jack.

7 Bake for 30 minutes or until golden brown and bubbly. If desired, broil for 2 minutes for an extra-golden top.

TURKEY-AND-VEGGIE POT PIE

MAKES 6 SERVINGS

¼ cup salted butter

1 small onion, chopped

1 small russet or large yellow or red potato, peeled and diced

2 carrots, diced

¾ teaspoon poultry seasoning

½ teaspoon fresh thyme

3 teaspoons salt

¼ cup all-purpose flour

1½ cups chicken or turkey broth or Quick Chicken Broth (page 44)

1 cup half-and-half

3 cups chopped or shredded cooked turkey, chicken, or ham

1 (15-ounce) package refrigerated piecrusts or homemade pastry for 2 crusts (page 150)

1 egg, lightly beaten

This family-friendly comfort meal is always on rotation after a holiday at our house, when leftover meat amounts are not large enough on their own to be a serving. Because this is a great recipe for cleaning out the pantry or fridge, use whatever potato you have, but red or yellow ones will hold their shape best. For a variation, you can even use sweet potatoes.

1. Melt butter in a large saucepan over medium heat. Add onion, potatoes, carrots, poultry seasoning, thyme, and salt. Cook, stirring frequently, for 10 minutes or until vegetables begin to brown and potatoes are almost cooked through.

2. Stir in flour. Cook for 1 minute, stirring constantly. Add broth and half-and-half, stirring until well blended. Bring to a simmer and cook for 5 minutes or until thickened and bubbly. Stir in turkey.

3. Preheat oven to 375°.

4. Place one piecrust in bottom of a 9-inch deep-dish pie plate. Add filling and cover with remaining crust. Fold over edges and crimp to seal. Make several slits in top. Brush top evenly with egg. Place on an aluminum-foil lined baking sheet.

5. Bake for 35 to 40 minutes or until golden brown and bubbly.

CHEESY TUNA-NOODLE CASSEROLE

MAKES 8 SERVINGS

1 (12-ounce) package wide egg noodles

3 tablespoons salted butter

½ large white or yellow onion, chopped

1 (8-ounce) package baby bella or button mushrooms, sliced

3 tablespoons all-purpose flour

2 cups chicken or vegetable broth or Quick Chicken Broth (page 44)

2 cups whole milk

2 cups (8 ounces) shredded cheddar cheese

½ (8-ounce) package cream cheese, softened

1 tablespoon Dijon mustard

2 teaspoons grated lemon zest

½ teaspoon salt

3 (6-ounce) cans oil-packed light tuna, drained and flaked

Panko Topping (recipe at right)

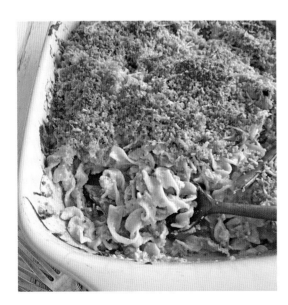

A homemade cheese sauce with a dash of lemon zest makes this dish extra flavorful. I add onions and mushrooms, but either can be omitted for picky eaters. Look for safe-catch or other responsibly caught tuna. I prefer the flavor and added health benefits of tuna packed in olive oil, but you can substitute any type you like.

1 Preheat oven to 375°. Lightly grease (with butter) a 2½- to 3-quart baking dish.

2 Cook noodles in boiling salted water according to package directions. Drain, rinse with cold water, and drain again. Set aside.

3 Melt butter in a large skillet over medium heat. Add onion and mushrooms. Cook, stirring frequently, for 5 to 7 minutes. Sprinkle in flour. Cook, stirring constantly, for 1 minute.

4 Pour in broth and milk. Bring mixture to a boil, reduce heat, and simmer for 4 to 5 minutes or until sauce is smooth and thickened.

5 Remove from heat and stir in cheddar, cream cheese, mustard, lemon zest, and salt. Fold in tuna. Place noodles in prepared baking dish and add tuna mixture, tossing to coat.

6 Sprinkle Panko Topping over casserole. Bake, uncovered, for 30 minutes or until top is golden brown and bubbly.

Panko Topping: Combine **2 tablespoons extra-virgin olive oil or melted salted butter; 2 garlic cloves, minced; ¾ cup panko breadcrumbs; and ¼ cup (1 ounce) shredded Parmesan cheese** in a small bowl. Makes 1 cup.

QUICK SEARED SOCKEYE

MAKES 4 SERVINGS

1 tablespoon paprika

2 teaspoons firmly packed brown sugar

1 teaspoon dried Italian seasoning

¾ teaspoon salt

½ teaspoon garlic powder

½ teaspoon onion powder

1 (1- to 1½-pound) sockeye salmon, cut into 4 fillets

1 tablespoon extra-virgin olive oil, divided

Chimichurri Sauce (optional; recipe on page 105)

It's important to sear the top of the salmon for seconds rather than minutes; otherwise, the bit of brown sugar in the seasoning blend will burn. I usually buy whole sides of salmon and cut into serving pieces without removing the skin first. The skin is much easier to remove after it has cooked, and it helps hold thin pieces together. Even though this recipe is flavorful on its own, I enjoy serving it with Chimichurri, a tangy herb sauce (page 105).

1 Combine paprika, brown sugar, Italian seasoning, salt, garlic powder, and onion powder in a small bowl.

2 Brush top of salmon fillets lightly with olive oil and sprinkle seasoning blend evenly over top and sides of fish.

3 Pour remaining oil (about 2 teaspoons) in a nonstick skillet. Heat over medium-high heat. Add salmon fillets, skin side up, and cook for 30 seconds to 1 minute. Turn fillets over and cover pan. Cook for 3 to 5 minutes or until desired degree of doneness. Serve with Chimichurri Sauce, if desired.

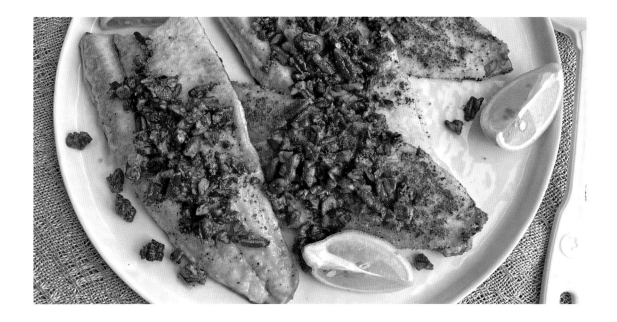

BROWNED BUTTER-AND-PECAN TROUT

MAKES 2 TO 4 SERVINGS

½ cup all-purpose flour or almond flour

½ teaspoon salt

¼ teaspoon coarsely ground black pepper

4 (6-ounce) trout fillets

2 tablespoons extra-virgin olive oil

4 tablespoons salted or unsalted butter

½ cup chopped pecans or slivered or sliced almonds

2 tablespoons lemon juice

2 teaspoons Worcestershire sauce

2 tablespoons chopped fresh parsley

Garnish: lemon wedges

This variation of trout meunière (a classic sauce of browned butter, lemon, and parsley) includes a bit of salty Worcestershire sauce and sautéed pecans. Top with sliced or slivered almonds as a variation. You can use the same sauce with other fish fillets, such as flounder, sole, or yellow-tail snapper.

1 Combine flour, salt, and pepper in a shallow dish. Dredge trout fillets in flour, shaking off excess.

2 Heat 1 tablespoon oil in a large nonstick skillet over medium heat. Add 2 trout fillets, skin side up, and cook for 2 minutes. Turn and cook for 2 minutes or until done. Transfer to a plate or platter. Repeat with remaining 1 tablespoon olive oil and 2 trout fillets. Cover with aluminum foil to keep warm.

3 Melt butter in skillet. Add nuts and cook for 1 to 2 minutes or until golden brown. Stir in lemon juice, Worcestershire, and parsley. Pour over fish. Garnish, if desired, and serve immediately.

CHEESY SHRIMP AND GRITS

MAKES 4 SERVINGS

3 cups chicken broth or Quick Chicken Broth (page 44)

1 cup quick-cooking grits

2 tablespoons salted butter, divided

1½ cups (6 ounces) shredded white or yellow cheddar cheese

½ teaspoon salt

¼ teaspoon coarsely ground black pepper

1 tablespoon extra-virgin olive oil

12 ounces smoked turkey sausage, sliced

2 pounds medium-size shrimp, peeled and deveined

½ teaspoon lemon zest

2 tablespoons fresh lemon juice

2 teaspoons Worcestershire sauce

2 tablespoons chopped fresh parsley

4 green onions, chopped

2 garlic cloves, minced

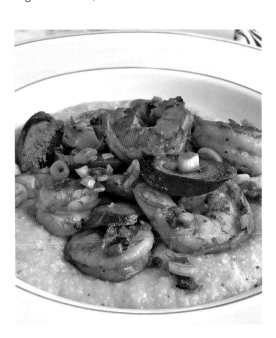

Over the years, I've made a lot of variations of this Southern breakfast or main dish. The one I developed while working for *Coastal Living* magazine is one of my favorites, and it seems to be quite popular. In this interpretation, I substitute sliced smoked turkey sausage for the bacon, depending on my mood. There is admittedly a lot of cheese in the grits. That originally started as a way to tease my daughters into eating them! Feel free to use half the amount of cheese called for here.

1 Bring chicken broth to a boil in a saucepan over medium-high heat. Stir in grits. Cook, stirring frequently, for 5 to 7 minutes or until thickened. Remove from heat and stir in 1 tablespoon butter, cheese, salt, and pepper. Cover and keep warm.

2 Heat oil in a large skillet over medium heat. Add sausage and cook for 5 to 7 minutes or until browned on both sides. Transfer to a plate.

3 Melt remaining 1 tablespoon butter in the same pan (no need to wipe clean) over medium-high heat. Add shrimp and cook, stirring frequently, for 3 minutes. Add zest, lemon juice, Worcestershire, parsley, green onions, and garlic. Cook, stirring constantly, for 3 minutes. Stir in sausage.

4 Spoon grits onto serving plates, and top evenly with shrimp-and-sausage mixture.

APRICOT-GLAZED CHOPS-AND-RICE CASSEROLE

MAKES 4 SERVINGS

3 cups cooked rice

3 tablespoons melted salted butter

4 (1-inch thick) boneless pork chops, trimmed

½ cup apricot or peach preserves

2 tablespoons firmly packed dark brown sugar

2 tablespoons apple cider vinegar

2 teaspoons whole-grain mustard

1 teaspoon sriracha or hot sauce

1 teaspoon fresh thyme leaves

¼ teaspoon salt

Garnish: fresh thyme sprigs

Pork chops are lean and tend to get dry if overcooked. This method is quick—especially if you have leftover rice—and the ingredients surrounding the chops help keep them moist. If you prefer bone-in chops, increase the cooking time by 5 minutes.

1 Preheat oven to 350°. Lightly grease (with butter) a 9x9-inch (8-cup) baking dish.

2 Spread rice in bottom of prepared baking dish; drizzle with melted butter, tossing to coat. Arrange pork chops over rice.

3 Combine preserves, brown sugar, vinegar, mustard, hot sauce, thyme, and salt in a bowl. Spread preserves mixture over pork chops.

4 Cover with aluminum foil and bake for 30 minutes. Uncover and cook for 15 minutes or until pork is cooked through. Garnish, if desired.

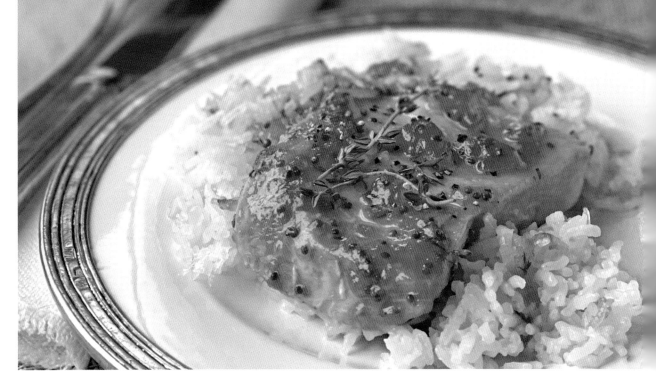

MUSTARD-PANKO-CRUSTED PORK TENDERLOINS

MAKES 6 SERVINGS

Butter

½ cup firmly packed light brown sugar

⅓ cup whole-grain mustard

1 tablespoon extra-virgin olive oil

1 tablespoon fresh or 1 teaspoon dried thyme

½ teaspoon garlic powder

½ teaspoon salt

½ teaspoon coarsely ground black pepper

1 cup plain or seasoned panko breadcrumbs

2 (1-pound) pork tenderloins

Garnish: fresh thyme sprigs

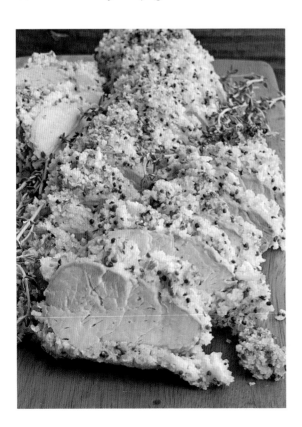

Lean pork tenderloins get a flavor boost with a coating of zesty mustard and sweet brown sugar. If using a pork loin, adjust time. According to the Pork Board, safe internal temperature for fresh cuts is 145°, while ground pork should be cooked to 160°. At 145°, pork cuts such as tenderloins or loin will appear slightly pink in the center.

You can see the tiny mustard seeds in whole-grain mustard. Some versions are almost all seeds, while others have some floating around. There are different levels of moisture, so the breading might be crumbling or sticky, depending on the pork you use.

1 Preheat oven to 350°. Lightly grease (with butter) bottom of a large roasting pan.

2 Combine brown sugar, mustard, oil, thyme, garlic powder, salt, and pepper in a medium-size bowl. Stir in panko.

3 Trim pork and remove any excess fat or silverskin. Spread mustard mixture around outside of pork. Place in prepared roasting pan.

4 Roast for 25 to 35 minutes or until thermometer reads 145° when inserted in center. Let rest, covered with foil, for 5 to 10 minutes before slicing. Garnish, if desired.

MAPLE-GLAZED SPIRAL HAM

MAKES 10 SERVINGS

My favorite thing about spiral hams is that the deep cuts allow flavorful syrup to coat almost every slice while it's baking. But I'll often pick up a good-quality whole ham and create my own slices to allow the glaze to sink in. The first hour of baking serves to get the ham completely heated, while the last minutes are to caramelize and cook the sauce onto the slices. If you put the sauce on first, it will either become diluted with the pan juices and slip to the bottom of the pan, or the sugars will burn.

1 (6- to 8-pound) cooked bone-in, cured-and-smoked spiral or whole ham

2 tablespoons salted or unsalted butter

1 shallot, minced

½ cup pure maple syrup

⅓ cup firmly packed dark brown sugar

1 tablespoon chopped fresh rosemary

1 tablespoon whole- or coarse-grain mustard

1 tablespoon apple cider vinegar

½ teaspoon coarsely ground or cracked black pepper

Garnish: fresh parsley sprigs

> A beautifully roasted ham is not only the star of the show at a family gathering during spring or winter holidays, but it can also take center stage any time of the year.

1. Preheat oven to 325°. Place ham in a roasting pan. Cover with aluminum foil and bake for 1 hour.

2. Meanwhile, melt butter in a small saucepan over medium heat. Add shallot and cook for 3 minutes or until tender. Stir in syrup, brown sugar, rosemary, mustard, vinegar, and pepper. Cook, stirring frequently, until sugar melts.

3. Remove foil from ham. Brush with half of maple syrup mixture. Continue to bake, uncovered, for 30 to 40 minutes to an hour, brushing with additional glaze, until ham is thoroughly heated and a thermometer inserted in center reads 135°. Serve with any remaining sauce.

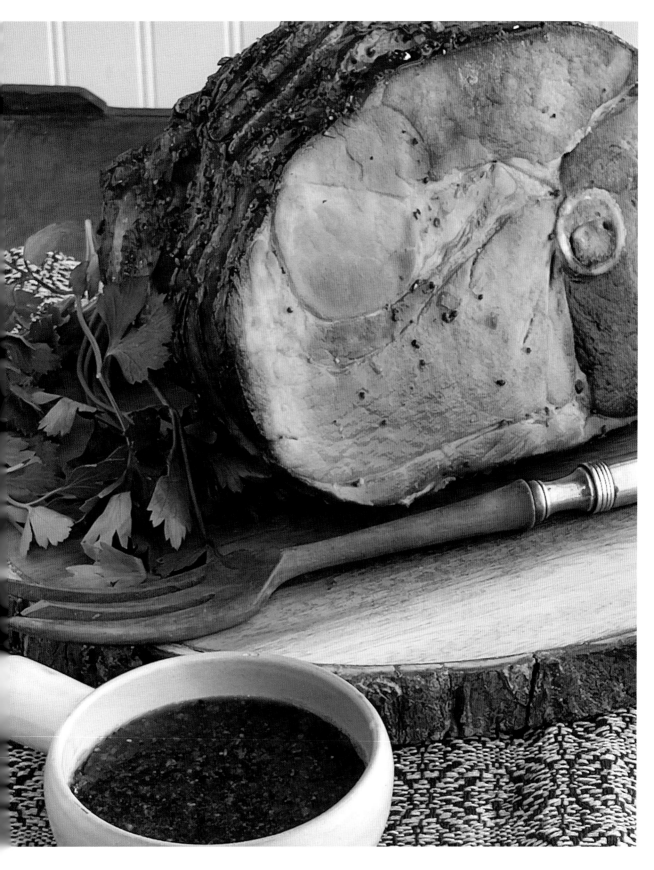

MEATBALLS AND MARINARA

MAKES 6 SERVINGS

1 pound lean ground beef, chicken, or turkey

½ pound bulk sweet Italian sausage, casings removed

⅓ cup seasoned breadcrumbs

1 tablespoon dried Italian seasoning

½ teaspoon garlic powder

2 tablespoons chopped fresh parsley or green onions, divided

1 large egg

1 (1-pound) package spaghetti, linguini, or other pasta

Basic Marinara Sauce (recipe on page 131)

Grated or shredded Parmesan cheese

This meatball recipe is a variation of one used for cocktail meatballs but with a bit more Italian seasoning. If you like really large meatballs, roll about 3 to 4 table-spoons of the meat mixture into a ball. Cooking time will be longer for the larger size, about 25 minutes. Ground meats in these recipes should always be cooked to well done or 165° when measured with a thermometer.

1 Preheat oven to 350°. Line a rimmed baking sheet with aluminum foil or parchment paper.

2 Combine ground beef, sausage, breadcrumbs, seasoning, garlic powder, 1 tablespoon parsley, and egg in a large bowl. Shape into 1-inch balls and arrange on prepared baking sheet. Bake for 8 to 10 minutes or until browned and cooked through.

3 Meanwhile, cook spaghetti or other pasta according to package directions. Drain.

4 Heat Basic Marinara Sauce in a saucepan over medium heat. Add meatballs and cook until thoroughly heated.

5 Arrange pasta on serving plates, and top with meatballs and sauce. Sprinkle with Parmesan cheese.

BASIC MARINARA SAUCE

MAKES 8 CUPS

¼ cup extra-virgin olive oil

2 large, sweet onions, finely chopped

1 (6-ounce) can tomato paste

6 garlic cloves, coarsely chopped

2 tablespoons dried Italian seasoning

2 teaspoons unsweetened cocoa powder

½ teaspoon crushed red pepper flakes

1 teaspoon sea salt

½ cup red wine

2 (28-ounce) ounce cans crushed tomatoes, undrained

2 teaspoons granulated sugar

Use this multipurpose pasta sauce for spaghetti, lasagna, or anything else where a seasoned tomato sauce is used. It freezes beautifully. Keep some in your freezer up to 6 months for easy, spontaneous meals.

1. Heat olive oil in a Dutch oven or soup pot over medium-high heat. Add onions. Cook, stirring frequently, for 5 to 7 minutes or until tender. Stir in tomato paste, garlic, Italian seasoning, cocoa powder, red pepper flakes, and salt. Cook, stirring constantly, for 2 minutes.

2. Stir in wine. Cook for 1 minute, stirring constantly. Stir in tomatoes and sugar. Bring mixture to a boil; reduce heat, cover, and simmer over low heat for 45 to 60 minutes, stirring occasionally.

3. For a smooth texture, blend with an immersion blender. Keep warm.

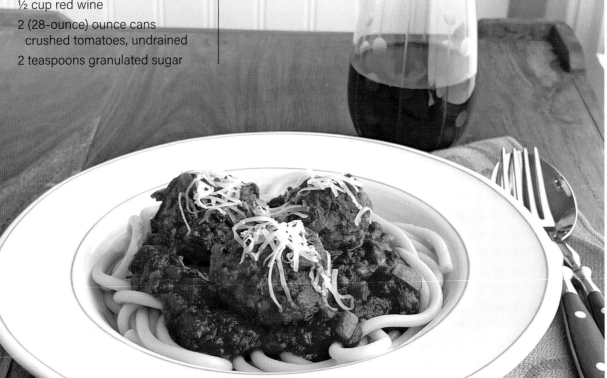

OLD-FASHIONED MEAT LOAF

MAKES 6 SERVINGS

1½ pounds extra-lean ground beef

½ pound ground pork, chicken, or turkey

¾ cups old-fashioned or quick oats

¾ cup whole milk

1 small yellow onion, finely chopped

2 teaspoons dried Italian seasoning

2 large eggs, lightly beaten

1 tablespoon Worcestershire sauce

1 teaspoon salt

½ teaspoon coarsely ground black pepper

⅓ cup ketchup

1 tablespoon firmly packed dark or light brown sugar

1 teaspoon apple cider vinegar

Thrifty cooks have long used meat loaf as a way to stretch ingredients—one reason why there are so many variations. It'll always be a value meal, but it now represents family comfort. This version uses old-fashioned oats instead of breadcrumbs or crackers, as well as a couple of eggs to help bind the ingredients. Leftovers reheat well and might taste even more delicious between toasted buns as a "meat loaf burger."

1 Preheat oven to 400°. Line sides and bottom of a 9x5-inch loaf pan with aluminum foil.

2 Combine ground beef, ground pork, oats, milk, onion, seasoning, eggs, Worcestershire, salt, and pepper in a large bowl. Use hands to blend mixture just until combined. Do not overmix. Spoon meat mixture gently into prepared loaf pan (do not pack down).

3 Stir together ketchup, brown sugar, and vinegar in a small bowl. Spread ketchup mixture over top of meat loaf.

4 Bake for 55 to 60 minutes or until meat loaf is cooked through and a meat thermometer registers 160°. Lift meat loaf out of pan, remove foil, and slice to serve.

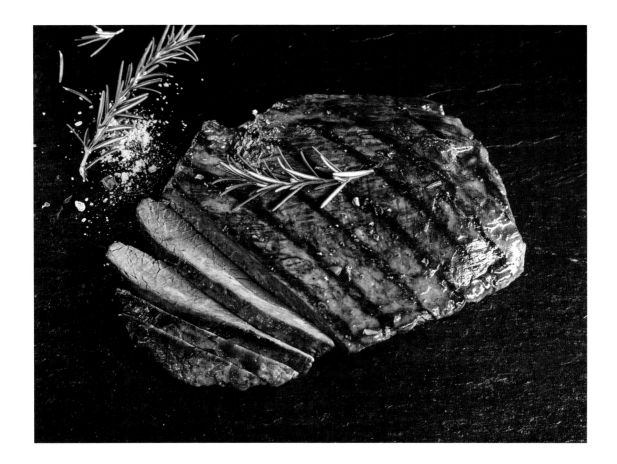

MARINATED FLANK STEAK

MAKES 4 SERVINGS

½ cup soy sauce

¼ cup honey

2 tablespoons extra-virgin olive oil

1 teaspoon sesame oil

4 garlic cloves, minced

2 teaspoons grated ginger

½ teaspoon pepper

¼ teaspoon crushed
 red pepper flakes

1 (1½- to 1¾-pound) flank steak

Garnish: fresh rosemary sprigs

Here's my go-to marinade for beef. Try it on chicken breasts or wings for another option. For an easy dinner, serve the grilled steak with roasted broccoli and steamed rice or riced cauliflower.

1 Combine soy sauce, honey, olive oil, sesame oil, garlic, ginger, pepper, and red pepper flakes in a zip-top plastic storage bag or shallow dish. Add steak and marinate for 2 to 6 hours.

2 Heat grill or grill pan to medium-high heat. Brush grill grate with olive oil. Grill steak for 5 minutes on each side for medium rare or until desired degree of doneness. Let stand for 15 minutes before slicing. Garnish, if desired.

GRILLED STEAKHOUSE KEBABS

MAKES 4 SERVINGS

1½ to 1¾ pounds sirloin, skirt, or flank steak, cut into cubes

1 (8-ounce) package cremini or button mushrooms

1 large onion, cut into pieces

2 red, yellow, or orange bell peppers, cut into pieces

2 tablespoons extra-virgin olive oil

3 tablespoons Worcestershire sauce

2 tablespoons soy sauce

2 tablespoons lemon juice

2 teaspoons Dijon mustard

2 teaspoons firmly packed light brown sugar

½ teaspoon coarsely ground black pepper

½ teaspoon liquid smoke

Romesco Sauce (recipe at right)

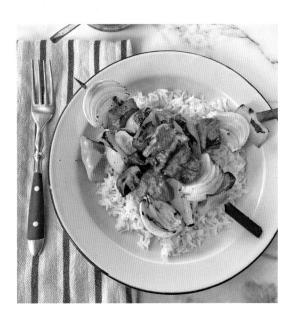

The key to even grilling is to cut the meat into equal-size pieces. Cut large pieces if you prefer medium-rare meat and small pieces if you like meat well done. If using wooded skewers, soak in water for 30 minutes to avoid burning. If skewers are thick, mushrooms may split and fall off. If that happens, grill them on the side. If you don't have a jar of roasted bell peppers in the pantry for the Romesco Sauce, then broil bell peppers until the skins are blackened and bubbled on all sides. Place them in a bowl and cover to steam. Once peppers are cool enough to handle, peel skins and remove core and seeds.

1 Thread steak, mushrooms, onion, and bell pepper onto skewers. Place in a baking or roasting pan.

2 Whisk together oil, Worcestershire, soy sauce, juice, mustard, brown sugar, pepper, and liquid smoke in a small bowl. Drizzle over kebabs, turning to coat. Cover and chill for 1 to 4 hours, turning occasionally, until ready to cook.

3 Grill kebabs over medium-high heat (about 375° to 425°), turning occasionally, for 6 to 8 minutes or until vegetables are tender and meat is cooked to desired degree of doneness. Serve with Romesco Sauce.

Romesco Sauce: Place **2 roasted red bell peppers (jarred or homemade); 1 large ripe tomato, halved; 3 tablespoons silvered toasted almonds; 2 garlic cloves, minced; 1 tablespoon sherry vinegar; 1 tablespoon extra-virgin olive oil; ¼ teaspoon salt; and ¼ teaspoon smoked paprika** in a blender. Blend until smooth. Makes 1 cup.

BEEF STROGANOFF

MAKES 4 SERVINGS

3 tablespoons all-purpose flour

1 teaspoon paprika

⅛ teaspoon ground cayenne pepper

1½ teaspoons salt, divided

½ teaspoon coarsely ground black pepper, divided

1½ pounds beef sirloin, flank steak, boneless ribeye, or tenderloin

2 tablespoons extra-virgin olive or vegetable oil, divided

¼ cup salted or unsalted butter, divided

1 (8-ounce) package button or cremini mushrooms, quartered

¼ cup chopped white or yellow onion

¼ cup dry white wine

½ cup beef broth or Homemade Beef Stock (page 45)

1 cup sour cream

1 teaspoon Worcestershire sauce

1 (12-ounce) package wide egg noodles

2 tablespoons chopped fresh parsley

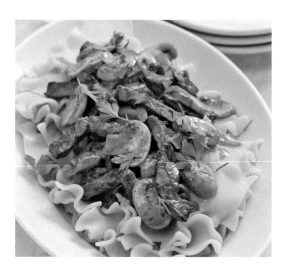

This classic comfort food is versatile—use a cut of beef you find on sale or a mix of cuts. Egg noodles work best with the rich mushroom gravy, and you can choose wide or narrow varieties.

1 Combine flour, paprika, cayenne pepper, ½ teaspoon salt, and ¼ teaspoon black pepper in a large shallow dish.

2 Slice beef against the grain into 2½-inch strips. Pound lightly to ¼-inch thickness. Dredge meat in flour mixture, shaking off excess.

3 Heat 1 tablespoon oil in a large skillet over medium-high heat. Add half of beef, and cook for 1 to 2 minutes or until browned on all sides; transfer to a plate. Repeat with remaining 1 tablespoon oil and remaining beef. Transfer meat to plate; cover with aluminum foil to keep warm.

4 Melt 2 tablespoons butter in the same skillet (no need to wipe clean) over medium-high heat. Add mushrooms, onion, remaining 1 teaspoon salt, and remaining ¼ teaspoon black pepper. Cook, stirring frequently, for 10 to 12 minutes or until golden brown and most of the liquid has evaporated. Add wine to mushroom mixture, stirring well. Cook until liquid is mostly evaporated. Stir in broth, sour cream, Worcestershire, beef, and any juices. Keep warm over low heat; do not boil.

5 Meanwhile, cook noodles in boiling water according to package directions. Drain and transfer to a bowl. Add remaining 2 tablespoons butter; toss until butter melts and coats noodles.

6 Divide noodles evenly between four plates. Ladle beef and sauce over noodles, and sprinkle with parsley before serving.

CORNED BEEF AND VEGGIES

MAKES 4 TO 6 SERVINGS

1 (3- to 3½-pound) corned beef brisket with pickling spice packet

5 garlic cloves, crushed

3 onions, quartered

2 bay leaves

1 teaspoons whole peppercorns

1 tablespoon firmly packed light or dark brown sugar

2 teaspoons crushed red pepper flakes

6 medium-size Yukon Gold, yellow, or red potatoes, halved

1 pound carrots, cut into 3-inch pieces

1 head green cabbage, cored and cut into wedges

3 tablespoons salted or unsalted butter, melted

¼ teaspoon coarsely ground black pepper

Corned beef is made from brisket that has been salt-cured or "pickled" in a seasoned brine. Brisket is a tough cut that requires a lengthy cooking time to create a delicious fork-tender meal, about 45 minutes per pound. Although the meat is cooked through, it will remain pink due to the pickling ingredients.

1 Place corned beef, fat side up, in a large stockpot; cover with water. Add enclosed spice packet, garlic, onions, bay leaves, peppercorns, brown sugar, and red pepper flakes.

2 Bring to a boil, reduce heat to medium-low, and simmer for 2 hours. (Beef should be tender but not falling apart. Add more time if using a larger cut of meat.) Add potatoes and carrots. Cover and simmer for 30 minutes. Add cabbage; cover and simmer for 15 minutes or until vegetables and meat are very tender.

3 Remove corned beef and transfer to a cutting board; cover with aluminum foil to keep warm. Scoop out vegetables, discarding bay leaves, and arrange in a baking dish or deep platter. Slice corned beef and add to vegetables. Drizzle vegetables with melted butter. Sprinkle with black pepper.

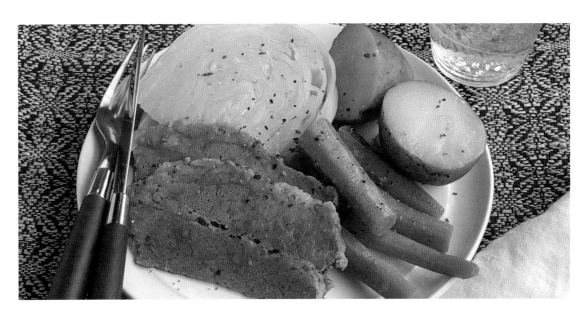

BEER-BRAISED SHORT RIBS

MAKES 4 TO 6 SERVINGS

1½ pounds beef short ribs

1½ pounds boneless beef short ribs

1½ teaspoon salt, divided

1 teaspoon coarsely ground black pepper, divided

1 red onion, chopped

2 celery stalks, sliced

5 garlic cloves, smashed

4 carrots, cut into pieces

2 tablespoons tomato paste

2 tablespoons firmly packed light or dark brown sugar

1 (12-ounce) bottle or can beer

2 tablespoons Worcestershire sauce

1½ tablespoons cornstarch

1 cup frozen petite peas

Mashed potatoes or cooked polenta

Slow cooking turns these beef ribs into melt-in-your-mouth bites. Sometimes you'll see meat labeled as "boneless" short ribs. They will be meatier, but the dish may lack the rich flavor that bone-in ribs offer. I use half of each type of short rib to get the richness and flavor the bones offer, as well as enough meat for hearty servings.

1 Trim excess fat from short ribs, leaving an even layer of fat. Sprinkle evenly with ¾ teaspoon salt and ½ teaspoon pepper. Sear short ribs on all sides in a heavy skillet over medium-high heat. Place ribs in an even layer in a (5-quart) slow cooker. Add onion, celery, garlic, and carrots.

2 Stir together tomato paste, brown sugar, beer, Worcestershire sauce, remaining ¾ teaspoon salt, and remaining ½ teaspoon pepper. Pour mixture over ribs and vegetables. Cover and cook on low heat for 6 to 8 hours or until ribs are tender.

3 Skim off excess fat from surface. Pour ½ cup broth into a small bowl. Whisk in cornstarch. Stir liquid back into slow cooker. Stir in peas; cover and let stand 5 to 10 minutes, stirring occasionally, until peas are thoroughly heated and mixture is slightly thickened. If desired, remove excess fatty pieces and any bones that have fallen away from meat.

4 Serve with mashed potatoes or polenta. Drizzle sauce over ribs and vegetables.

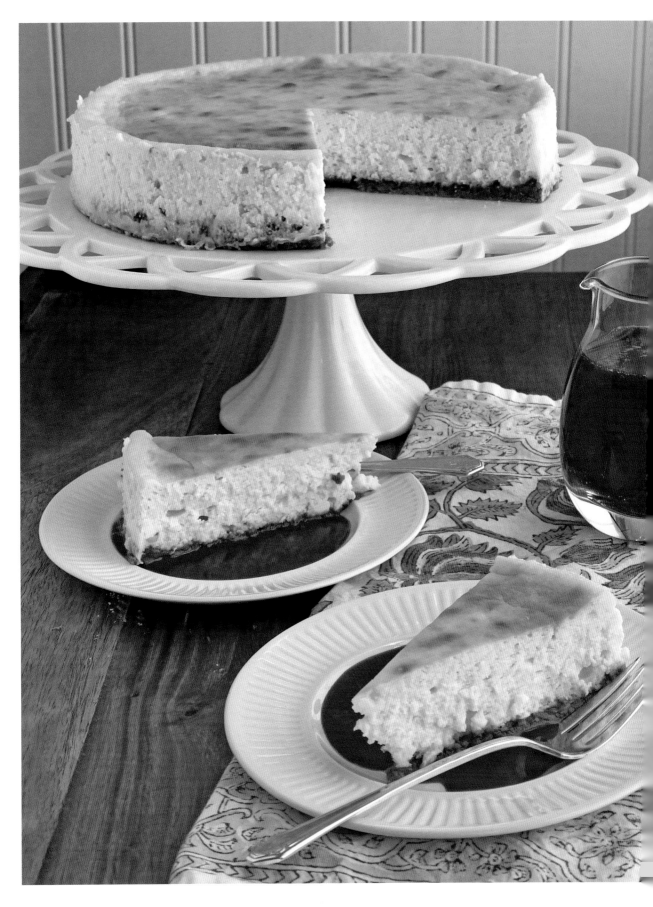

DESSERTS

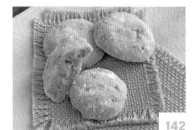
142

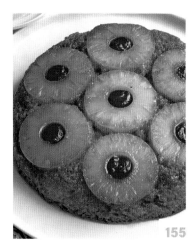
155

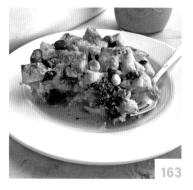
163

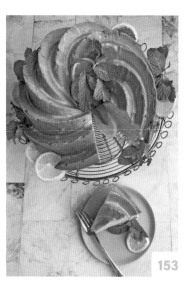
153

164

BASIC VANILLA SUGAR COOKIES

MAKES 3 TO 4 DOZEN COOKIES

1 cup unsalted or salted butter, softened

1 cup granulated sugar

1 large egg

2 teaspoons vanilla extract

3 cups all-purpose flour

½ teaspoon salt

Royal Icing (recipe at right)

My family's favorite cookies are these simple cut-outs. I add a bit of vanilla extract to make them special. The recipe makes an ample amount of Royal Icing, in case you want to dye it in multiple colors. You can freeze any extra icing up to 2 months or make half a recipe for a simple one-color glaze. Meringue powder adds firmness and stability to the icing without making it too sweet. Find it at crafts stores or order it online.

1 Beat butter and sugar at medium speed with an electric mixer until light and creamy. Add egg and vanilla, and beat until combined.

2 Combine flour and salt. Beat flour mixture gradually into butter mixture.

3 Divide dough in half; cover and refrigerate for 30 minutes.

4 Preheat oven to 350°. Line baking sheets with parchment paper, nonstick aluminum foil, or silicone baking mats.

4 Roll half of dough out on a floured surface to ¼-inch thickness. Cut with 2- to 3-inch cutters and place on prepared baking sheets about 2 inches apart. Bake for 10 minutes or until edges are just beginning to brown. Cool on pan for 5 minutes, then transfer to wire racks to cool completely. Decorate with Royal Icing.

Royal Icing: Combine **1 (16-ounce) package powdered sugar, 3 tablespoons meringue powder, ¼ cup water,** and **1 teaspoon corn syrup** in a mixing bowl, mixing well. Add additional water, a little bit at a time, until desired consistency is reached. Use a thinner consistency for dipping the tops; use a thicker one for writing letters or creating fine details. Divide icing into bowls and tint with desired food coloring. Makes 3 cups.

BROWN BUTTER-CHOCOLATE-TOFFEE COOKIES

MAKES 3 DOZEN

1 cup unsalted butter, cut into pieces

1 cup firmly packed dark brown sugar

⅓ cup granulated sugar

2 large eggs

1 egg yolk

2 teaspoon vanilla extract

2¼ cups all-purpose flour

1 teaspoon baking soda

1 teaspoon salt

1½ cups chopped sweet dark chocolate or dark chocolate morsels

1 cup toffee bits or 3 (1.4-ounce) chocolate toffee candy bars, chopped

Flaky sea salt (optional)

This cookie recipe flew across the internet, so I'm not exactly sure where it originated. When I sampled a batch made by my daughter Corinne's friend, Kiki Lemke, I instantly swooned at the flavor. They are delicious anytime, but they are sublime still warm from the oven. For toffee, use Heath Bits O' Brickle English Toffee Bits or chopped SKOR Crisp Butter Toffee and Chocolate Candy bars. I adore Maldon Sea Salt Flakes, but you can substitute kosher salt.

1 Place butter in a skillet or pan (preferably a light color) and cook over medium heat until melted. Continue to cook, stirring frequently, for 5 to 7 minutes or until golden brown. Transfer to a mixing bowl to stop the cooking process. Stir in sugars. Let cool for 5 minutes.

2 Beat eggs, yolk, and vanilla into butter mixture. Combine flour, baking soda, and salt in a medium-size bowl. Beat flour mixture into butter mixture. Stir in chopped chocolate and toffee. Cover and refrigerate for 2 hours or overnight.

3 Preheat oven to 325°. Line baking sheets with parchment paper or non-stick aluminum foil. Roll cookies into 1½-inch balls. Place cookies 3 inches apart on prepared baking sheets. Bake for 8 to 10 minutes or until golden brown. Sprinkle with sea salt, if desired. Cool on baking sheets for 10 minutes, then transfer to wire racks to cool completely.

ALMOND-LIME COOKIES

MAKES 3 DOZEN

1 cup sliced or slivered almonds

1 cup unsalted butter

1½ cups powdered sugar, divided

1 tablespoon lime zest

2 cups all-purpose flour

½ teaspoon salt

This sweet variation of a wedding cookie is filled with lime zest, giving the little bites a summery, tropical flavor.

1 Preheat oven to 350°. Spread almonds in a single layer on a baking sheet. Bake for 5 to 7 minutes or until toasted and fragrant. Cool completely; chop very finely and set aside.

2 Line baking sheets with parchment paper or nonstick aluminum foil.

3 Beat butter and 1 cup powdered sugar in a large bowl with an electric mixer until light and creamy. Beat in zest.

4 Add flour and salt. Beat at low speed until well blended. Stir in almonds.

5 Shape dough into 1- to 1½-inch balls. Place 1 inch apart on prepared baking sheets. Bake for 10 minutes or until very lightly browned on bottom.

6 Let stand about 5 minutes or until cool enough to handle. While still warm, roll cookies in remaining ½ cup powdered sugar. Let stand until completely cool. Roll again in any remaining powdered sugar.

OATMEAL-CHOCOLATE CHIP COOKIES

MAKES ABOUT 4 DOZEN

1 cup salted or unsalted butter

¾ cup firmly packed light or
 dark brown sugar

¾ cup granulated sugar

2 large eggs

1 tablespoon vanilla extract

2 cups all-purpose flour

1 teaspoon baking soda

½ teaspoon fine sea salt

2 cups old-fashioned or quick oats

2 cups or 12 ounces dark or semisweet
 chocolate chunks or morsels

I've never really enjoyed raisins in my oatmeal cookies and happily substitute chocolate chips. The combination of oatmeal and chocolate is especially delicious with a high proportion of brown sugar to granulated sugar. If you like an even distribution of chocolate, use mini-morsels.

1 Preheat oven to 325°. Line two baking sheets with parchment paper or nonstick aluminum foil.

2 Beat butter and sugars at medium speed with an electric mixer until creamy. Add eggs and vanilla, beating well.

3 Combine flour, baking soda, and salt in a bowl, stirring well. Stir in oats. Add oat mixture to butter mixture, blending well. Stir in chocolate morsels.

4 Roll into 1½-inch balls and flatten slightly.

5 Bake for 15 minutes or until brown around edges and set in center. Cool on pan for 3 minutes or until firm. Remove cookies from pan; cool completely on wire racks.

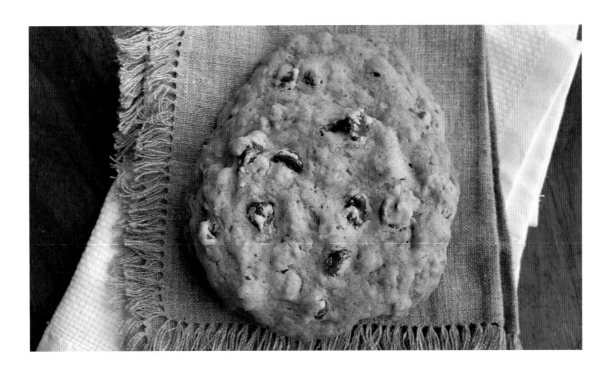

MOLASSES COOKIES

MAKES 3 DOZEN

¾ cup salted or unsalted butter

1 cup granulated sugar

¼ cup molasses

1 large egg

2 cups all-purpose flour

2 teaspoons baking soda

1 teaspoon ground cinnamon

½ teaspoon ground cloves

½ teaspoon ground ginger

½ teaspoon salt

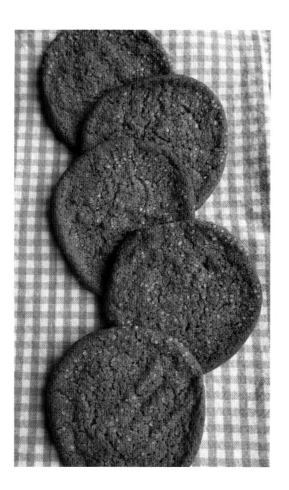

Molasses is a dark liquid sweetener that is a byproduct of making sugar. Sugarcane and sugar beets are crushed to extract their juices, then the liquid is boiled down to produce sugar crystals. Molasses is the syrup left over. Then the process is repeated; the darker the color, the deeper and richer the flavor. Blackstrap is the darkest and can be bitter. "Sulfured" means sulfur dioxide was added as a preservative, and these types tend to be less sweet. I prefer to use light or dark unsulfured in my recipes.

1 Melt butter in a saucepan over medium-low heat. Cool slightly and stir in sugar, molasses, and egg.

2 Combine flour, baking soda, cinnamon, cloves, ginger, and salt in a bowl, mixing well. Add butter mixture to flour mixture, blending well. Cover and refrigerate for at least 1 to 2 hours or until well chilled and firm.

3 Preheat oven to 350°. Line baking sheets with parchment paper or non-stick aluminum foil.

4 Portion dough into pieces and roll into 1-inch balls. Roll in additional granulated sugar and place on prepared baking sheets at least 2 inches apart (cookies will spread). Press with a fork until slightly flattened.

5 Bake for 8 to 10 minutes. Cool in pan for 5 minutes; transfer cookies to a wire rack to cool completely.

PEANUT BUTTER COOKIES

MAKES 2 DOZEN

2 cups all-purpose flour

¾ teaspoon baking powder

½ teaspoon baking soda

½ teaspoon salt

1 cup unsalted butter

1 cup firmly packed light brown sugar

½ cup granulated sugar

2 large eggs

1¾ cups natural creamy or chunky peanut butter

2 teaspoons vanilla extract

Granulated sugar (optional)

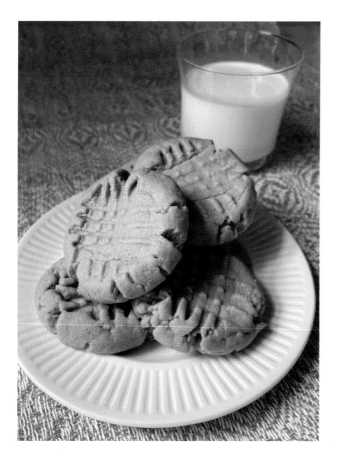

Peanut butter cookies are always comforting and remind me of childhood. You can substitute different nut butters like almond or pecan. I prefer natural varieties without added sugar because there's already plenty of brown sugar to give the cookies a richer sweet flavor. Stir well if the butter separates. I flip the jar upside down a few times to help incorporate the oil, then stir well before refrigerating.

1 Preheat oven to 350°. Line a baking sheet with parchment paper or nonstick aluminum foil.

2 Combine flour, baking powder, baking soda, and salt in a medium-size bowl.

3 Beat butter and sugars together in a mixing bowl until smooth and creamy. Add eggs and beat until blended. Add peanut butter, beating until well blended, scraping down sides as needed. Beat in vanilla.

4 Gradually beat flour mixture into peanut butter mixture. Cover and chill until dough is firm.

5 Roll dough into 1-inch balls. If desired, roll in additional granulated sugar. Place on baking sheet and press with a fork in a crisscross pattern to flatten.

6 Bake for 10 minutes or until golden brown. Cool for 5 minutes on pan or until firm (cookies will be soft); transfer to a wire rack to cool completely.

BUCKWHEAT-AND-BITTERSWEET CHOCOLATE COOKIES

MAKES 3 DOZEN

1 cup oat or other gluten-free flour

⅔ cup buckwheat flour

½ teaspoon salt

½ teaspoon baking powder

¼ teaspoon baking soda

½ cup unsalted butter, melted

½ cup granulated sugar

½ cup firmly packed light brown sugar

1 large egg

1 large egg yolk

1 teaspoon vanilla extract

8 ounces chopped semisweet or bittersweet chocolate or morsels

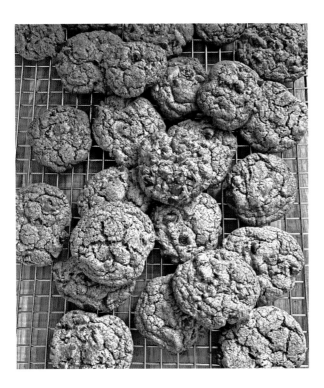

Buckwheat was one of the first domesticated grain crops. It's often ground into flour and used worldwide in blini, soba noodles, kasha, and pancakes. Buckwheat is not wheat—it's botanically an herb. It does not contain gluten and can be substituted for whole wheat flour in recipes that don't require a lot of rising. It has a robust, strong flavor and is often used mixed with other mild-flavored flours.

1 Combine flours, salt, baking powder, and baking soda in a medium-size bowl.

2 Combine butter and sugars in a large bowl, stirring until smooth. Stir in egg, yolk, and vanilla extract.

3 Stir flour mixture into butter mixture. Stir in chopped chocolate. Cover and refrigerate for 1 hour up to overnight.

4 Preheat oven to 375°. Line three baking sheets with parchment paper or nonstick aluminum foil. Scoop dough by heaping tablespoons and place 2 inches apart on prepared baking sheets.

5 Bake cookies for 8 to 10 minutes, rotating pans, if necessary. Cool cookies for 5 minutes on pans, then transfer to a wire rack to cool completely.

APRICOT-AMARETTO CHEWS

MAKES 5 DOZEN

1 cup all-purpose flour

¼ teaspoon salt

1 teaspoon baking soda

2½ cups old-fashioned or
 quick-cooking oats

1 (6-ounce) package dried apricots,
 coarsely chopped

⅔ cup sliced almonds, coarsely
 chopped

1 cup unsalted butter, softened

¾ cup firmly packed
 light brown sugar

½ cup granulated sugar

1 large egg

1 teaspoon almond extract

2 cups powdered sugar

4 tablespoons amaretto liqueur

These chewy, textured cookies feature the delicate flavor of dried apricots and almonds. Amaretto is a sweet, almond-flavored liqueur made from the kernels inside of apricot pits. (You can substitute ¼ teaspoon almond extract mixed with just enough water to create a good drizzling consistency.)

1. Preheat oven to 375°. Line two baking sheets with parchment paper or nonstick aluminum foil.

2. Combine flour, salt, and baking soda in a small bowl. Combine oats, apricots, and almonds in a medium-size bowl.

3. Beat butter, brown sugar, and granulated sugar in a mixing bowl on medium speed until light and fluffy. Beat in egg and almond extract. Beat in flour mixture. Stir in oat mixture.

4. Drop by rounded teaspoonfuls onto prepared baking sheets.

5. Bake for 8 to 10 minutes. Cool on pan for 2 minutes, then transfer to a wire rack to cool completely.

6. Stir together powdered sugar and liqueur. Drizzle over cooled cookies.

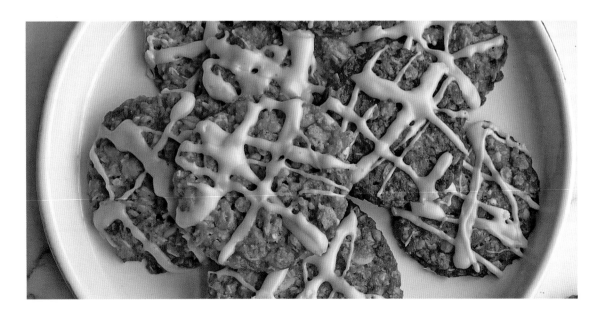

BENNE SEED WAFERS

MAKES 4 DOZEN

These sweet, thin, and crispy cookies are a hallmark food of the South Carolina Lowcountry area. They feature benne seeds, the West African name for sesame seeds, which were introduced to the colonies in the 1700s. Benne seeds are the heirloom ancestors of modern sesame seeds and considered more flavorful. Common sesame seeds are often substituted.

½ cup benne or sesame seeds

¼ cup unsalted butter

1 cup firmly packed
 dark brown sugar

1 large egg

½ teaspoon vanilla extract

½ cup all-purpose flour

¼ teaspoon baking powder

⅛ teaspoon baking soda

⅛ teaspoon salt

1 Preheat oven to 350°. Spread seeds in a single layer on a baking sheet. Bake for 3 to 5 minutes or until a dark golden brown. Transfer to a plate and set aside. Line baking sheets with parchment paper or nonstick aluminum foil.

2 Beat butter and brown sugar at medium speed with an electric mixer until smooth, scraping sides of bowl as necessary. Beat in egg and vanilla.

3 Combine flour, baking powder, baking soda, and salt in a medium-size bowl. Beat flour mixture into butter mixture. Beat in toasted seeds.

4 Drop batter by teaspoonfuls onto prepared baking sheets about 2 to 3 inches apart (cookies will spread). Flatten dollops with a butter knife or fingers dipped in water.

5 Bake for 8 minutes. Remove from oven and cool for 2 minutes. Slide a thin spatula under cookies to loosen, and transfer to a wire rack to cool completely.

PECAN TASSIES

MAKES 2 DOZEN

3 ounces cream cheese, softened

½ cup salted butter

1 cup all-purpose flour

1 large egg

¾ cup firmly packed
 light brown sugar

1 teaspoon vanilla extract

Pinch of salt

⅔ cup chopped pecans

The word "tassie" comes from the Scottish word for little cup or glass, but it may also be an Americanized derivation of the French "tasse." Pecan pie recipes were first seen in Texas cookbooks written in the late 1800s, and these little tartlets have been popular ever since.

Many early recipes use a 3-ounce package of cream cheese. That size is no longer commonly sold, but the marks on modern 8-ounce packages show where to cut for each ounce. For a richer pecan flavor, toast pecans at 350° for 5 minutes and cool before mixing into egg mixture.

1 Beat cream cheese and butter with an electric mixer until smooth. Gradually add flour and beat until well blended. Cover with plastic wrap and refrigerate for 1 hour.

2 Preheat oven to 350°.

3 Beat together egg, brown sugar, vanilla, and salt until well blended. Stir in pecans.

4 Divide pastry dough into 24 pieces, and roll each into a ball. Press into bottom and sides of nonstick mini-muffin tins. Stir pecan mixture to reincorporate ingredients. Divide filling among tartlet shells.

5 Bake for 15 minutes. Reduce heat to 250° and continue baking for 10 minutes. Cool in pans for 10 minutes; transfer to wire racks to cool completely.

PEACH CRUMBLE PIE

MAKES 8 SERVINGS

Pastry Dough (recipe at right)

Crumb Topping (recipe at right)

4 cups peeled and sliced peaches
(about 6 medium)

1½ tablespoons lemon juice

¼ to ½ cup granulated sugar

¼ cup firmly packed
light brown sugar

3 tablespoons cornstarch

½ teaspoon ground cinnamon

If you're short
on time, you may
substitute a store-
bought refrigerat-
ed piecrust for the
homemade Pastry
Dough in this recipe.

I've always classified peaches in two camps—perfectly delicious or not worth peeling. I'm not fan enough to tolerate "just okay" flavor or texture. The ideal peach is sweet, fragrant, and tender—characteristics easy to attain with in-season and locally grown fruit. Fuzzy skinned peaches are easy to peel. Cut an "x" shape at the bottom and carefully drop in boiling water for about 30 seconds, then place in an ice bath until cool enough to handle. The skins will easily slip off.

1 Prepare Pastry Dough and Crumb Topping; set aside.

2 Preheat oven to 375°.

3 Combine peaches and lemon juice in a large bowl. Combine sugars, cornstarch, and cinnamon in a small bowl. Fold gently into peach mixture until sugar melts and mixture is well blended.

4 Line a 9½-inch shallow pie plate with Pastry Dough. Flute edge, if desired. Stir peach mixture just before spooning into pastry. Sprinkle with Crumb Topping.

5 Bake for 45 minutes or until top is golden brown and filling thickens. Cool on a wire rack.

Pastry Dough: Combine **1½ cups all-purpose flour, 1 tablespoon granulated sugar,** and **¼ teaspoon salt** in a food processor. Pulse until well blended. Add **½ cup cold unsalted butter, cut into pieces,** and pulse until mixture resembles coarse sand. Sprinkle **2 tablespoons water** onto flour mixture. Pulse several times. Add another **2 tablespoons water.** Pulse until blended (there may be crumbs that do not hold together). Remove from processor and flatten into a disk. Cover with plastic wrap and chill for 1 hour or overnight. Makes 1 crust.

Crumb Topping: Combine **⅔ cup old-fashioned or quick oats, ¼ cup all-purpose flour, ¼ cup firmly packed light brown sugar, ¼ cup melted unsalted butter,** and **¼ teaspoon salt** in a bowl. Makes 1 cup.

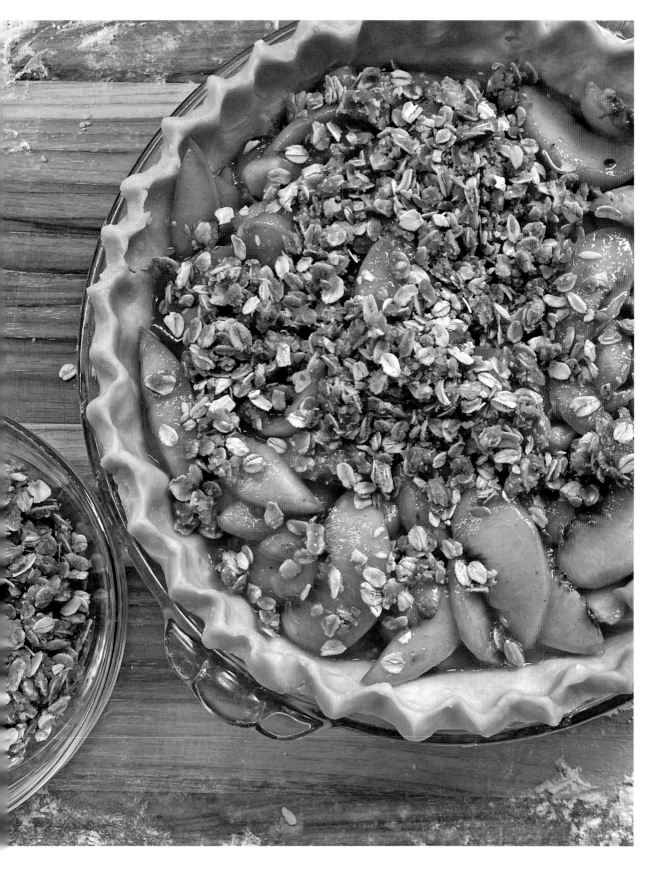

PEANUT BUTTER PIE

MAKES 1 (9-INCH) PIE

1 cup whipping cream

1 (8-ounce) package cream cheese, softened

⅔ cup creamy peanut butter

½ cup powdered sugar

1 teaspoon vanilla extract

Chocolate Cookie Piecrust (recipe at right)

Chocolate Ganache (recipe at right)

Two of the world's greatest flavors—chocolate and peanut butter—combine here in a cool-and-creamy dessert. You may substitute a store-bought chocolate cookie piecrust (there are sometimes gluten-free options), but they are occasionally difficult to find. You could also use the piecrust recipe from the cheesecake on page 164.

1 Beat whipping cream at medium speed with an electric mixer until soft peaks form; set aside.

2 Combine cream cheese, peanut butter, powdered sugar, and vanilla in a large bowl; beat until creamy. Fold in half of whipped cream to lighten mixture. Fold in remaining whipped cream. Spoon filling into Chocolate Cookie Piecrust and smooth top. Freeze for at least 1 hour.

3 Spread Chocolate Ganache over pie. Freeze for 2 to 3 hours or until firm. Let stand at room temperature for about 30 minutes before slicing. Cover and store in the freezer.

Chocolate Cookie Piecrust: Combine **1⅓ cups chocolate graham cracker cookie crumbs** (such as Teddy Grahams), **5 tablespoons melted butter,** and **3 tablespoons granulated sugar** in a bowl, stirring until well blended. Press into a 9-inch pie plate, and bake at 350° for 7 minutes. Cool completely.

Chocolate Ganache: Heat **½ cup heavy cream** in a small saucepan over low heat or in a glass container in the microwave until hot but not boiling. Remove from heat and stir in **4 ounces chopped semisweet chocolate.** Let stand for 2 or 3 minutes. Stir until smooth. Makes ¾ cup.

SOUR CREAM–LEMON POUND CAKE

MAKES 10 TO 12 SERVINGS

3 cups all-purpose flour
½ teaspoon baking powder
¼ teaspoon salt
1 cup sour cream
½ cup buttermilk
1 cup unsalted butter, softened
2½ cups granulated sugar
5 large eggs
1 teaspoon lemon zest
2 tablespoons fresh lemon juice
Lemon Glaze (recipe at right)
Garnishes: lemon slices,
 fresh mint sprigs

Adding lemon zest to the batter and glaze is the key to the bright citrus flavor of this rich cake.

1 Preheat oven to 325°. Butter and flour a 10-cup Bundt pan.

2 Combine 3 cups flour, baking powder, and salt in a bowl. Combine sour cream and buttermilk in another bowl.

3 Beat butter and sugar in a mixing bowl on medium speed with an electric mixer until light and fluffy. Add eggs and beat until smooth.

4 Alternate adding flour mixture and sour cream mixture to sugar mixture. Stir in lemon zest and juice.

5 Spoon into prepared pan. Bake for 70 to 80 minutes or until a wooden pick inserted in center comes out clean. Cool in pan for 20 minutes. Remove from pan and cool completely on a wire rack.

6 Transfer to a cake plate and drizzle Lemon Glaze over cooled cake. Garnish, if desired.

Lemon Glaze: Combine **1 cup powdered sugar, 1 teaspoon lemon zest, 2 tablespoons fresh lemon juice,** and **½ teaspoon vanilla extract** in a small bowl. Makes ½ cup.

LEMON ANGEL FOOD CAKE

MAKES 12 SERVINGS

12 large egg whites

¼ teaspoon salt

1 teaspoon vanilla extract

1 tablespoon fresh lemon juice

¾ teaspoon cream of tartar

1 cup granulated sugar

1 teaspoon lemon zest

1 cup cake or all-purpose flour

Garnishes: lemon slices, lemon
 zest, powdered sugar

For best results, avoid getting any egg yolk mixed in with the egg whites. It's easier to separate white and yolk when the eggs are very cold, but you'll want to allow the egg whites to stand until room temperature before beating. Don't overbeat the egg whites and do not grease the pan—the eggs need to cling to the sides to get a good rise and to ensure that soft, fluffy texture. If desired, serve with Raspberry Sauce (page 166).

1 Preheat oven to 350°.

2 Combine egg whites and salt in a mixing bowl; beat at high speed with an electric mixer until foamy. Beat in vanilla and lemon juice. Add cream of tartar; beat until soft peaks form. Combine sugar and zest in a small bowl; add to egg mixture a few tablespoons at a time, beating until stiff peaks form.

3 Fold in flour, ¼ cup at a time. Pour batter into an ungreased 10-inch tube pan, spreading evenly. Break air pocket by cutting through batter with a knife.

4 Bake for 20 to 25 minutes or until cake springs back when lightly touched (or when a wooden pick inserted in center comes out clean). Invert pan; cool completely. Loosen cake from sides of pan and invert onto a plate. Garnish, if desired.

PINEAPPLE UPSIDE DOWN SKILLET CAKE

MAKES 8 TO 10 SERVINGS

¾ cup salted butter, softened and divided

¾ cup firmly packed light brown sugar

1 (20-ounce) can pineapple rings

7 to 9 maraschino cherries

⅔ cup granulated sugar

2 large eggs

½ teaspoon vanilla extract

1 cup all-purpose flour

1 teaspoon baking powder

¼ teaspoon salt

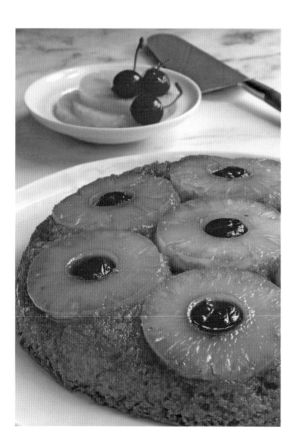

This old-school dessert has been around for 100 years! It is simple to prepare and has a lightly sweet tropical flavor, thanks to pineapple slices and a caramelized brown sugar topping.

1. Preheat oven to 350°.

2. Melt 6 tablespoons butter in a 9-inch cast-iron skillet over medium heat. Add brown sugar and cook, stirring frequently, until butter melts and mixture is smooth. Remove from heat.

3. Drain pineapple, reserving ¼ cup juice. Arrange slices evenly over sugar mixture. Place maraschino cherries in pineapple holes and spaces, if desired. Cover and refrigerate remaining pineapple slices for another use.

4. Beat remaining 6 tablespoons butter and granulated sugar in a mixing bowl until creamy. Beat in eggs, ¼ cup reserved pineapple juice, and vanilla. Combine flour, baking powder, and salt in a medium-size bowl. Gradually beat flour mixture into sugar mixture.

5. Pour batter over pineapple mixture. Bake for 35 to 40 minutes or until a wooden pick inserted in center comes out clean.

6. Cool in skillet for 10 minutes. Carefully invert cake onto a platter. Serve warm or at room temperature.

HOT FUDGE PUDDING CAKE

MAKES 6 SERVINGS

1 cup all-purpose flour

1½ cups granulated sugar, divided

¼ cup plus 2 tablespoons cocoa
 powder, divided

1 teaspoon baking powder

½ teaspoon baking soda

½ teaspoon salt

½ cup milk

¼ cup melted butter or
 vegetable oil

1 teaspoon vanilla extract

½ cup chopped pecans (optional)

½ cup light brown sugar

1½ cups hot water

Powdered sugar

Vanilla ice cream

Pudding cakes are amazing desserts! A thick batter is spread on the bottom of the baking dish and a hot water mixture is poured over the top. The dessert flips as the batter bakes and rises to the top. The recipe doubles easily in a 9x13-inch (3-quart) baking dish. Serve warm with a scoop of real vanilla ice cream.

1 Preheat oven to 350°.

2 Combine flour, ¾ cup granulated sugar, 2 table-spoons cocoa, baking powder, baking soda, and salt in a large mixing bowl. Stir in milk, butter, and vanilla. Fold in pecans, if desired. Spoon mixture into an ungreased 8x8-inch (2-quart) baking dish.

3 Combine remaining ¾ cup sugar, remaining ¼ cup cocoa, brown sugar, and 1½ cups hot water. Pour gently over batter.

4 Bake for 35 minutes. Cake will have a cooked layer on top of a liquid bottom. Sauce on the bottom will thicken slightly after standing. Sprinkle with powdered sugar and serve with ice cream.

WACKY CAKE

MAKES 9 SERVINGS

1½ cups all-purpose flour

1 cup granulated sugar

3 tablespoons cocoa powder

1 teaspoon baking soda

¼ teaspoon salt

6 tablespoons vegetable oil

1 tablespoon white vinegar

1 teaspoon vanilla extract

1 cup water

Powdered sugar or Coconut-Pecan Frosting
(recipe at right)

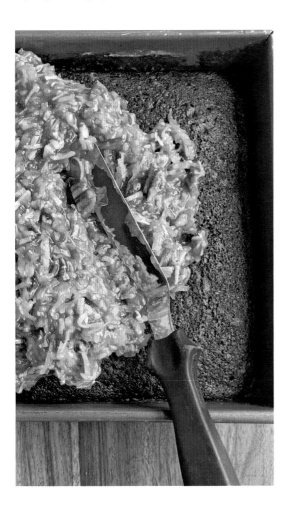

It's theorized that this recipe was created during the Great Depression or World War II when ingredients like butter, eggs, and milk were rationed. I grew up eating Wacky Cake as a treat at least once a month because it's easy to make on the spur of the moment. This recipe was the first one I remember following and preparing by myself. It's easy and fun for kids, especially when the vinegar hits the baking soda. The original calls for a simple dusting of powdered sugar, but my family recipe has included a nutty coconut frosting ever since one of my ancestors decided the dessert would go well with the frosting used on German chocolate cake.

1 Preheat oven to 350°.

2 Combine flour, sugar, cocoa, baking soda, and salt in an ungreased 8x8- or 9x9-inch baking pan. Stir together until well blended. Create 3 holes in the mixture.

3 Pour oil in one hole, vinegar in another, and vanilla in the third hole. Pour 1 cup water over entire mixture and stir together with a fork. Bake for 30 minutes. Cool in pan on a wire rack.

4 Sprinkle cake with powdered sugar or spread with Coconut-Pecan Frosting.

Coconut-Pecan Frosting: Combine **½ cup salted butter, ½ cup firmly packed light or dark brown sugar, ¼ cup evaporated or whole milk,** and **2 large egg yolks** in a saucepan over medium heat. Cook, stirring constantly, for 5 minutes or until mixture is golden brown and thickened. Remove from heat and stir in **½ teaspoon vanilla extract, 1⅓ cups sweetened coconut flakes,** and **½ cup toasted chopped pecans.** Makes 1½ cups.

BLUEBERRY BUCKLE

MAKES 9 SERVINGS

Streusel Topping (recipe at right)

5 tablespoons unsalted butter, softened

¾ cups granulated sugar

1 large egg

1 teaspoon vanilla extract

2 cups all-purpose flour

1½ teaspoons baking powder

½ teaspoon fine sea salt

½ cup whole milk

1½ cups blueberries, fresh or frozen

Garnish: powdered sugar

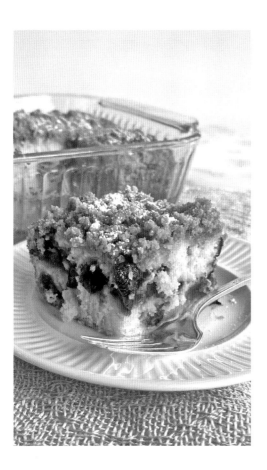

Similar to a coffee cake, a buckle includes fruit in the batter and a streusel topping. The term "buckle" refers to how this dish bakes. As the batter rises, the combined weight of the fruit and streusel topping causes the cake to appear indented and buckled.

1 Preheat oven to 350°. Lightly grease (with butter) bottom and sides of an 8x8- or 9x9-inch baking dish. Prepare Streusel Topping; set aside.

2 Beat together butter, sugar, egg, and vanilla in a mixing bowl until smooth. Combine flour, baking powder, and salt in a medium-size bowl. Beat flour mixture into butter mixture, alternating with milk. Gently fold in blueberries.

3 Spoon batter into prepared dish, smoothing top with a spatula. Sprinkle evenly with Streusel Topping. Bake for 30 to 35 minutes or until a wooden pick inserted in center comes out clean. If using frozen berries, baking time may be extended by 15 to 20 minutes. Cover with aluminum foil after 30 minutes to prevent overbrowning.

4 Remove from oven and cool in dish. Garnish, if desired. Serve warm or at room temperature.

Streusel Topping: In a small bowl, stir together **½ cup all-purpose flour, ½ cup lightly packed light or dark brown sugar, ¾ teaspoon ground cinnamon, and ¼ teaspoon fine sea salt.** Cut **¼ cup unsalted butter** into dry ingredients with a pastry blender or fork until mixture has a crumb-like texture. Makes about 1 cup.

CHERRY CLAFOUTIS

MAKES 6 SERVINGS

2½ cups stemmed and pitted sweet cherries

3 tablespoons butter

3 large eggs

1 cup half-and-half or milk

½ cup granulated sugar

½ cup all-purpose flour

1 teaspoon vanilla extract

½ teaspoon almond extract

½ teaspoon sea salt

¼ cup toasted sliced almonds

Powdered sugar

While we have several ornamental cherry trees that bloom gloriously each spring, none provide edible fruit. My family is quite lucky to have neighbors—Ingrid and Joe Page and Danielle and Dennis Arakelian—who generously supply us with bowls of ripe, juicy cherries each year. Removing the pits from cherries can be tedious, but the rest of this recipe is incredibly easy. It's worth the effort!

1 Preheat oven to 375°. Lightly grease (with butter) a 2-quart baking dish. Place cherries in an even layer in bottom of prepared baking dish. Melt 3 tablespoons butter.

2 Combine melted butter, eggs, half-and-half, sugar, flour, vanilla and almond extracts, and salt in a blender. Blend for 30 seconds to 1 minute or until smooth. Pour egg mixture over cherries.

3 Bake for 45 minutes or until golden brown and puffed. Sprinkle with almonds and powdered sugar.

STRAWBERRIES ROMANOFF

MAKES 4 TO 6 SERVINGS

There are a few variations on this simple dessert, some using brandy and others using orange liqueur. You can substitute either one or simply use vanilla extract. To make it more filling, place madeleine cookies or lady fingers on the bottom of the serving bowl, then top with berries and sauce.

1 quart strawberries, hulled and halved

2 tablespoons granulated sugar

1 to 2 tablespoons orange liqueur

½ cup sour cream

3 tablespoons light brown sugar

1 tablespoon brandy, orange liqueur, or
 2 teaspoons vanilla extract

Pinch of ground cinnamon

½ cup heavy whipping cream

Garnish: ground cinnamon

1 Combine berries, granulated sugar, and orange liqueur in a medium-size bowl. Cover and refrigerate for 1 hour or until ready to serve.

2 Combine sour cream, brown sugar, and brandy in another medium-size bowl. Stir in cinnamon. Set aside.

3 Beat whipping cream in another bowl until soft peaks form. Fold into sour cream mixture.

4 Spoon strawberries into serving dishes and dollop with whipped cream mixture. Garnish, if desired.

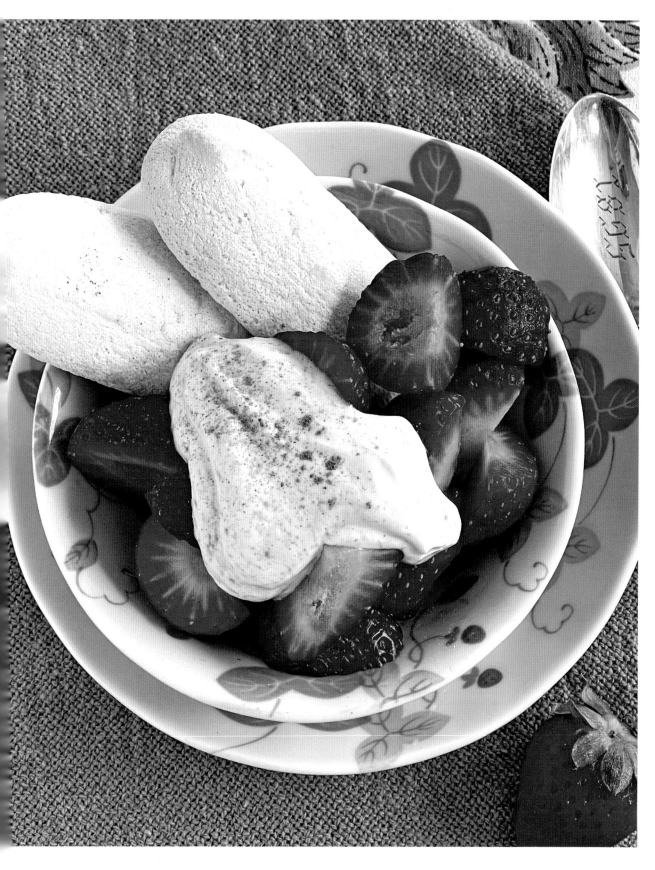

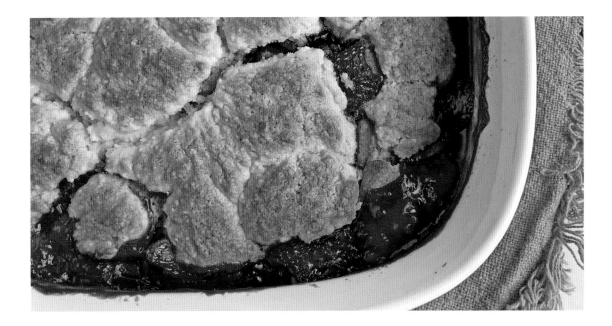

BERRY-CREAM CHEESE COBBLER

MAKES 8 SERVINGS

6 cups mixed berries, such as black-berries, raspberries, blueberries, and quartered strawberries

¾ cup plus 1 tablespoon granulated sugar, divided

½ teaspoon lemon zest

2 tablespoons cornstarch

½ teaspoon ground cinnamon (optional)

½ (8-ounce) package cream cheese, softened

1 teaspoon vanilla extract

1 cup all-purpose flour

1½ teaspoons baking powder

¼ teaspoon salt

5 tablespoons butter, cut into pieces

⅓ cup buttermilk

Use a blend of your favorite berries in this seasonal treat. You don't have to wait until summer to enjoy it, though—use frozen and thawed fruit. It's convenient and often a better value than fresh.

1 Preheat oven to 375°. Lightly grease (with butter) an 8x8-inch (2-quart) baking dish.

2 Combine berries, ½ cup sugar, zest, corn-starch, and, if desired, cinnamon in a large bowl. Set aside.

3 Combine cream cheese, 1 tablespoon sugar, and vanilla in a small bowl.

4 Combine flour, remaining ¼ cup sugar, baking powder, and salt in a large bowl. Cut butter in with a pastry blender or fork until small pea-size lumps remain. Add buttermilk, stirring just until combined.

5 Stir berry mixture and pour into prepared baking dish. Drop cream cheese mixture by spoonfuls over berry mixture. Dollop flour mixture on top.

6 Bake for 45 minutes or until topping is golden brown and berries are bubbling. Cool slightly before serving.

DARK-AND-WHITE-CHOCOLATE BREAD PUDDING

MAKES 8 SERVINGS

Butter

1 (16-ounce) loaf French or sourdough bread, cubed

1 cup dark chocolate morsels

1 cup white chocolate morsels

4 large eggs

1 cup granulated sugar

1 tablespoon vanilla extract

3 cups half-and-half

¼ teaspoon salt

Caramel-Coffee Sauce (recipe at right)

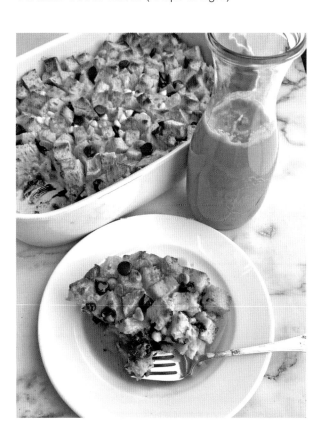

Always a crowd-pleaser, this is a great make-ahead dessert. It's important to allow the bread to soak for a few hours so it can absorb the sweet custard. Removing the crust from the bread makes it softer, but I like the chewiness it provides (plus the faster prep), so I keep the crust on the bread cubes.

1 Lightly grease (with butter) a 9x13-inch (3-quart) baking dish. Combine bread with dark chocolate and white chocolate morsels in prepared dish.

2 Wisk together eggs, sugar, vanilla extract, half-and-half, and salt in a large bowl. Pour into bread mixture, pressing down to soak all pieces of bread. Cover and refrigerate for 8 hours or overnight.

3 Preheat oven to 350°. Bake bread pudding for 40 to 45 minutes or until edges are golden brown and center is set. Cool for 10 minutes. Serve warm with Caramel-Coffee Sauce.

Caramel-Coffee Sauce: Combine **½ cup butter, ½ cup firmly packed light brown sugar,** and **1 cup heavy whipping cream** in a saucepan. Bring to a boil; boil for 1 minute. Remove from heat and stir in **¼ cup coffee liqueur.** Makes 1¾ cups.

VANILLA CHEESECAKE

MAKES 8 SERVINGS

1 cup gingersnap or
 graham cracker crumbs

1¼ cups granulated sugar, divided

¼ cup salted or unsalted butter,
 melted

3 (8-ounce) packages cream cheese,
 softened

1 tablespoon vanilla extract

Pinch of salt

3 large eggs

½ cup heavy whipping cream

Raspberry Sauce (page 166)

Several steps are
involved in the
making, but this
gorgeous home-
made cheesecake is
definitely worthy of
your time and sure
to impress!

The most tender and luscious cheesecakes are baked in a water bath (also called a bain-marie). Baking the dessert surrounded by hot water ensures even cooking, soft texture, and no cracks on the top. Even though the springform pan might seem watertight, wrap the exterior in aluminum foil to prevent any liquid from seeping into the crust. A deep roasting pan works well. Make sure you use hot to boiling water—cold water will lower the oven temperature and lengthen baking time.

1 Preheat oven to 350°. Wrap outside bottom and sides of a 9-inch springform pan in aluminum foil.

2 Combine crumbs, ¼ cup sugar, and melted butter in a medium bowl. Press into bottom of prepared pan. Bake for 10 minutes. Cool on a wire rack. Reduce heat to 325°.

3 Beat cream cheese until light and fluffy. Add remaining 1 cup sugar, vanilla, and salt; beat until blended. Add eggs, one at a time, beating well after each addition. Beat in whipping cream. Pour batter over crust.

4 Set cake pan inside a large, shallow roasting pan. Transfer to hot oven. Carefully pour boiling water halfway up sides of cake pan. Bake for 60 to 65 minutes or until center barely moves when pan is slightly moved (cheesecake will firm when chilled).

5 Transfer to a wire rack to cool completely. Refrigerate, uncovered, for 8 hours or overnight. Run a knife around outside edge and remove from pan. Serve with Raspberry Sauce.

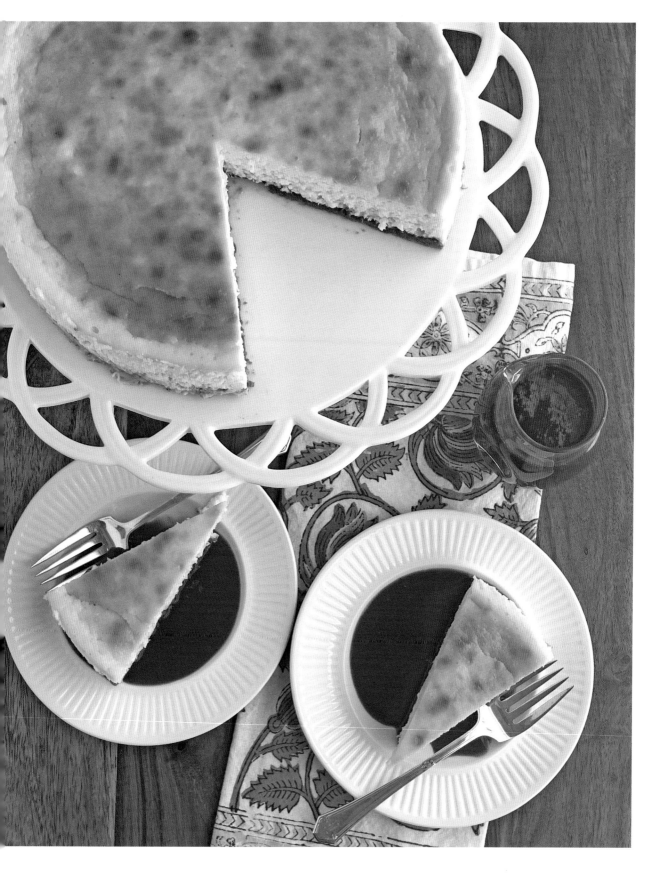

RASPBERRY SAUCE

MAKES 1½ CUPS

Bright and beautiful, this sweet-and-tangy dessert sauce is delicious over cheesecake, ice cream, and chocolate pie, as well as breakfast dishes like pancakes and waffles. You can even stir it into lemonade or iced tea—it's so versatile! Store it in the freezer for up to 6 months.

1 (12-ounce) bag frozen raspberries, thawed
½ cup granulated sugar
1 tablespoon lemon juice

1 Combine raspberries, any juice from package, sugar, and lemon juice in a medium-size saucepan over medium heat. Cook, crushing raspberries against side of pan and stirring constantly, for 6 minutes.

2 Pour mixture through a fine wire-mesh strainer into a bowl, pressing with a spatula or back of a spoon, discarding seeds. Cover and chill until ready to serve.

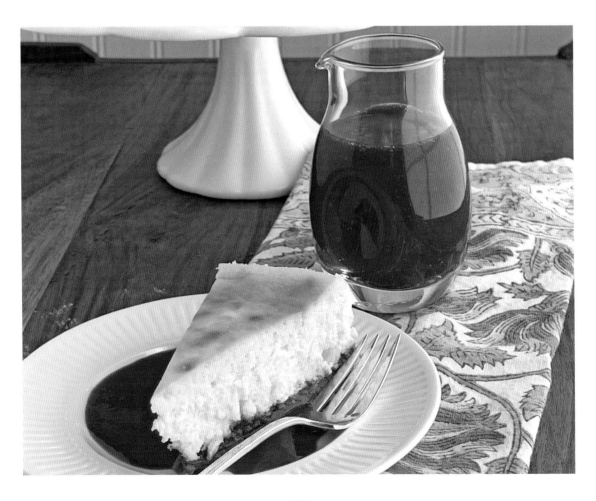

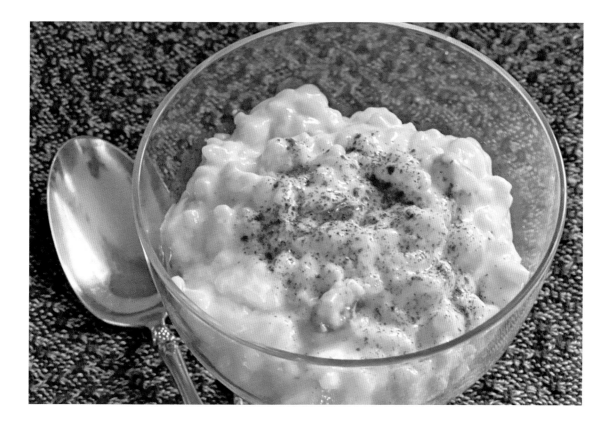

CINNAMON-VANILLA RICE PUDDING

MAKES 4 CUPS

½ cup uncooked Arborio rice, rinsed and drained

4 cups whole milk

½ cup granulated sugar

2 pinches of salt, divided

1 egg

1 teaspoon vanilla extract

¼ cup golden raisins or other dried fruit

Ground cinnamon

Arborio is a short-grain rice famously used for risotto recipes. It creates a creamy texture, ideal for this pudding. If necessary, long-grain rice can be substituted, but the texture may be different. Serve warm or chilled.

1 Combine rice, milk, sugar, and 1 pinch of salt in a medium-size saucepan. Bring to a boil over medium-high heat. Reduce heat to medium-low and simmer, stirring occasionally, for 45 to 50 minutes or until rice is tender. There will be some liquid surrounding the rice. Don't cook until completely dry; the pudding thickens as it cools.

2 Whisk egg in a small bowl until lightly beaten. Add about ¼ cup cooked rice mixture to egg and whisk briskly. Repeat with another ¼ cup rice mixture. Add egg mixture to pan. Cook for 1 minute, whisking constantly. Remove from heat. Stir in vanilla, raisins, and remaining 1 pinch of salt. Let stand until pudding thickens. Divide into small bowls and sprinkle with cinnamon.

EQUIVALENTS

Almonds	1 pound shelled	4 cups slivered	
Bacon	1 slice bacon	1 tablespoon crumbled	
Beans (Black)	1 pound dried	2⅓ cups uncooked	4¼ cups cooked
Beans (Black)	1 (15½-ounce) can	2 cups cooked	
Beans (Green)	1 pound fresh	3½ cups	
Beans (Green)	9 ounces frozen	1½ cups	
Beans (Green)	1 (15½-ounce) can	1¾ cups	
Bell Peppers	1 large	1 cup chopped	
Blueberries	1 pint fresh	2 cups	
Blueberries	10 ounces frozen	1½ cups	
Butter	1 stick	½ cup	8 tablespoons
Butter	2 sticks	1 cup	½ pound
Butter	4 sticks	2 cups	1 pound
Carrots	1 pound fresh	2½ cups grated	
Celery	2 medium ribs	½ cup chopped	
Cheese	4 ounces	1 cup shredded	
Cheese (Blue, Feta)	¼ pound	1 cup crumbled	
Cheese (Cheddar, Swiss, Jack)	8 ounces	2 cups shredded	
Cheese (Parmesan, Romano)	4 ounces	1 cup grated	
Corn	2 medium ears	1 cup kernels	
Crackers	28 soda or saltine crackers	1 cup crumbs	
Crackers	15 graham squares	1 cup crumbs	
Garlic	1 clove	½ teaspoon minced	
Lemon	1 medium	2 tablespoons juice	
Lemon	1 medium	2 teaspoons zest	
Lime	1 medium	1½ tablespoons juice	
Lime	1 medium	1 teaspoon zest	
Nuts	1 pound shelled	4 cups chopped	
Onion	1 large onion	1 cup chopped	

Orange	1 medium	⅓ cup juice
Orange	1	2 tablespoons zest
Pasta	2 ounces uncooked	1 serving cooked
Pasta	1 cup uncooked small macaroni	2 cups cooked
Pasta	4 ounces uncooked spaghetti	4 cups cooked
Rice	1 cup long-grain uncooked	3 cups cooked
Sour Cream	8 ounces	1 cup
Strawberries	1 pint	2 cups sliced
Tomato	1 large	1 cup chopped
Whipping Cream	1 cup	2 cups whipped

MEASUREMENT CONVERSIONS

Pinch	less than ⅛ teaspoon
3 teaspoons	1 tablespoon
2 tablespoons	⅛ cup
4 tablespoons	¼ cup
5⅓ tablespoons	⅓ cup
8 tablespoons	½ cup
16 tablespoons	1 cup
1 tablespoon	½ fluid ounce
2 tablespoons	1 fluid ounce
¼ cup	2 fluid ounces
½ cup	4 fluid ounces
1 cup	8 fluid ounces
2 cups	16 fluid ounces
4 cups	32 fluid ounces
½ cup	¼ pint
1 cup	½ pint
2 cups	1 pint
4 cups	1 quart
4 quarts	1 gallon
16 cups	1 gallon

BAKING DISH CONVERSIONS

ROUND	
8x1½-inch	4 cups
8x2-inch	6 cups
9x1½-inch	6 cups
9x2-inch	8 cups
SQUARE	
8x8x1½-inch	6 cups
9x9x1½-inch	2 quarts
9x9x2-inch	2½ quarts
RECTANGLE	
11x7x2-inch	2½ quarts
13x9x2-inch	3 quarts
LOAF	
8½x4½x2½-inch	1½ quarts
9x5x3-inch	2 quarts
BUNDT—1 QUART	
9x3-inch	9 cups
10x3-inch	12 cups

SUBSTITUTIONS

BAKING POWDER	
1 teaspoon	¼ teaspoon baking soda + ½ teaspoon cream of tartar

BISCUIT MIX	
1 cup	1 cup all-purpose flour + 1½ teaspoons baking powder + 2 tablespoons shortening or butter

BREADCRUMBS	
1 cup	¾ cup cracker crumbs

BROTH	
1 cup	1 cup boiling water + 1 bouillon cube or 1 teaspoon granules or paste

BUTTERMILK	
1 cup	1 cup milk + 1 tablespoon lemon juice or vinegar
1 cup	1 cup plain yogurt

CHOCOLATE	
1 ounce unsweetened	3 tablespoons cocoa powder + 1 tablespoon butter or vegetable oil
1 ounce unsweetened	1½ ounces semisweet and remove 1 tablespoon sugar from recipe
1 ounce bittersweet or semisweet	⅔ ounce unsweetened chocolate + 2 teaspoons sugar
1 ounce bittersweet	1 ounce semisweet
1 ounce semisweet	1 ounce unsweetened + 1 tablespoon sugar
1 ounce sweet baking chocolate	3 tablespoons cocoa powder + 4 teaspoons sugar + 1 tablespoon butter or vegetable oil

CORN SYRUP (LIGHT)	
1 cup	¾ cup sugar + ¼ cup additional liquid in recipe

CORN SYRUP (DARK)	
1 cup	¾ cup light corn syrup + ¼ cup molasses

FLOUR, ALL-PURPOSE FLOUR (FOR THICKENING)	
2 tablespoons	1 tablespoon cornstarch
2 tablespoons	2 tablespoons quick-cooking tapioca

FLOUR, CAKE	
1 cup	1 cup - 2 tablespoons all-purpose flour + 2 tablespoons cornstarch

FLOUR, SELF-RISING	
1 cup	1 cup all-purpose flour + 1½ teaspoons baking powder + ⅛ teaspoon salt
HALF-AND-HALF	
1 cup	½ cup milk + ½ cup whipping cream
HERBS	
1 tablespoon fresh	1 teaspoon dried
LEMON JUICE	
1 teaspoon fresh juice	½ teaspoon vinegar
MOLASSES	
1 cup	1 cup almond butter
PEANUT BUTTER	
1 cup	1 cup almond butter
SUGAR (LIGHT BROWN)	
1 cup	½ cup dark brown sugar + ½ cup granulated sugar
SUGAR (GRANULATED)	
1 cup	1¾ cups powdered
1 cup	1 cup firmly packed light brown sugar
TOMATO SAUCE	
2 cups	1 cup tomato paste + 1 cup water

INDEX

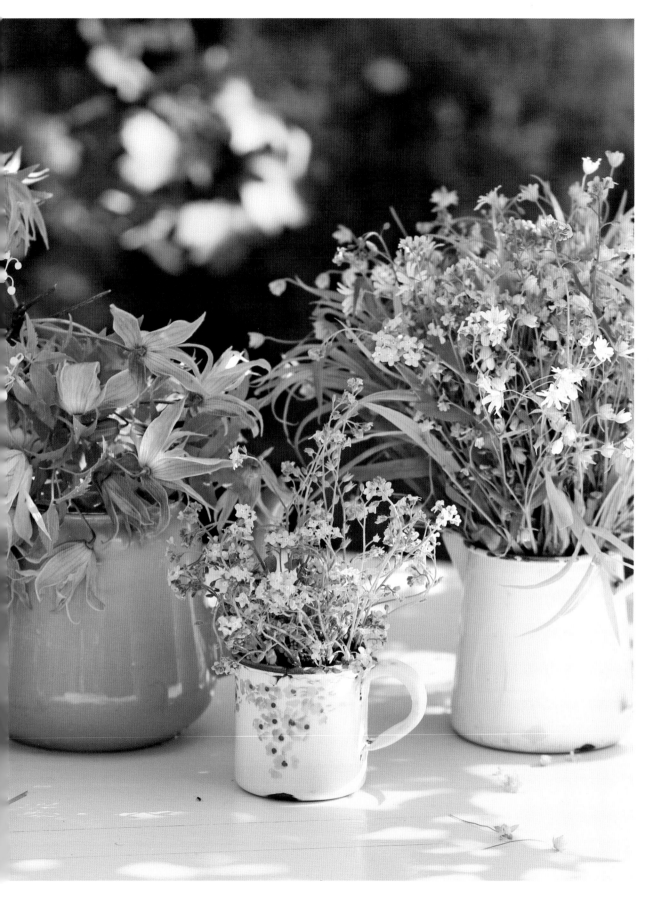

Cover design by Jonathan Norberg
Book design by Hilary Harkness
Edited by Emily Beaumont

Cover images: All photos copyright by **Julia Rutland** unless otherwise noted.
J u n e/Shutterstock.com: wood spoon; **One Pixel Studio/Shutterstock.com:** table cloth; **Pinkyone/Shutterstock.com:** woodgrain; **Rubanitor/Shutterstock.com:** flour; and **Vladislav Noseek/Shutterstock.com:** butter & eggs.

All photos by **Julia Rutland** unless otherwise noted.

Images used under license from Shutterstock.com:
Abel Tumik: 97m (corn); **Afanasieva:** 176; **akepong srichaichana:** 88 (green onions); **Aleksey Patsyuk:** 130 (tomatoes); **Alena Ozerova:** 23; **AmyLv:** 91 (wild rice); **Anna Chelnokova:** 106 (garlic cloves); **Armas Vladimir:** 94 (rosemary); **ArtKio:** grainy background on pages 168, 169, 171-173; **baibaz:** 40 (chocolate ice cream), 146 (chocolate bits); **bergamont:** 59 (mushrooms), 150 (peaches); **bonchan:** 135; **Brent Hofacker:** 97 (corn pudding); **Business stock:** 163 (bread cubes); **chyworks:** 183; **Civil:** 71 (blue cheese); **Cloud Cap Photography:** 9 (chocolate chips); **D_M:** 56 (thyme); **Da-ga:** 29 (radishes); **Daria Minaeva:** 173 (rosemary cut); **den781:** 30; **Egor Rodynchenko:** 41 (mint); **Elena Eryomenko:** 2; **Elovich:** 27 (garlic); **EM Arts:** 68 (red onion); **Fablok:** 37 (dill); **FooTToo:** v; **Galayko Sergey:** 50 (black beans); **Galina Grebenyuk:** 181; **gowithstock:** vii; **GSDesign:** 110 (basil); **Hitdelight:** 170; **Hong Vo:** 70 (potatoes), 77 (cheddar cheese); **Hurst Photo:** 34 (cheddar cheese); **ifong:** 20 (berries); **Ines Behrens-Kunkel:** 83 (green beans); **Irina Mur:** 141 (toffee); **Irina Rostokina:** 116; **JeniFoto:** 100; **JIANG HONGYAN:** 50 (green pepper); **Jmcanally:** 31 (cranberry sauce); **Joshua Resnick:** 169 (lemons with juice); **Jr images:** 93 (kidney beans); **Kaiskynet Studio:** 54 (celery); **Kelly vanDellen:** 98 (round crackers); **Lens7:** 158 (blueberries); **Lepas:** 48 (parsnips); **Lulub:** 164 (graham crackers); **LumenSt:** 144 (cloves); **Maceofoto:** 160 (vanilla beans); **MaraZe:** 33; **marekuliasz:** 171 (measuring spoons); **matkub2499:** 128 (rosemary); **maxbelchenko:** 1; **mylisa:** 32 (onions); **mythja:** 179; **NataliaZa:** 74 (spinach); **Nataly Studio:** 16 (sweet potato), 128 (brown sugar), 142 (lime), 154 (lemon zest); **Nattika:** 14 (eggs); **New Africa:** 45, 99 (sweet potatoes), 160 (cinnamon sticks); **NG-Spacetime:** 182; **Nik Merkulov:** 49 (broccoli), 68 (broccoli); **NIKCOA:** 52 (sweet corn); **NinaM:** 52 (red potatoes); **NIPAPORN PANYACHAROEN:** 125 (shrimp); **oksana2010:** 84 (Brussels sprouts); **Paul Orr:** 130 (spaghetti noodles); **Peter Zijlstra:** 86; **photogal:** 60 (potatoes); **Picture Partners:** 22 (Gruyère cheese), 160 (brown sugar); **Pineapple studio:** 97 (egg); **Pinkyone:** woodgrain on pages ii, 5, 25, 43, 65, 103, 139, 168-173; **PixaHub:** 75 (avocado), 107 (orange slice), 155 (pineapple); **PIXbank CZ:** 72 (cucumber); **Pixel-Shot:** 128 (maple syrup); **R7 Photo:** 2; **Ratana Prongjai:** 148 (sesame seeds); **Rolandas Grigaitis:** 72 (tomatoes); **Roman Samokhin:** 108; **Rtstudio:** 115; **Snowbelle:** 10 (cranberries); **Spalnic:** 17 (honey); **stockcreations:** 133, 180; **Tang Yan Song:** 98 (yellow squash); **TaniaKitura:** 18, 56 (bay leaves); **Tanya Sid:** 29 (butter); 127 (mustard); **Tiger Images:** 36 (artichoke); **Tim UR:** 41 (peach), 59 (celery), 160 (strawberries), 164 (raspberries); **timquo:** 91 (pecans); **tOOn_in:** i (coffee pot); **Valery121283:** 89 (spinach); **Volodymyr Krasyuk:** 80 (Parmesan cheese); **Volosina:** 12 (rosemary), 32 (lemons); **Vova Shevchuk:** 130 (Parmesan cheese), **Washdog:** 184 (picture frame); **Wealthylady:** 130 (parsley); and **Yeti studio:** 9 (coffee beans), 19 (cinnamon sticks).

10 9 8 7 6 5 4 3 2
Homestyle Kitchen:
Fresh & Timeless Comfort Food for Sharing
Copyright © 2024 by Julia Rutland
Published by Adventure Publications
An imprint of AdventureKEEN
310 Garfield Street South
Cambridge, Minnesota 55008
(800) 678-7006
www.adventurepublications.net
All rights reserved
Printed in China
LCCN 2023050180 (print); 2023050181 (ebook)
ISBN 978-1-64755-427-9 (pbk.);
ISBN 978-1-64755-428-6 (ebook)

The Story of AdventureKEEN

We are an independent nature and outdoor activity publisher. Our founding dates back more than 40 years, guided then and now by our love of being in the woods and on the water, by our passion for reading and books, and by the sense of wonder and discovery made possible by spending time recreating outdoors in beautiful places.

It is our mission to share that wonder and fun with our readers, especially with those who haven't yet experienced all the physical and mental health benefits that nature and outdoor activity can bring.

In addition, we strive to teach about responsible recreation so that the natural resources and habitats we cherish and rely upon will be available for future generations.

We are a small team deeply rooted in the places where we live and work. We have been shaped by our communities of origin—primarily Birmingham, Alabama; Cincinnati, Ohio; and the northern suburbs of Minneapolis, Minnesota. Drawing on the decades of experience of our staff and our awareness of the industry, the marketplace, and the world at large, we have shaped a unique vision and mission for a company that serves our readers and authors.

We hope to meet you out on the trail someday.

#bewellbeoutdoors

ABOUT THE AUTHOR

Julia Rutland has 25 years of experience in the food, publishing, travel, and marketing industries. She is the author of a dozen cookbooks, including *The Campfire Foodie Cookbook*, *Apples*, *Blueberries*, *Eggs*, *Honey*, *Squash*, *Tomatoes*, *Foil Pack Dinners*, *101 Lasagnas*, and *The Christmas Movie Cookbook*. Before moving to the Washington, D.C., area and developing her own business, Julia worked at *Coastal Living* magazine as senior food editor, with Wimmer Cookbooks as a sales and marketing consultant, and in the test kitchens of *Southern Living* magazine. Julia has deep knowledge of cooking principles, is passionate about consumer education, and is skilled in savvy story packaging. She is a member of Les Dames d'Escoffier, an international philanthropic organization of women leaders in the fields of food, fine beverage, and hospitality. Julia is also a trained volunteer with the Virginia Cooperative Extension Master Gardeners program in Loudoun County. Julia lives in the D.C. wine-country town of Hillsboro, Virginia, with her husband, two daughters, and many furred and feathered friends.